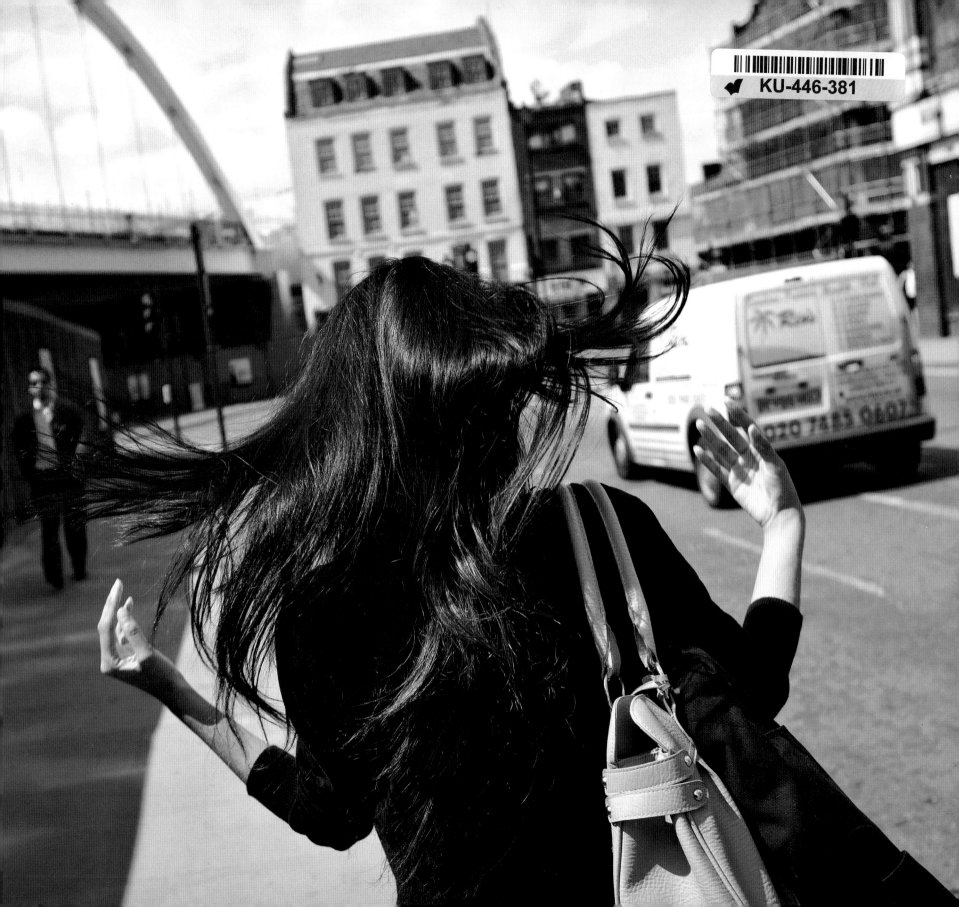

Sophie Howarth *and* Stephen McLaren

STREET PHOTOGRAPHY NOW

with 301 photographs in colour and black-and-white

Thames & Hudson

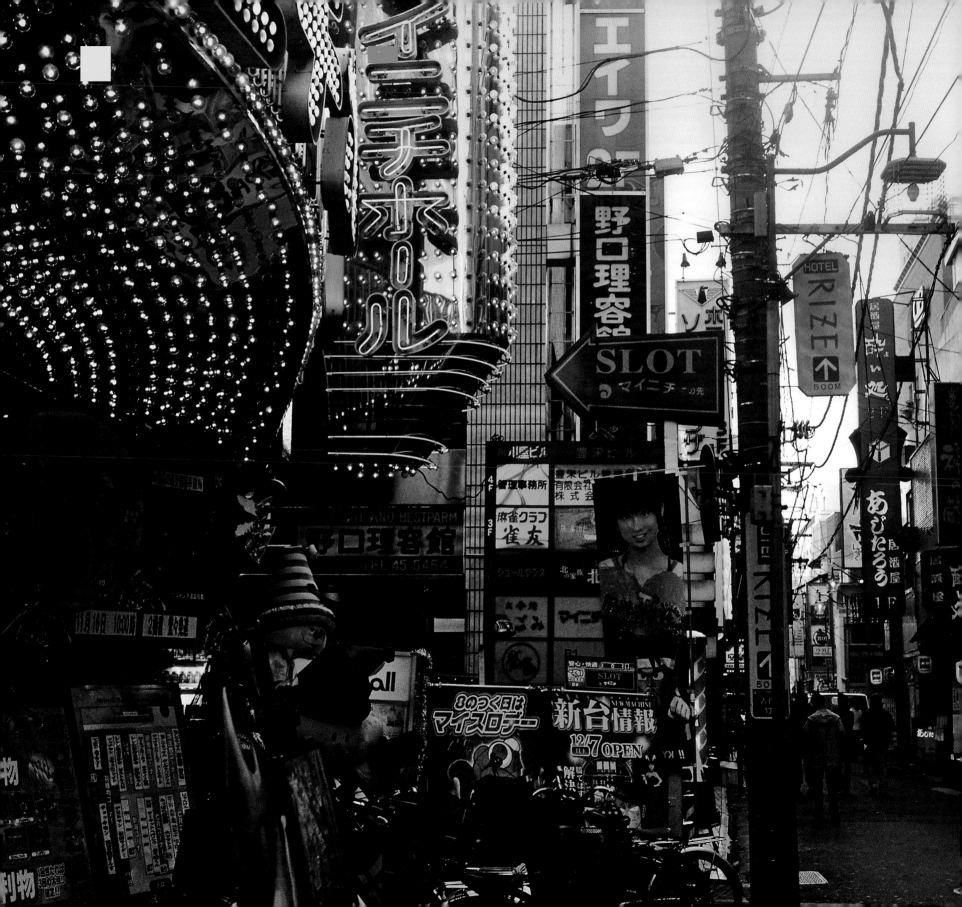

First published in the
United Kingdom in 2010
by Thames & Hudson Ltd,
181A High Holborn,
London WC1V 7QX

First paperback edition 2011

Copyright © 2010
Thames & Hudson Ltd, London

Text copyright © 2010 Sophie
Howarth and Stephen McLaren

Images copyright © 2010 the
photographers

p. 11 Image copyright © Martin Parr
pp. 24–25 Images courtesy of
Stills Gallery/Agence Vu
p. 62 (top, l–r) Images courtesy
of Lisson Gallery, London
pp. 96–97 Images courtesy of
Osiris, Tokyo
pp. 118, 124–29 Images courtesy
of Rick Wester Fine Art, New York
pp. 130–33 Images courtesy of
Edwynn Houk Gallery, New York

British Library Cataloguing-in-
Publication Data
A catalogue record for this book
is available from the British Library

ISBN 978-0-500-28907-5

Printed and bound in China by
1010 Printing International Ltd

To find out about all our
publications, please visit
www.thamesandhudson.com.
There you can subscribe to our
e-newsletter, browse or download
our current catalogue, and buy
any titles that are in print.

CONTENTS

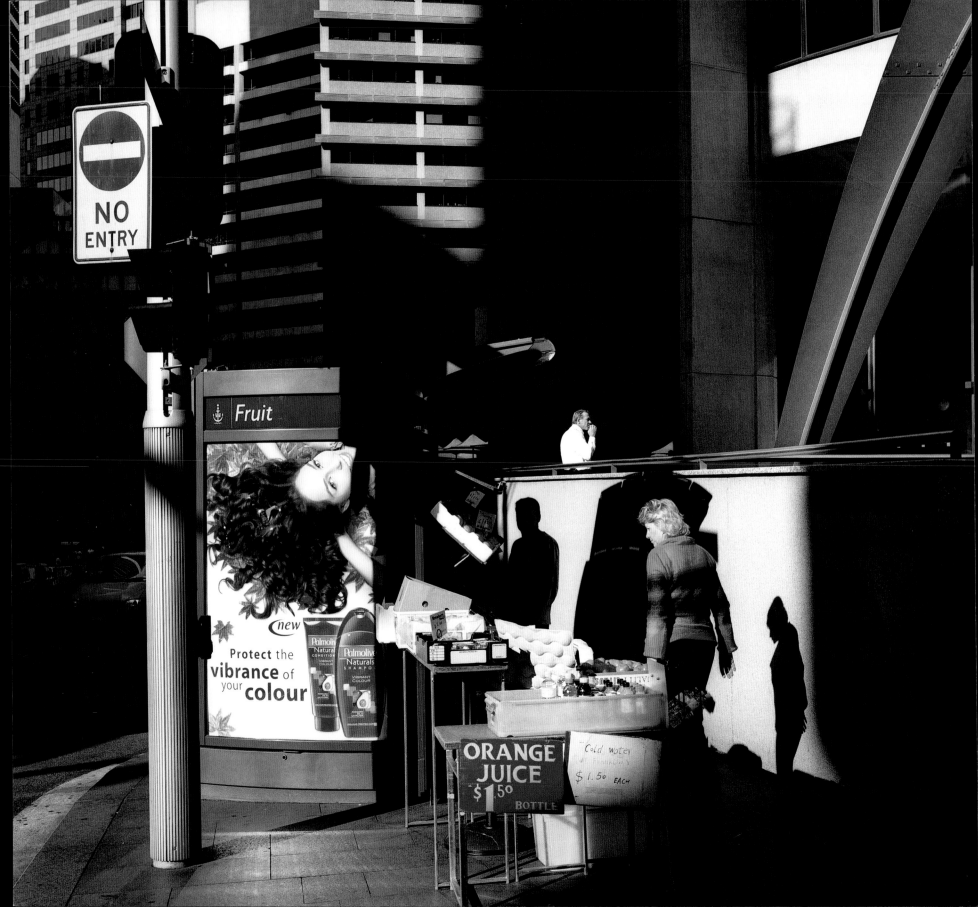

PREFACE

Writing this book has taken us on a remarkable armchair journey across the globe. Leafing the pages of hundreds of books and browsing the windows of thousands of websites, we have travelled from Mexico to Moscow, Dubai to Dakar, Sydney to Seoul. We have found ourselves wandering through the back alleys of Hong Kong with Michael Wolf, surfing the retail nirvana of London's Oxford Street with Matt Stuart, ploughing through Delhi's light-frazzled thoroughfares with Raghu Rai and descending into the bowels of the New York subway with Christophe Agou. We are grateful to all the photographers for guiding us through streets we may never physically have the opportunity to visit.

Street photography attracts an unusually open-minded and generous group of practitioners. It is a tradition that has been fertilized by an international conversation going back over seventy years which, thanks to the internet, is now more vibrant than ever. We have been struck by the kindness of all the photographers in this book towards one another's work, and by the culture of peer critique that exists between them. We are particularly grateful for all the leads given to us by better-known photographers about newer talent emerging around the globe.

We would like to thank Johanna Neurath, champion of street photography and a wonderful photographer herself, who nurtured this book every step of the way. We are also grateful to all the staff at Thames & Hudson for their dedication and diplomacy. Through collaborations over several years, the London members of In-Public have all particularly helped open our eyes to the variety, humour and acuity of great street photography.

Stephen would like to thank Paul Trevor and Sian Jones for their insights and encouragement. Sophie would like to thank Charlotte Cotton, David Campany, Susan Bright and Anne Braybon for their enlightening conversations about all aspects of photography, Mark Lythgoe for keeping my feet on the ground, and Isaac, who shared the same gestation as this book.

Sophie Howarth and Stephen McLaren

TITLE SPREAD:
Arif Asci, Seoul, 2008

PRECEDING PAGE:
Osamu Kanemura,
*Keihin Machine Soul
No. 31*, Tokyo, 1996

OPPOSITE:
Trent Parke, George
Street, Sydney, 2006

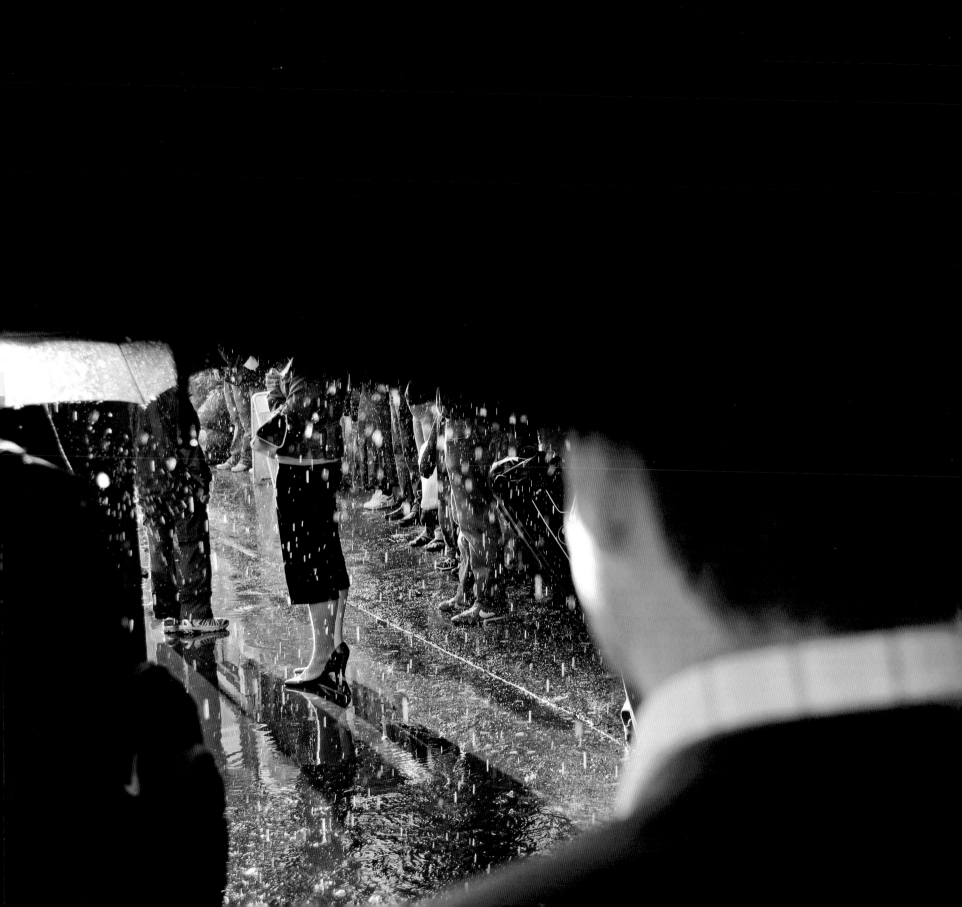

STARE, PRY, LISTEN, EAVESDROP

No better advice has ever been given to street photographers than that offered by Walker Evans, one of the greatest American photographers of the mid-twentieth century: 'Stare. It is the way to educate your eye, and more. Stare, pry, listen, eavesdrop. Die knowing something. You are not here long.'

Evans would never have described himself as a 'street photographer'. In the decades when he was most active – the 1930s and 1940s – the term still described someone who solicited strangers, often at tourist landmarks and holiday destinations, offering to take their portraits for a fee. A brief pose, a puff of flash powder and the job was done. Evans would have regarded the term far too limiting, for he drew inspiration not only from the street but also from underground trains, front porches and parks – anywhere he could observe honest people going about their daily lives. However, his deliciously provocative instructions reveal the essence of what is now known as 'street photography': the impulse to take candid pictures in the stream of everyday life.

Street photography is an unbroken tradition, stretching back to the invention of photography itself. It revels in the poetic possibilities that an inquisitive mind and a camera can conjure out of everyday life. Like Evans, the photographers featured in this book get many of their best shots in shopping malls, parks, bars, museums, subways or coastal promenades. In their spontaneous and often subconscious reaction to the fecundity of public life, street photographers elevate the commonplace and familiar into something mythical and even heroic. They thrive on the unexpected, seeing the street as a theatre of endless possibilities, the cast list never fixed until the shutter is pressed. They stare, they pry, they listen and they eavesdrop, and in doing so they hold up a mirror to the kind of societies we are making for ourselves. At a time when fewer and fewer of the images we see are honest representations of real life, their work is more vital than ever.

We are all photographers now

Today's street photographers are living in a digital society in which ideas, images and money move with increasing fluidity across national and cultural boundaries. It is easy to travel between far-flung geographical locations with lightweight, high-quality equipment, instantly uploading and sharing images with an expanding global community via the internet. The inheritance of past masters and the growing archive of street photography can easily be accessed online. These are exhilarating times. As William A. Ewing, curator of the New York Photo Festival, puts it: 'Everything is changing. How we take photographs, manipulate them, share them, store them — even how we pose for them. Our tools are mutating quickly, promising ever faster, clearer, brighter and cheaper pictures. Meanwhile, telephones become cameras, desktop printers morph into mini-printing labs, and high-definition screens threaten to dislodge the venerable photographic print from gallery walls.' For the street-hardened photographer, the sheer ubiquity of cameras in public life creates an aesthetic obstacle. 'It's harder and harder to take a picture without somebody in the picture who's also taking a picture,' says Brooklyn-based photographer Gus Powell. 'We all take pictures now, that's just what we do.'

OPPOSITE:
Nils Jorgensen,
Wimbledon, London,
2007

BELOW:
Peter Funch, *Memory Lane*, from the series *Babel Tales*, New York City, 2007

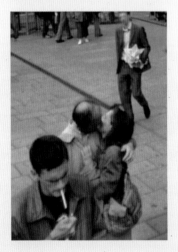

Perhaps the most prolific street photographer today is the Google Street View system, in which a remote ocular camera fixed to a car records a continual stream of still images as it traverses the world's cities. In Paris, German photographer Michael Wolf has made a provocative and illuminating body of work by mining the Street View database for individual frames that show candid human moments not dissimilar to the scenes captured by conventional street photographers. Wolf's visual data mining has even turned up an image reminiscent of Robert Doisneau's classic street photograph *Kiss by the Hôtel de Ville* (*below left*). At a time when legal objections to street photography have become increasingly prevalent, especially in France, Wolf's project raises intriguing questions about the relevance of such protestations in the digital age.

Even at a time when CCTV already records vast amounts of our everyday life, street photographers still wait patiently on dismal street corners while gales of diesel fumes clog their lungs and sting their eyes. Again and again, the photographers interviewed for this book told us that they take pictures as a way of trying to understand the world we live in. 'My camera has led me on a personal journey through the unexpected nuances of life,' explains Tanzanian-born Amani Willet. 'Photography has become my tool to investigate, discover, confront and ultimately portray the complex, fascinating world around us.'

What's in a picture?
Amid the deluge of images now circulating in cyber-space, this book sets out to identify the strongest work by the most committed practitioners. A great street photograph may only show us a hundredth of a second of real life – indeed all the images in this book probably only account for two or three seconds altogether – but in a single frame it can distil a remarkable amount of truth, showing the everyday with such wit or honesty that it will time and again amaze, delight or move us. 'This is, for me,

the most fascinating aspect of street photography,' says British photographer Nick Turpin, 'the fact that these crazy, unreal images were all made in the most everyday and real locations. Friends who I met for lunch would just be back from the war in Bosnia and I would declare proudly that I was just back from the sales on Oxford Street.'

A great street photograph must elicit more than a quick glance and moment of recognition from the viewer. A sense of mystery and intrigue should remain, and what is withheld is often as important as what is revealed. The Flickr group Hardcore Street Photography, known for its ruthless rejection of much of the work submitted to it, demands the following of photographers: 'Give us a reason to remember the photograph.' It's the right question to ask but almost impossible to answer. As the great French street photographer Robert Doisneau commented: 'If I knew how to take a good photograph, I'd do it every time.'

Technical virtuosity, original composition and compelling content are all essential, even if they do not necessarily guarantee a great street photograph. Of the three, the question of what makes compelling content is probably the most contentious. Street photography is a form of documentary but it is decidedly not reportage and rarely simply tells a story. Sometimes a street photographer captures something truly unusual – an extraordinary face, an accident, or a crime in the making. But more often a good street photograph is remarkable because it makes something very ordinary seem extraordinary. Garry Winogrand marvelled that his predecessor Robert Frank could find gold in subjects as potentially uninspiring as an empty gas station set against a featureless desert landscape. The shot, taken for Frank's landmark photobook *The Americans*, struck Winogrand as being a 'photograph of nothing' with 'no dramatic ability of its own whatsoever'. What amazed Winogrand was that Frank could even 'conceive of that being a photograph in the first place....When he took that photograph, he couldn't possibly know – he just could

not know that it would work'. Frank's ability to sense a potentially great photograph from apparently meagre visual possibilities inspired Winogrand, who would famously explain that 'I photograph things to see what they look like photographed.'

Street photography can seem deceptively simple, and very occasionally a great photograph is casually shot or chanced-upon by an amateur. As British photographer David Gibson observes: 'The avalanche of imagery, especially on the internet, is wonderfully democratic and carefully sifted, is a source of unexpected inspiration. I am both unsettled and beguiled by a website such as Flickr, for example. I have often seen images there by amateurs which rival anything by some so-called master photographers. There is beauty, spontaneity, warmth, and untrammelled imagination – with not a curator in sight.'

However, the photographers who consistently produce interesting, well-composed street pictures do not do so by chance. For every outstanding image grabbed in a rare instant when the photographic gods smiled and all the necessary compositional elements cohered, there are thousands of failures, images that missed the 'decisive moment' by a split second, failed technically, or simply seemed to offer little that was surprising on sustained viewing. What the strongest photographers possess, in addition to patience and persistence, is the ability to edit.

Consider a delightfully eccentric image taken by Matt Stuart in a London park (*p. 189*). Fifteen failed shutter clicks yielded nothing from the elusive combination of child, balloon and dog. Then serendipity suddenly prevailed and for a split second the members of the cast all acted their parts. Stuart may not even have known he had a good picture at the time, and certainly he did not know exactly what it was he hoped the characters might do to make the composition work, but later, looking through the contact sheet, he knew how to recognize the frame in which it all came together.

Liberty or liability

These are not easy times for street photographers, for whom acting suspiciously is an occupational hazard and loitering with intent a modus operandi. Tightening privacy laws and fears about terrorism have created an environment in which to stare, pry, listen or eavesdrop is increasingly to invite suspicion. A poster campaign run by the London Metropolitan Police in 2008 summed up the change in attitude: 'Thousands of people take photos every day. What if one of them seems odd?', it asked, encouraging the public to report anyone with a camera who seemed to display unusual levels of curiosity. It has become much more common for street photographers to be reprimanded informally, to have their film or memory card confiscated, or even to be stopped and searched. Some have responded by setting up or supporting campaigning websites such as 'I'm A Photographer Not A Terrorist' and 'Photography Is Not A Crime'. One direct response to the London police campaign reworked the text of the advertisements to read: 'Millions of people take photos every day. Some of them are brown. Please do not shoot them.' Most photographers have simply voted with their feet by continuing to get out and make pictures.

Street photographers will always face threats or violence from those who expressly do not want their pictures taken, but most accept this as an intrinsic risk of the profession. In an increasingly litigious era where lawyers will take up their cudgels on behalf of anyone who feels they may been offended, violated or harassed by a photographer, we can expect further legal battles over the right to take photographs of strangers in public. Street photographers argue that if they are forced to rely on model release contracts and posed portraits, they will only be contributing to the manufacture of a stage-managed, air-brushed future. 'Street photography is an important part of the documentation of our time', argues New York photographer Jeff Mermelstein in an interview with Linton Chiswick. 'Some of the most significant images in any art medium in the last 150 years have been

'You need obsession, dedication and balls. Get out there while you still can.'
Martin Parr

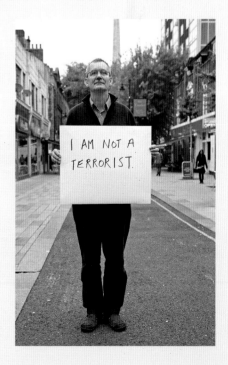

'Before I was a street photographer, or even a photographer, I was a walker – most native New Yorkers are. I would (and still do) choose to walk the long way home. At some point the camera became a part of the walking.' **Gus Powell**

made in the street by people like Henri Cartier-Bresson and Diane Arbus and Robert Frank. If that's discouraged, in the long term it will be a substantial loss.'

However, photographers do not exist in a moral bubble and those who behave as if an unfettered right to point a camera at a stranger is somehow enshrined in the Magna Carta or the Bill of Rights do not help the delicate contemporary situation. The truth is that photography, as a relatively recent invention, has always had to negotiate its place alongside complex social mores. Such was the concern in Victorian England, for instance, that women's modesty could be at risk from a surreptitious lens that photographers required official permits to shoot in parks. Although we may regret that so few of today's street photographers will document the spontaneity and fearlessness of children playing in public places, contemporary concerns about photographing minors seem unavoidable.

Street character

Public life is unpredictable, and while there are more and more discussed – and disputed – tactics for working on the street, there remain no hard and fast rules. The best practitioners must sometimes move at the speed of light to capture a split-second collision of line or form, at other times have the patience to wait all day on the same corner before the right compositional elements come together. They have to find ways of working that suit their personalities but also be willing to push themselves to the edge of what might feel comfortable. Richard Kalvar puts it succinctly in an interview on the blog 2point8: 'I'm kind of shy and sneaky and aggressive at the same time. Sometimes I have the nerve, sometimes I don't.'

The stereotype of the street photographer as a stealthy character able to slip deftly in and out of crowds without any direct engagement is very much a portrait of Henri Cartier-Bresson, certainly one of the greatest and probably still the most influential street photographer to date. 'A velvet hand, a hawk's eye; these are all one needs,'

he famously pronounced. He once compared himself to a cab driver, 'an anonymous someone to whom people reveal their inner selves'. Cartier-Bresson also had very firm views on photographic protocol: all his pictures were unposed, he never used flash (he considered it 'impolite – like coming to a concert with a pistol in your hand') and he rarely cropped his images in the darkroom. In many ways his very pure methods have come to be regarded as the gold standard of street photography. But not all great street photographers work the way Cartier-Bresson did and the diversity of approaches featured in this book testifies to the wide range of role models available to contemporary photographers, along with their readiness to keep breaking the rules and reinventing the genre.

William Klein, the *enfant terrible* of 1960s street photography, provides an obvious counterpoint to Cartier-Bresson in his methods. Klein thrived on confrontation and was wholly unconcerned at offending people, whether out in the street or with the gritty look of his prints. 'I didn't relate to European photography,' he has explained. 'It was too poetic and anecdotal for me. The kinetic quality of New York, the kids, dirt, madness – I tried to find a photographic style that would come close to it. So I would be grainy and contrasted and black. I'd crop, blur, play with the negatives. I didn't see clean technique being right for New York. I could imagine my pictures lying in the gutter like the *New York Daily News*.' Contemporary New York photographer Bruce Gilden's ostensibly 'smash and grab' approach owes a clear debt to Klein. 'I work on negative energy. If you get me mad in the street, I'm flinging a camera in anyone's face,' he says with pride. Fast, fluid, intuitive and fearless, Gilden has described his vigorous way of moving through the streets as like a dance. Temperamentally he is the kind of person who would probably relish turning up to a concert with a pistol in his hand, and he cannot imagine working without flash: its very intrusiveness is what gives his subjects

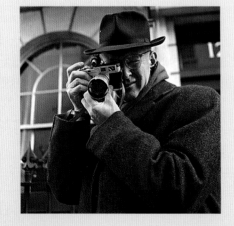

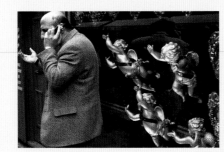
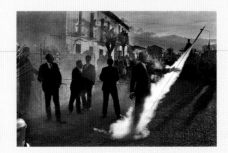
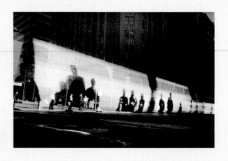

their hallmark startle. Where Cartier-Bresson spoke of discretion and the need to approach a subjects as if on tip-toe, Gilden speaks of sneakiness. 'I have to be a little bit sneaky because I don't want [people] to know that I'm going to take a picture of them....Sometimes they think that I'm taking something behind them.'

Klein's contemporary Elliott Erwitt delighted in chasing street-level high jinks. His cheeky visual non-sequiturs and artful juxtapositions rarely fail to find the funny bone. Photography, he has commented, 'has little to do with the things you see and everything to do with the way you see them.' Like all good jokes, Erwitt's are unforced and his approach to picture-making is laid-back: 'If you keep your cool, you'll get everything.' British photographer Matt Stuart has been hugely influenced by Erwitt's casual wit. He has a rare talent for spotting a visual pun and loves to play photographic games with signs, advertisements, gestures and reflections. Like Erwitt, his photographs wear their cunning lightly, but few other photographers are quick enough off the mark to spot the scenes he does. Stuart's work reminds us that humour has long formed as valid a part of the lexicon of street photography as more earnest social documentary.

In theory, Cartier-Bresson would have despaired of Australian Trent Parke's maverick technical methods, although in practice he would surely have recognized a truly original photographic talent. Willfully ignoring the 'good advice' generally given to photographers not to shoot directly into the sun, not to use flash in the daytime, always to keep the main subject in focus and so forth, Parke has developed a haunting, otherworldly visual style that flies in the face of photographic convention and pushes film to its technical limits. Parke cites Czech photojournalist Josef Koudelka as an important influence. Koudelka also aspired 'to go further, to go as far as I can' and in the process created urgent, magical images.

Cartier-Bresson was known for using only one type of camera: the Leica rangefinder. Discreet, light, small and nearly silent, it was also the camera of choice for André Kertész, Garry Winogrand and Lee Friedlander. In its new digital form it remains hugely popular with street photographers around the world. However, others choose to work more slowly and methodically, using medium- or very occasionally large-format cameras. There are precedents for this, too: even after the arrival of the handheld Leica in the 1930s, Brassaï persisted in working with a camera that used small glass plates instead of film (he would eventually adapt it for film), and required a tripod and long exposures. With such cumbersome equipment Brassaï's subjects always knew they were being photographed, but this suited him since he was more interested in getting them to cooperate in creating pictures than in capturing them unawares. Diane Arbus made her early work using a 35mm handheld camera but by the time she made her best-known portraits in the 1960s, she had adopted a medium-format twin-lens reflex, which provided a square aspect ratio and, crucially, a waist-level viewfinder that allowed her to keep eye contact with her subjects throughout the process. For contemporary French photographer Thierry Girard, the forward planning required when working with a medium-format camera forces a certain discipline. 'All my pictures are made with a tripod (even the ones that look like true snapshots) because I need a way to build a landscape, neatly and precisely. Once that is established, I wait for the people to appear like actors on a stage', he explains.

Shyness is a surprisingly common characteristic among street photographers. 'When I first started to take photos I'd pull the black cloth over my head and feel totally secure in the knowledge that no one could see me', Robert Doisneau recalled. 'What I liked about photography was precisely this: that I could walk away and I could be silent and it was done very quickly and there was no direct involvement,' admitted Robert Frank. Many contemporary practitioners consider it a matter of

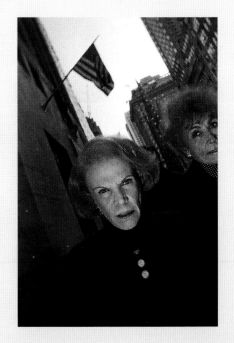

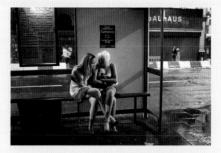 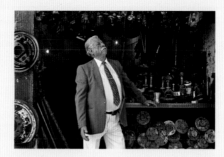

principle not to engage directly with their subjects. As Danish photographer Nils Jorgensen explains in an interview with Michael David Murphy, 'I don't really want to disturb the flow of life around me. I much prefer waiting and hoping for something to happen. It's also much simpler. For me the whole point of photography is not to interfere with what is happening, or might be about to happen. It could be more interesting than what I have in mind anyway. If nothing happens, that's just too bad.'

Polish photographer Maciej Dakowicz also describes himself as a 'quiet and shy person'. Dakowicz's documentation of night revellers in St Mary Street, Cardiff, is a sustained anthropological study of one of the more squalid aspects of British social life. 'When I go out to St Mary Street, I am there to take photos, not to party', he insists, 'but sometimes I need a drink or two to pluck up the courage the project calls for.' Going out with other photographers has also helped him. 'I don't like to go out to take pictures on my own, I need company. But when we are shooting at night we split and shoot in different spots of the street, not together. I shoot until I get very tired, it gets too late or too dodgy to shoot (fights and drunk people), or until somebody spoils my mood completely – it might be a girl shouting at me for a longer time, a guy trying to beat me up or a policeman telling me to go home.'

By far, the majority of street photographers like to blend into the crowd, being as invisible and unobtrusive as possible, but for those working outside their own culture there can be increased pressure to explain what they are doing. 'I struggled a lot in trying to convince people not to get angry at me because I was taking their photographs', recalls Mimi Mollica of working in Dakar. 'I shared my views with theirs, sometimes I spent entire days talking and not taking any pictures, even if I wanted to, but by showing respect I managed to create a bond that surely helped the final outcome.'

As an American working in Mexico, Mark Alor Powell finds a moment of eye contact or a smile can signal permission to shoot, and a short conversation can open up all sorts of possibilities. As he recounts on the street photography blog 2point8, 'I try to make people feel good about themselves. I like to tell little white lies to get into situations, using compliments and stuff. I just try to make people feel comfortable. I use anything to keep the focus off being photographed. I'll tell people that I love their necklace or their shirt, or the painting on their wall, or say I got a pet just like theirs, or tell them about my uncle back home, I got to take a picture for my uncle, please, he has to see this. I've found that when a picture is meant for someone else, people seem to think it is all right for you to take it.'

Working in predominantly Muslim communities within the Central Asian Republics, American photographer Carolyn Drake had to tread lightly and learn to take candid pictures while being the centre of attention as an outsider. 'It is rare for an American to visit many of these countries as they are extremely isolated, and getting visas is expensive and a logistical headache, so I am often greeted as an object of curiosity and excitement when I visit. To welcome and feed guests is part of Central Asian culture, but I was not always accepted.' The experience of being treated with suspicion led her to reflect deeply on the arrogance that many non-Western cultures perceive as characteristic of America. She feels that this perspective has enriched her work. 'I have also come to the easy realization from all this that our way isn't the only or best way.'

A new renaissance

Photographic historians often speak nostalgically about a golden age of street photography that blossomed in the 1920s when André Kertész, Henri Cartier-Bresson, Bill Brandt and Brassaï were starting out, and tailed off in the 1970s with the early deaths of Diane Arbus, Tony Ray-Jones and, a few years later, Garry Winogrand. While street photography by no means ground to a halt in the 1980s and 1990s, it did fall somewhat out of the spotlight. More conceptual forms of photography captured the

attention of the art world, while traditional publishing outlets increasingly favoured more sensational types of photojournalism, or staged fashion and lifestyle imagery. Many of the most notable street photographers of the 1960s and 1970s, including Robert Frank, William Klein and Tod Papageorge, took their practice in new and different directions. Although much new talent emerged in the 1980s and 1990s – Martin Parr, Tom Wood, Alex Webb and Boris Savelev are among those who stand out – many street photographers worked away during that time receiving little public recognition for their work.

For most of the last thirty years there has been almost no official patronage for street photography, a reality many find frustrating, but which can also be curiously liberating. 'Having worked for several years both in newspapers and advertising, I am fascinated by the things that I "choose" to photograph when I leave the house with my camera but without a story or brief to fulfill', Nick Turpin explains. 'It is important to me that my personal pictures don't have to "do" anything. They don't have to sell in a gallery or sit well beside the ads in a magazine. I don't have to make pictures that are easily categorized. They are not reportage, there is no subject, they are not art, there is no great technical craft or aesthetic beauty. They are just pictures about life.'

With the rise of the internet for popular use, as well as a revolution in digital SLR technology in the early 2000s, street photography has undergone a resurgence. Today, the world's most popular photo-sharing site, Flickr, hosts over 400 dedicated street photography groups comprising nearly half a million members. The photographer-run website In-Public, which calls itself the 'home of street photography', clocks up 40,000–100,000 hits a month. Universities and museums now offer courses in the history and practice of street photography, and increasing interest in citizen photojournalism has opened new online editorial opportunities for street photographers to display their work. Most importantly,

'At a time when staged narratives and rendered images are popular, I am excited by the fact that life itself offers situations far more strange and beautiful than anything I could set up.' **Melanie Einzig**

the international reach of the practice has exploded as young photographers find inspiration in the cities of the developing world and the southern hemisphere. As soon as a good body of work is produced, whether in New York or Tashkent, a slideshow quickly circulates on the blog sites, bringing instant feedback for the hungry young photographer, sometimes only hours after a particular picture was taken.

These are exciting times for street photography. As Joel Meyerowitz has put it: 'The seed is spreading like a virus out there.' Talented photographers – many featured in this book – are finding a burgeoning audience who appreciate the authenticity, rigour and playfulness of their work. The world remains a fascinating and ever-surprising source of human drama and the curious instincts that Walker Evans championed when he exhorted his fellow photographers to stare, pry, listen and eavesdrop are felt as keenly today as ever.

CHRISTOPHE AGOU

b. Montbrison, France, 1969, lives in New York City

'Trust your heart and open your eyes.' This is the deceptively simple maxim that guides French photographer Christophe Agou. Agou moved to New York City in 1992 and made his name with the publication of *Life Below*, an unflinching but compassionate portrait of the city's subway riders.

'There is a certain honesty underground, a certain truth,' says Agou. 'The sense of enclosure is sometimes oppressive, but I love feeling the pulse beneath the city.' Photography for Agou is simply a new technology to be directed at an age-old enquiry: how to fathom the soul of the ordinary man or woman. Well aware that photography is a medium of surfaces, Agou uses it to hint at the depth of what it is to be human but never to simplify. There are no caricatures here, only men and women in whose faces we sense a deeper mystery. 'I don't like to take a picture saying *this is what it is*,' says Agou, 'I want to take a picture that stimulates your imagination to make your own story.'

Since the early twentieth century, the New York subway has captured the imaginations of many photographers. Between 1938 and 1941, Walker Evans took over 600 photographs of passengers using a cable-release system hidden in his sleeve that enabled him to catch them unawares. At the time of writing, fears of terrorism have led to proposals to ban photography on the New York Transit system. 'To forbid certain locations, and subject matters, somehow makes me very emotional,' Agou laments. 'The subway system has been for me one of the most poignant spaces in which to work.'

Paradoxically, for a photographer who has spent so much of his life underground, one of Agou's great heroes is the high-wire artist Philippe Petit, who rose to fame when he walked a tightrope illegally strung between the twin towers of the New York World Trade Center in 1974. There is something in the bravery but also the frailty of this act that resonates with Agou. 'I always look for something unstable or limping,' he explains. His method is bold but his search is for the fragile and transitory nature of human existence, a truth we can't escape.

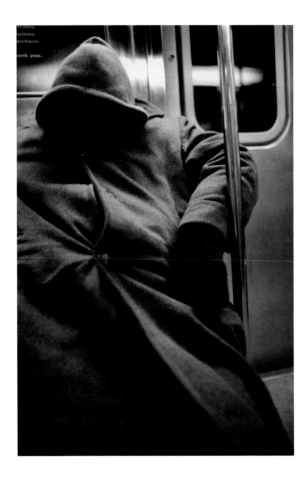 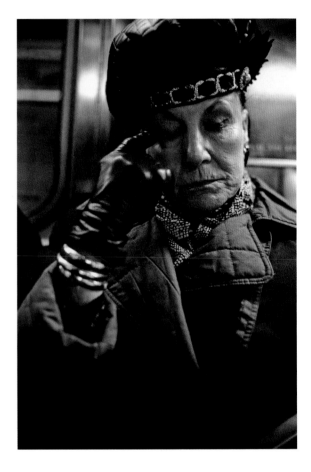

ALL IMAGES:
From the series *Life Below*,
New York City, 2002–9

16

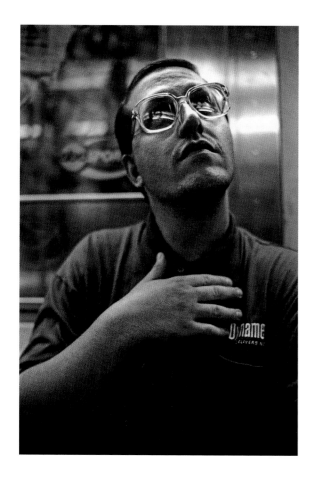

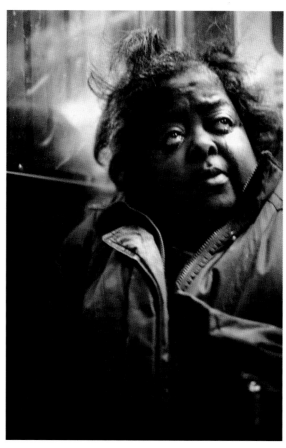

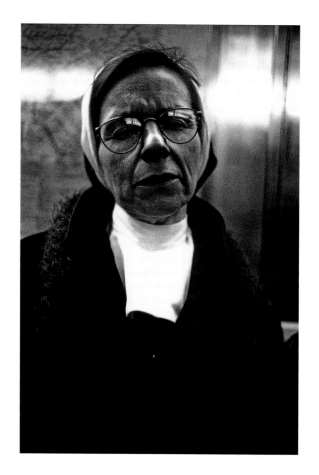

ALL IMAGES:
From the series *Life Below*,
New York City, 2002–9

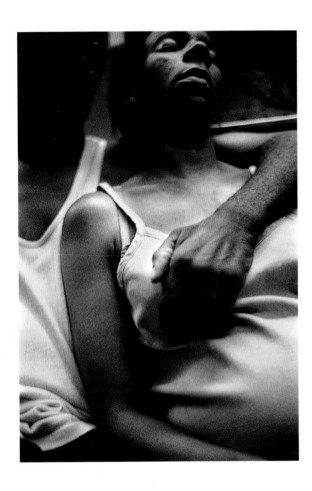 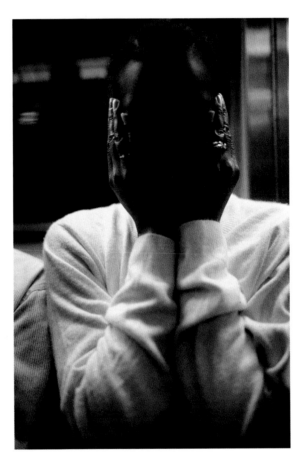 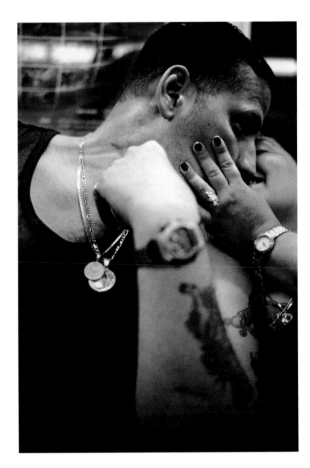

'There is a certain honesty underground, a certain truth. The sense of enclosure is sometimes oppressive, but I love feeling the pulse beneath the city.'

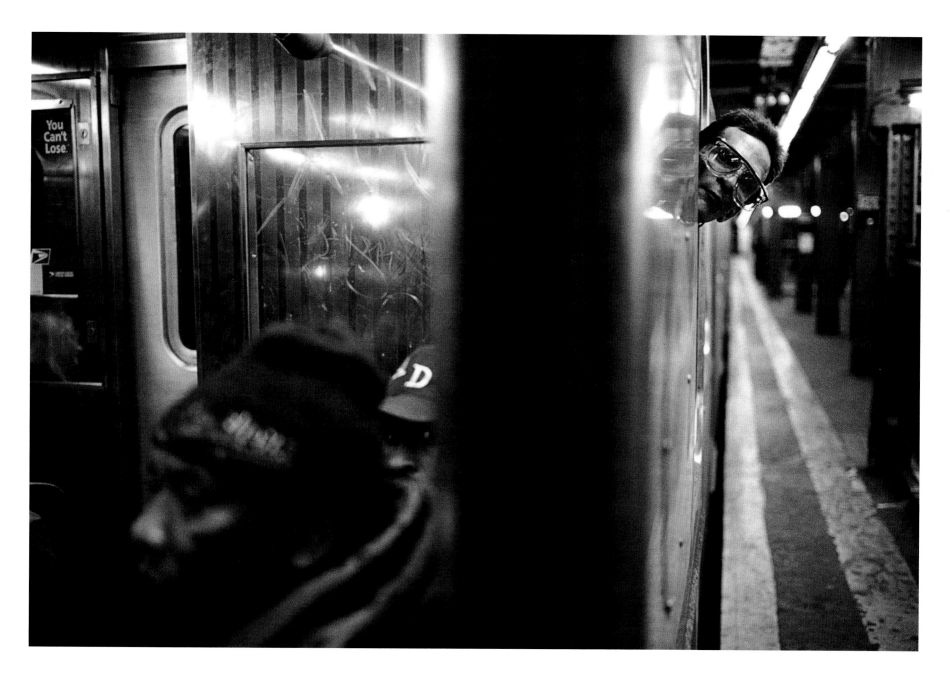

'Everything I need is in the street. I can create a beautiful landscape, a social drama, or a very personal, almost abstract photograph.'

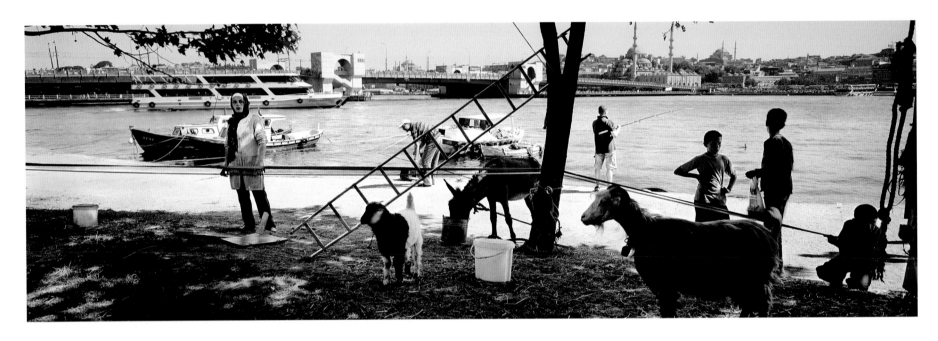

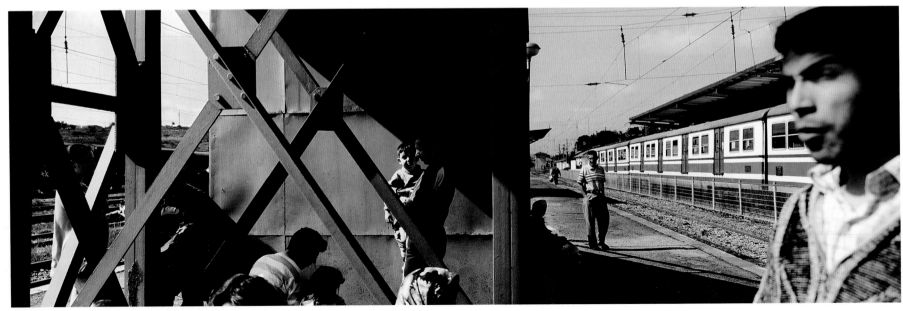

ARIF ASCI

b. Adana, Turkey, 1958, lives in Istanbul

Arif Asci trained as a fine artist and worked as a documentary filmmaker before turning full-time to photography. His work combines strong aesthetic instincts with an interest in social commentary. In a series of bold black-and-white horizontal panoramas he shows the residents of Istanbul going about their everyday lives: shopping, riding boats, chatting or drinking tea. A contrasting series of vertical panoramas focuses on the architectural structure of this rapidly changing city. Asci uses the tightness of the vertical format to emphasize how much is often crammed into narrow spaces.

After shooting in black-and-white for fifteen years, Asci turned to colour photography, initially inspired by the vivid colours he encountered on the streets of Seoul. He has also recently begun photographing his hometown of Istanbul in colour, producing almost abstract compositions by shooting through curtains of fabric or reflective windowpanes. His recent photographs show the play of light and pattern taking precedence over tangible subject matter. 'I dream of simplifying my photographs as much as possible,' he says.

OPPOSITE ABOVE:
Golden Horn, Istanbul, 2005

OPPOSITE BELOW:
Banliyo Station, Halkali, Istanbul, 2005

RIGHT:
Galata, Istanbul, 2005

CENTRE RIGHT:
Mecidiyekoy, Istanbul, 2004

FAR RIGHT:
Galata Bridge, Istanbul, 2004

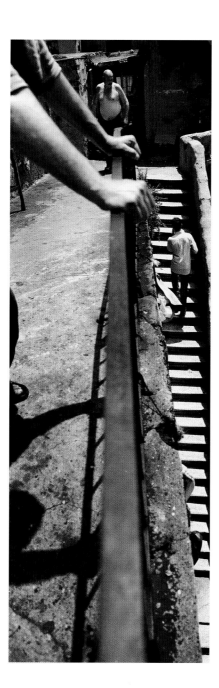
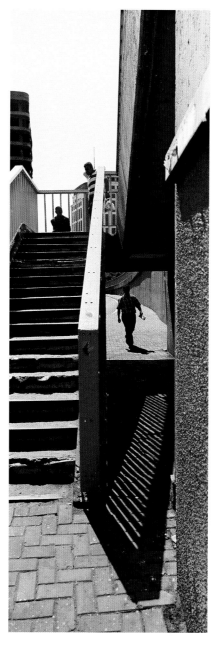
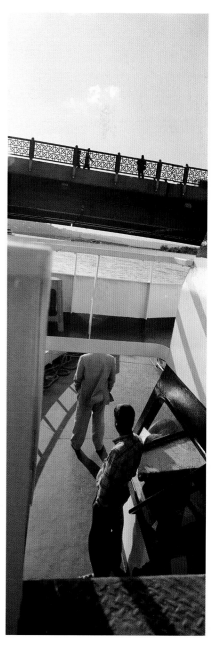

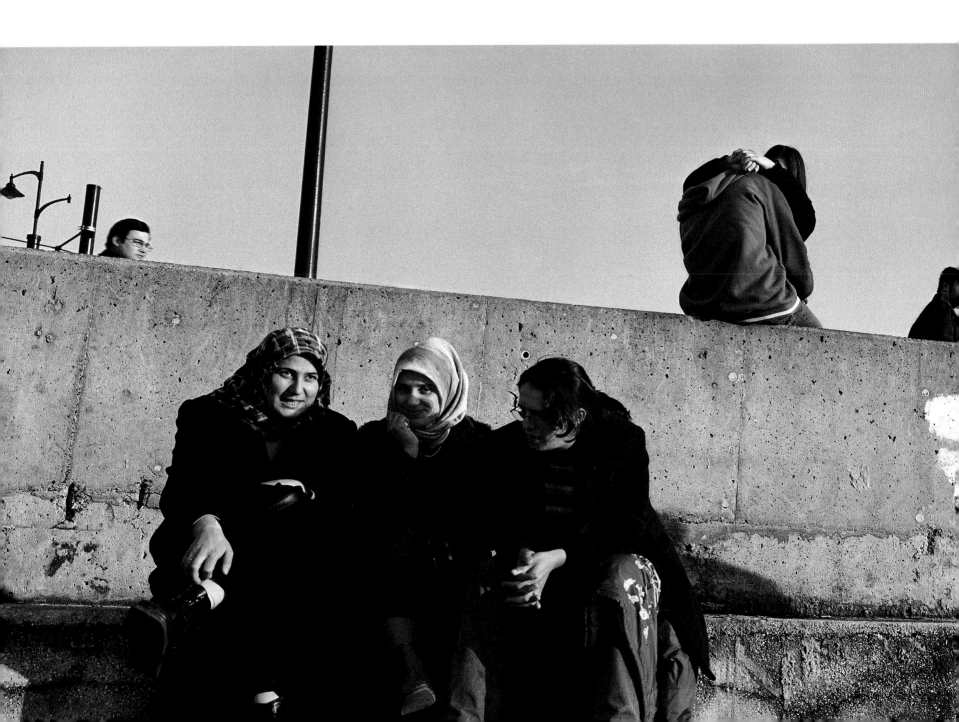

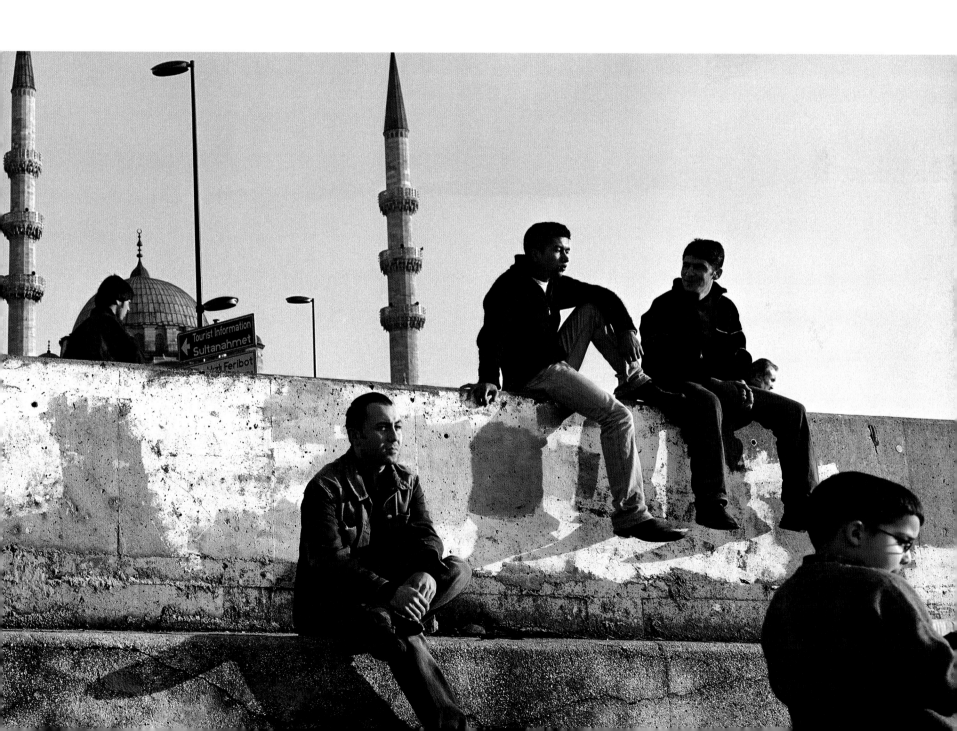

NARELLE AUTIO

b. Adelaide, Australia, 1969, lives in Adelaide

After excelling as a photojournalist in Adelaide, Sydney and then London, Narelle Autio decided that her home country offered a limitless source of inspiration for her personal work. 'Arriving back in Australia proved to be an awakening for me. It is true what they say: you don't miss what you have until you lose it. I realized there was so much here to photograph. Things I had grown up with, that I knew about and loved – all things that I had taken for granted.'

Autio is drawn to the lyrical possibilities of Australia's light-blasted cities and towns. 'As a nation we spend a lot of time outdoors, so there is a lot of subject matter roaming about. I am a bit of a voyeur by nature and I liken the street to a performance. I find a place that feels like it might offer up a picture, the light shifts about, shadows grow and change the backdrop. I watch the people move in and about, living their own quirky, beautiful, funny lives. It might all come together for a moment and then just as quickly it is gone.'

The ephemeral and unpredictable nature of her subject matter is the central tenet of Autio's approach to street photography. 'By its very nature, candid photography will always give up something new. I cannot control what is going to happen and therefore it will never be contained within the limits of my imagination. If I am open and don't resist the changing state of mind or mood while I am shooting, subconsciously there will always be something new I will be drawn to photograph.'

ABOVE LEFT:
Blood Red Shed,
Redfern, Sydney, 2001

LEFT:
Autumn Leaves,
Martin Place, Sydney,
2000

OPPOSITE:
Angel, George Street,
Sydney, 2001

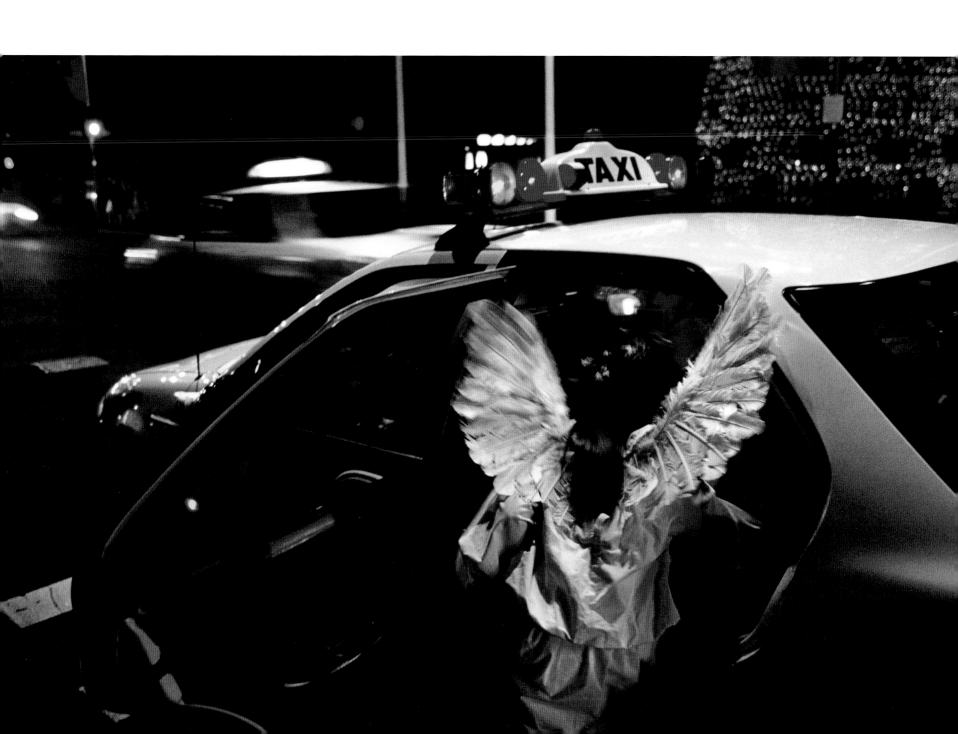

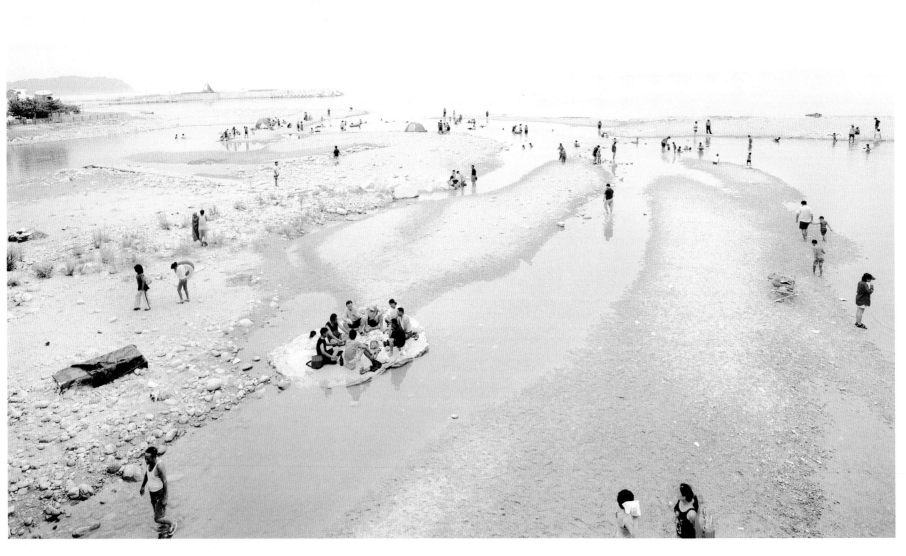

BANG BYOUNG-SANG

b. Chuncheon, South Korea, 1970, lives in Seoul

The emergent mega-cities of the Asian continent have become popular destinations for street photographers. For nearly ten years, Korean photographer Bang Byoung-Sang has been chronicling how Seoul, with its massive population, is coping with rapid modernization. He is particularly interested in the movement of crowds through the urban landscape and how individuals retain their identities among the throng.

'The street is an open space where we show our appearances without being filtered,' says Bang. 'It is also a field of practice where we gain firsthand experience of tradition and modernity, history and memories, society and culture.'

Bang manages to switch between two very different perspectives when portraying the city. His large-format work observes Seoul's inhabitants from a respectful distance in recreation areas, parks and riverbanks, showing families and friends marking out their own personal spaces in very crowded environments. 'I've tried to visualize the relationships between the typical spaces of a metropolis and the masses, the gestures and behaviour of each individual,' he explains.

Bang shows Seoul as much more than a densely populated metropolis; it is also a thriving cultural capital where people are becoming increasingly creative in the way they dress and more forthright in expressing their individuality. In a series of close-ups taken on the city pavements, Bang delights in the fabrics and patterns that pass in front of him, creating dynamic photographs rich in colour and motion that evoke the many facets of Seoul's complex personality.

OPPOSITE:
Storyteller, 2005

ABOVE RIGHT:
Untitled 6, from the series *Flowers*, 2001

RIGHT:
Untitled 3, from the series *Flowers*, 2001

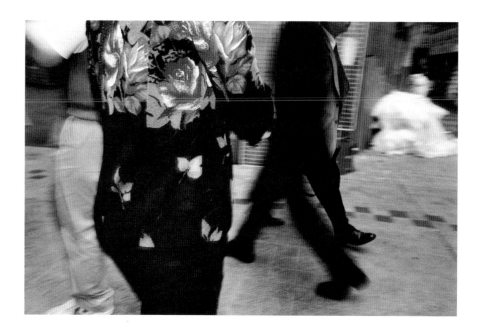

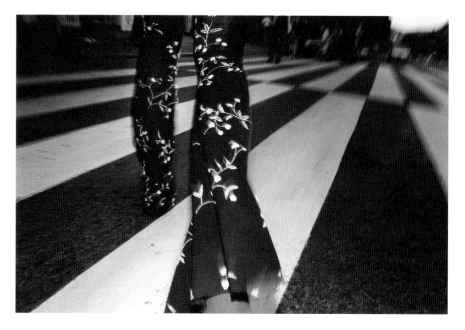

POLLY BRADEN
b. London, 1974, lives in London

'Street photography is time for myself, to watch and observe the world around me,' explains British photographer Polly Braden. 'When I am not photographing on commission, there's a freedom to my work, a permission to observe patiently without having to force a picture.'

Braden first went to China over fifteen years ago and has returned many times, slowly collecting images for her first book, *China Between*. As the title suggests, she is fascinated by the transformation from communist to capitalist ways of living. She looks for evidence of how people are adapting to modernization, honing in on the small moments rather than the events more often considered newsworthy. Her subjects are frequently women and children; she is curious about how they manage their day-to-day lives within the aggressive and alienating environment of the city. 'Life in Chinese cities can be brutal…I try to pick out individuals from the surrounding noise, pollution and commerce, and to show very human moments of reflection or interaction.'

For Braden, street photography is not a matter of catching people off guard; indeed she dislikes the idea of 'grabbing' a picture and is adamant that photography should never ruin a real-life moment. Although her subjects often are unaware that they are being photographed, they are never taken advantage of, and her lens is instinctively a generous and tender one. Occasionally, as in the photograph of waitresses listening to their daily pep talk (*p. 31*), one of Braden's subjects catches her eye and seems pleased to be observed.

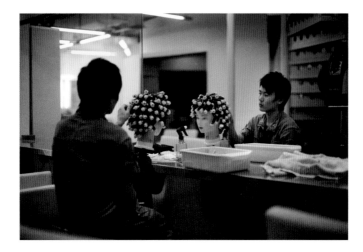

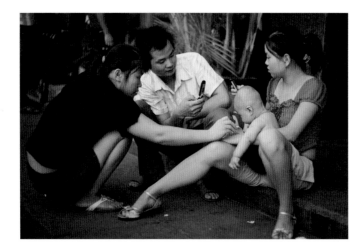

TOP:
A hairdresser practises
after hours, Shanghai,
2007

ABOVE RIGHT:
Last-minute family
snapshots and phone
calls, train station,
Xiamen, China, 2007

RIGHT:
Night walk, Xiamen,
China, 2007

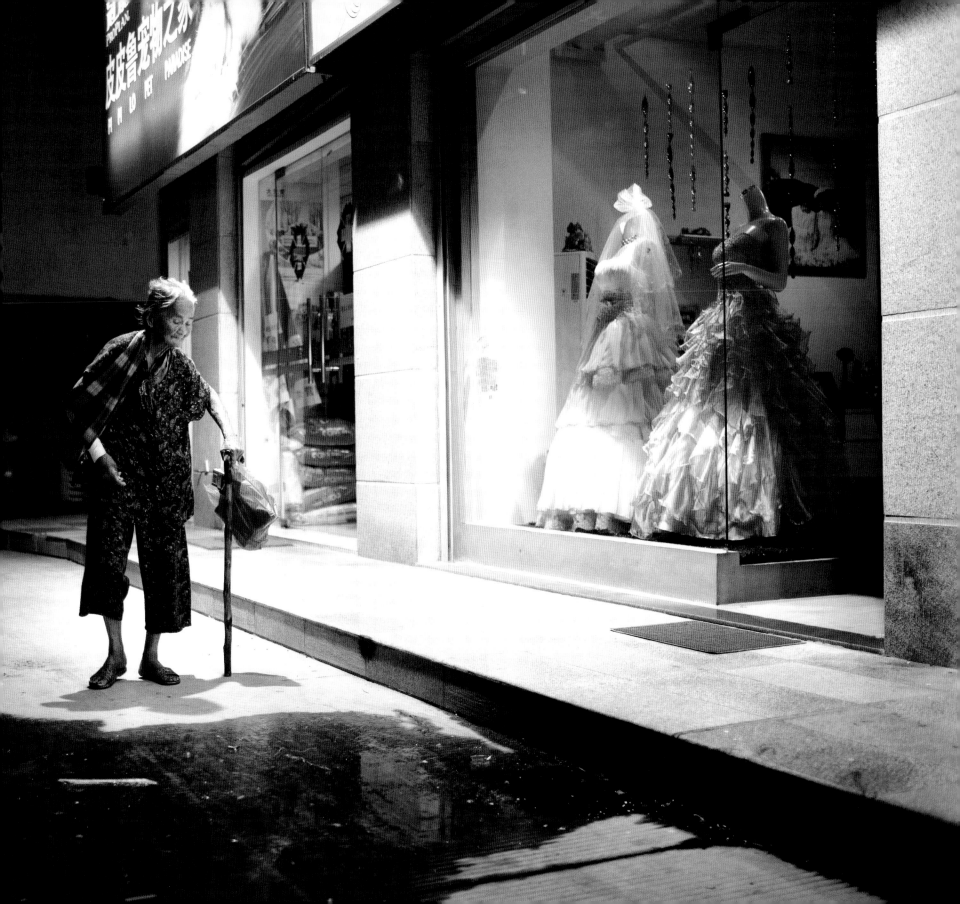

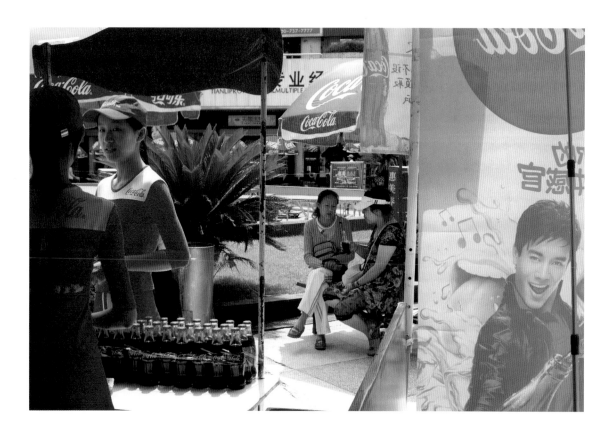

'I'm looking for the small details of everyday life
that can tell you something about the bigger picture
of China today.'

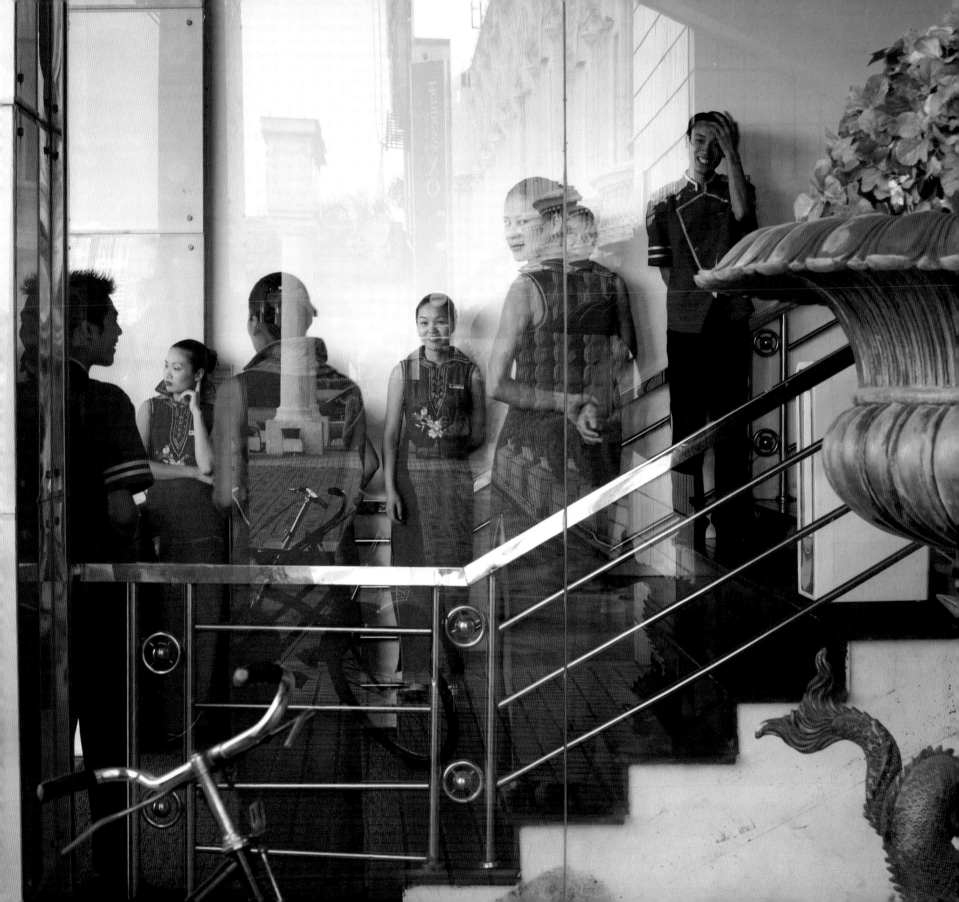

MACIEJ DAKOWICZ

b. Białystok, Poland, 1976, lives in Cardiff, Wales

As a professional photojournalist, Polish-born Maciej Dakowicz reports back from global emergencies in Asia and the Middle East, but it is the carnage he documents in the streets of his adopted hometown of Cardiff, Wales, that marks him out from his colleagues.

Every weekend Dakowicz joins the throngs of scantily clad binge-drinking men and women who turn the streets of the Welsh capital into one big alcohol-sodden urban playground. Dakowicz's Cardiff is a dystopian carnival where CCTV cameras patrol street-corner trouble spots, rubbish bins are used as toilets, phone boxes become stripping booths and alcohol-flushed faces are illuminated by a multitude of flashing electronic oracles. Out of this chaos he conjures images that both beguile and appal.

'When I started this project I didn't consider whether it was something unique or not. I did it to make use of weekend nights on the way back home from the pub. But when I realized how few photographers persist in shooting nightlife, I began to be stubborn, and just kept at it.'

Dakowicz's images capture the uneasy mix of bravado and vulnerability that characterizes the young clubbers of Cardiff. He goes out when the last stragglers are heading home, and documents a world without glamour, where goose-flesh, rheumy eyes and flabby buttocks are more often on display than celebrity, glitter and urbane sophistication. It would be easy simply to mock his subjects but Dakowicz's project is more sincere, and probes deeper, inviting the viewer to consider what drives this strange and sad compulsion to seek obliteration in the company of friends and strangers.

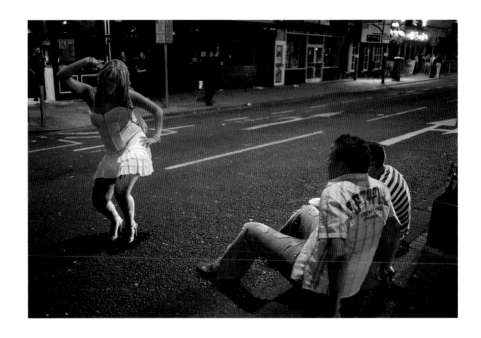

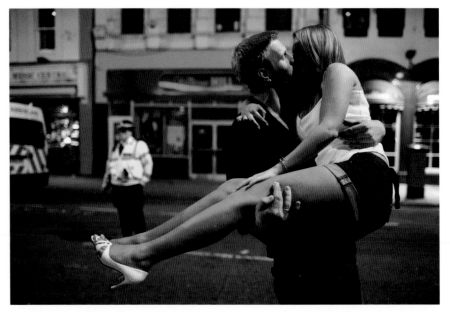

ABOVE:
01:00, Pose, Cardiff, 2006

RIGHT:
01:06, Kiss, Cardiff, 2007

OPPOSITE:
23:42, Pink Hat, Cardiff, 2006

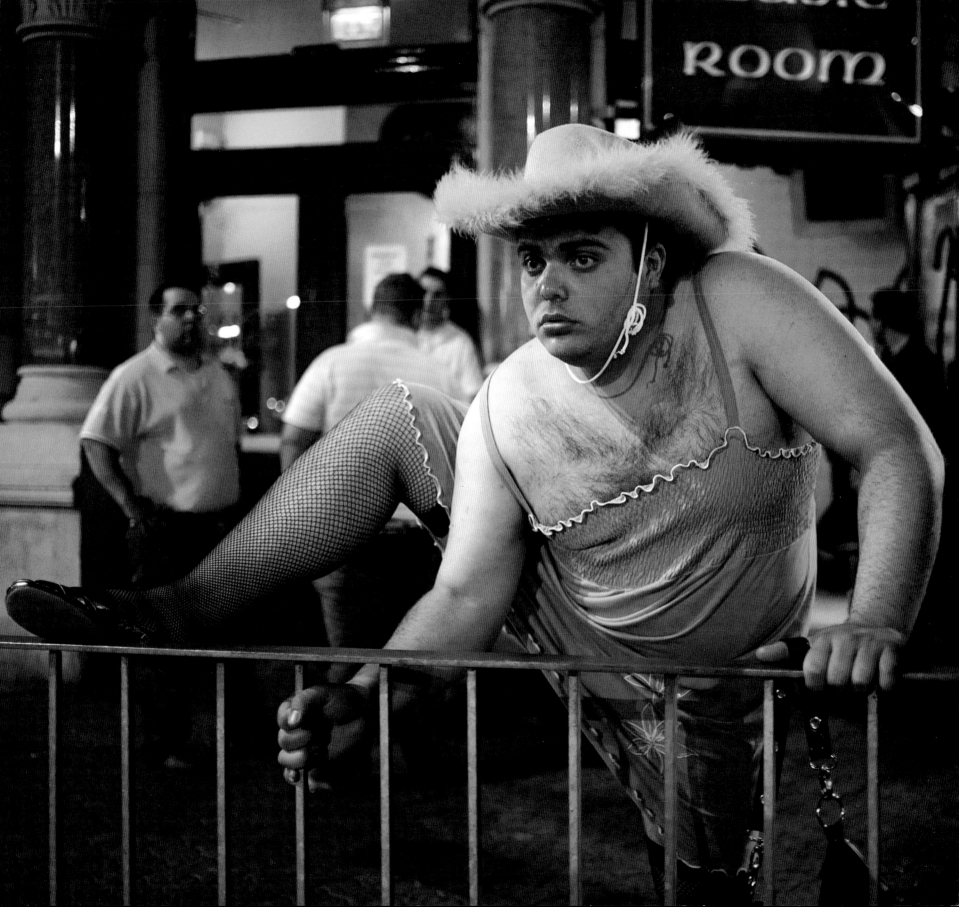

OPPOSITE:
02:49, *Late Meal*, Cardiff,
2007

BELOW:
22:52, *Street Scene*,
Cardiff, 2007

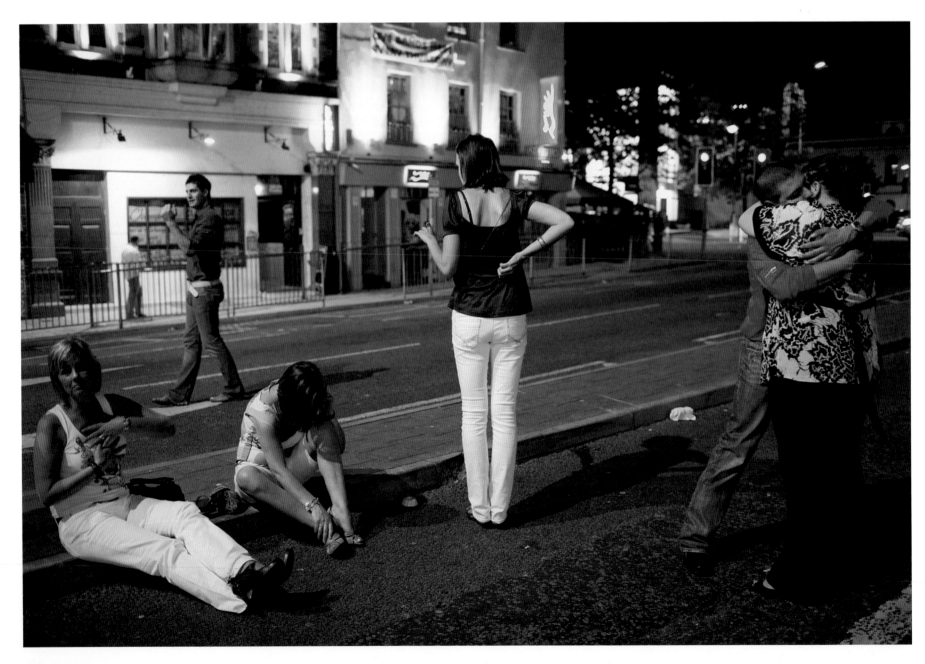

'When I take pictures of Cardiff's nightlife I need to have a good time myself, be like the party people I'm photographing and forget about potential dangers. Having a couple of drinks helps. Less thinking means better pictures.'

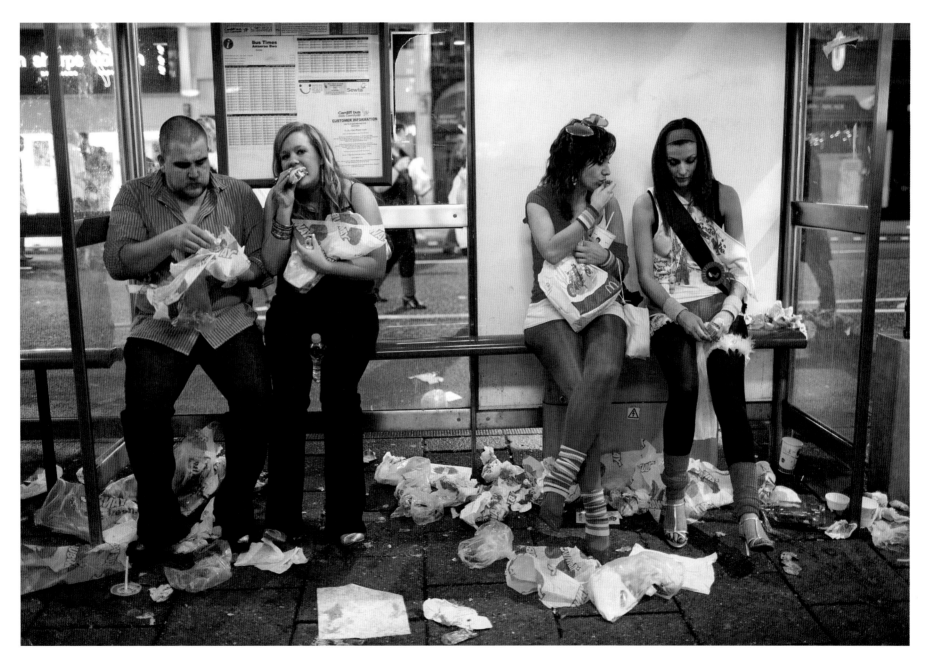

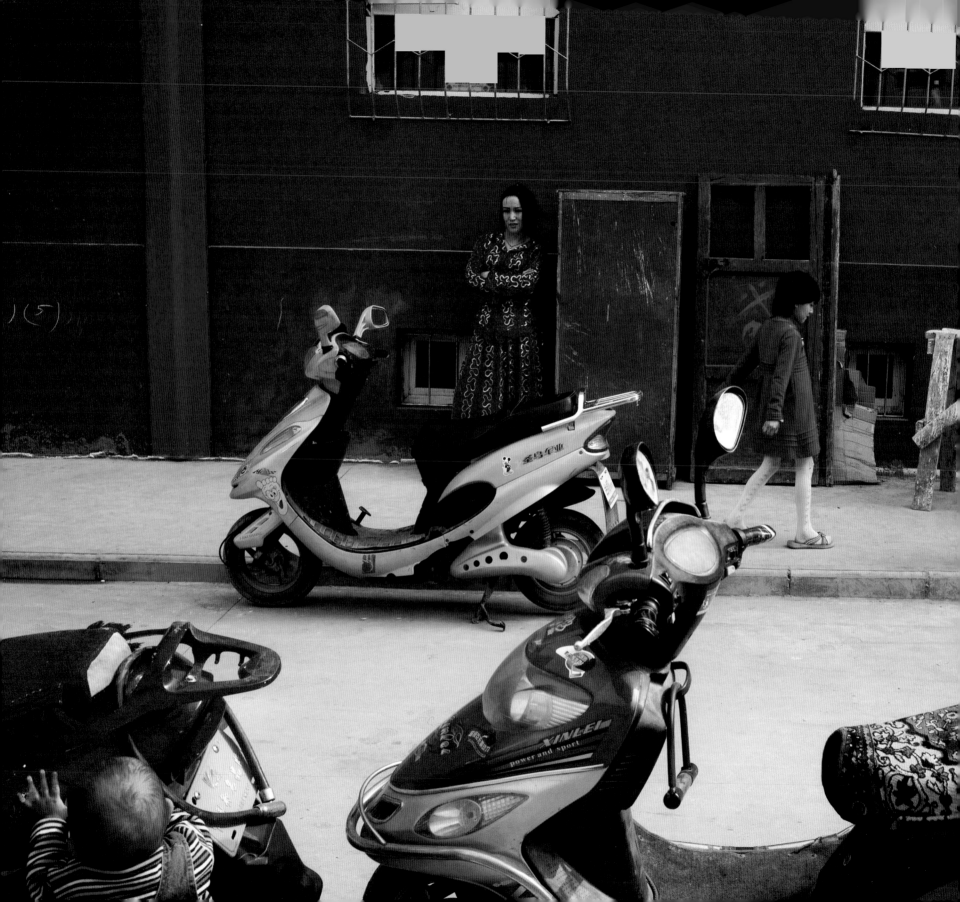

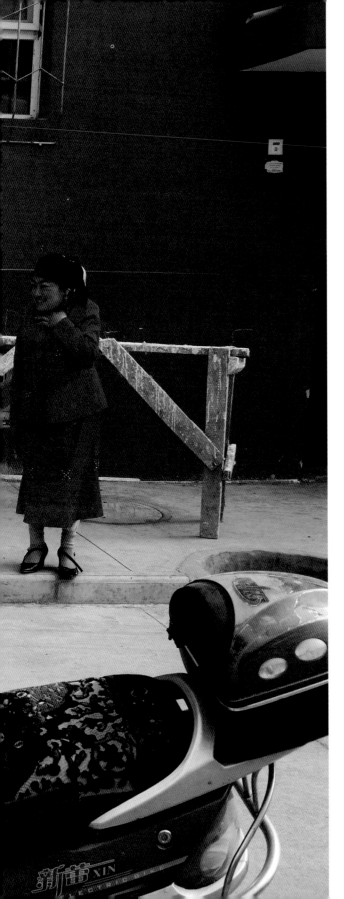

CAROLYN DRAKE

b. Los Angeles, 1971, lives in Istanbul

'I am weary of stereotypes and aware that photos often perpetuate them. I'd like to take pictures that somehow counteract this.'

Carolyn Drake worked as a multimedia producer in New York and California before abandoning the virtual world to explore the real one as a photographer. Frustrated by the narrowness of the American mediascape, she has made a career of documenting everyday life in areas of central Asia that are rarely included in the Western news agenda. Her work focuses on Tajikistan, Turkmenistan, Kyrgyzstan, Kazakhstan and Uzbekistan, where she portrays predominantly rural ways of life that are both fiercely traditional and rapidly adapting to change. Her work tries to uncover the 'human side of a place that I had learned about through the filter of the Cold War', presenting 'the complexity of these places without bundling them into sensational or easy narratives'.

Although she often sells work to magazines, Drake's assignments are usually self-initiated. 'As my body of work from the region has developed, photo editors have become more interested in it, so some of the recent trips were partly funded by magazine or newspaper assignments', she acknowledges. 'But generally assignments have to be connected to news that is considered relevant in Europe or America, and that is rare.'

Drake experiences both advantages and disadvantages to being a foreigner in the countries where she works. 'It can be invigorating to work in a place where I feel like an outsider because it usually means it is a place that I don't fully understand and I enjoy the process of trying to understand. Guests are treated with honour in a lot of the places I've worked. But I was not always accepted. Particularly in Uzbekistan, I was often welcomed with a degree of hesitation, fear or suspicion. If there is a language barrier, you can't directly connect with people and you can't just sit back and listen or start a spontaneous, unplanned conversation. It is particularly hard to be a fly on the wall in conservative Muslim places because I'm one of the only women on the street and I don't follow local gender rules. My pictures aren't directly about this, but a huge part of what I get from my work is a chance to come face to face with what "American" means to the rest of the world.'

Kashgar, China, 2009

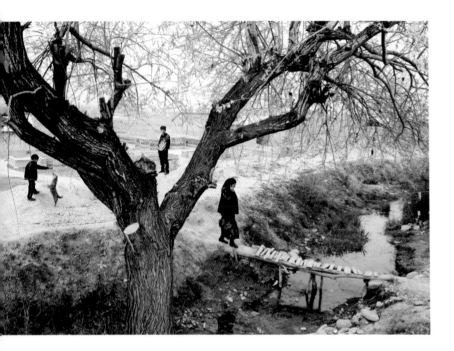

BELOW LEFT:
Navruz, Uzbekistan,
2007

BELOW RIGHT:
Border Town,
Kyrgyzstan, 2008

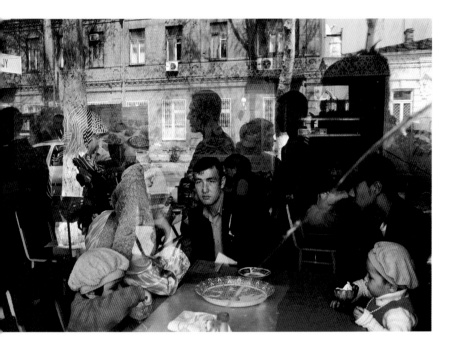

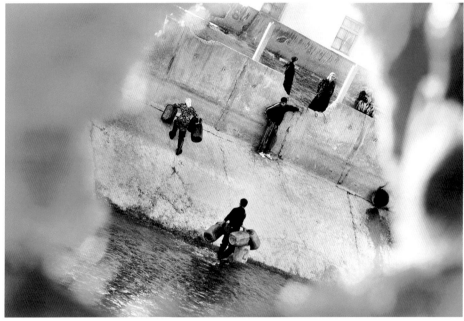

'It can be invigorating to work in a place where I feel like an outsider because it usually means it is a place that I don't fully understand and I enjoy the process of trying to understand.'

MELANIE EINZIG

b. Los Angeles, 1967, lives in New York City

New York photographer Melanie Einzig wanders the city that has been her home since 1990, sniffing out eccentric characters and tuning into tiny little plays that spontaneously erupt on city corners. Einzig's New York is not the gentrified city cleaned up by Mayor Giuliani, but a place full of oddities and idiosyncrasies. Little surprise that Einzig feels a strong affiliation with the writings of Luc Sante, whose best-known book, *Low Life: Lures and Snares of Old New York* (1991), documented an early twentieth-century city populated by bums, con artists and free spirits.

Einzig is a whimsical anthropologist whose seemingly arbitrary samplings show up sharp revelations. A photograph of a man on the subway dressed head-to-toe in yellow and white crochet, busily creating his next remarkable outfit, fascinates not only for the peculiarity of its protagonist but also for the complete indifference of everyone else on the train.

'Only on rare occasions do I go out specifically to shoot,' Einzig explains. 'My best photographs were taken going to or from work, or some other destination. It's about tuning in to intuitive clues to turn this way and that.'

Picture her then, en route to a paid assignment, on a street corner, glancing to her left and immediately recognizing the instantaneous choreography of six characters in search of an author: two lovers, a man slumping on methadone, a dog, a parrot and his owner. Sante sums it up: 'Melanie Einzig represents the very ideal of the street photographer. She's alert, funny, sympathetic, quick-witted, drily romantic – she finds the life force wherever she goes. And she has a lively and pleasantly jagged sense of colour and composition. The world as she portrays it is flawed and often ridiculous, but never short of richness and promise.'

'Photographing in public keeps me awake and aware, always looking around, in awe at what we humans are up to.'

RIGHT:
Spring Corner,
New York City, 2000

40

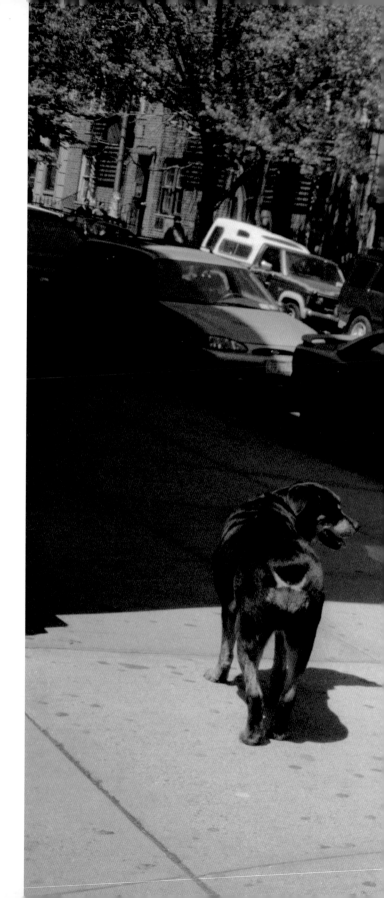

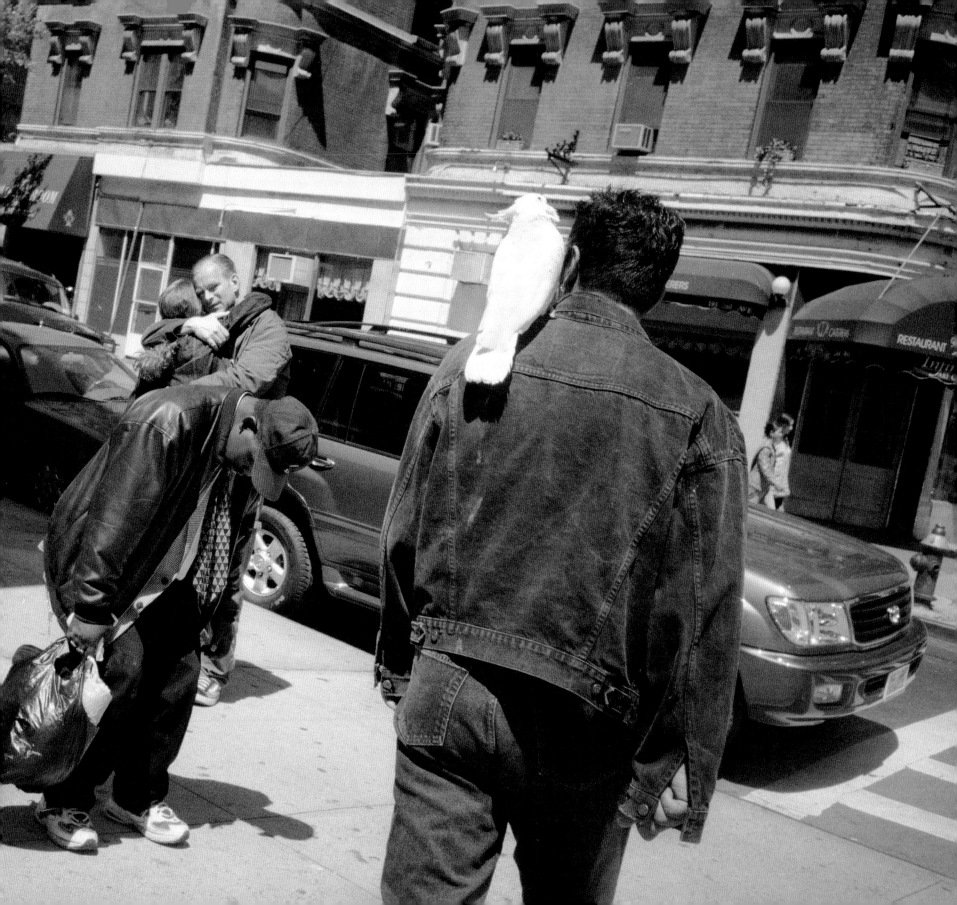

OPPOSITE:
Six Train, New York City,
2004

BELOW:
First Avenue, New York
City, 2004

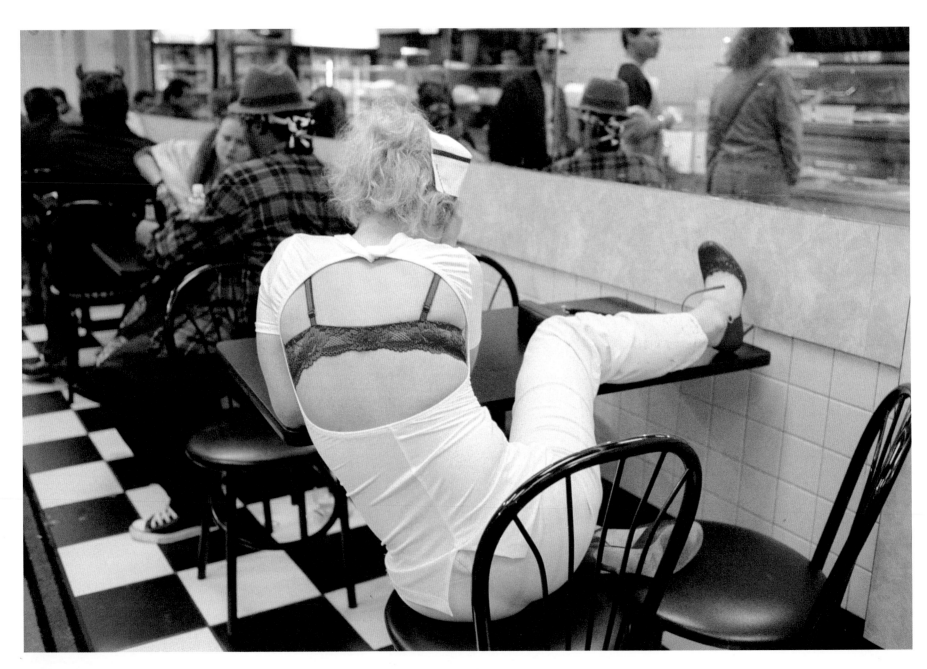

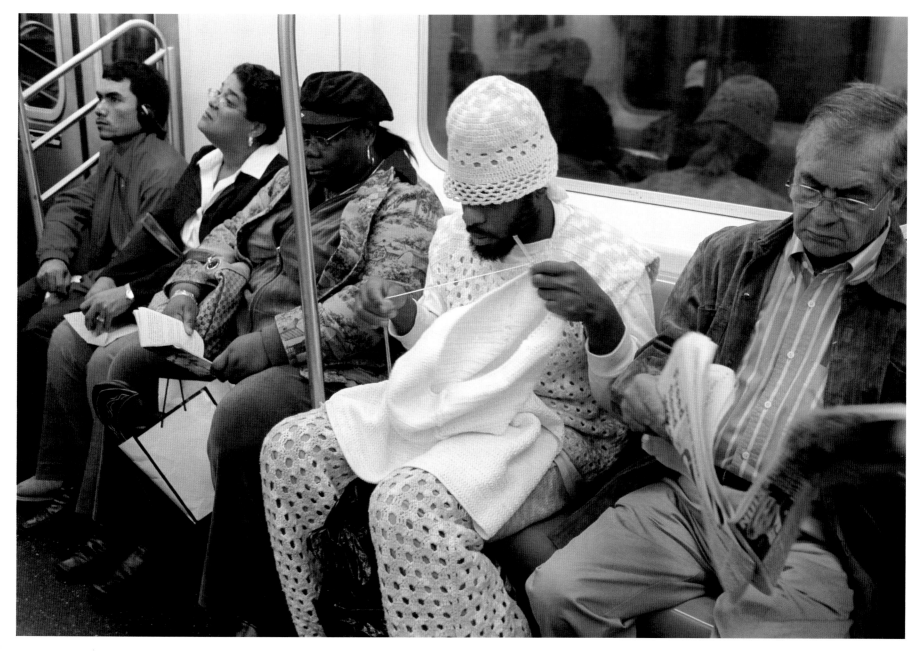

GEORGE GEORGIOU

b. London, 1961, lives in London

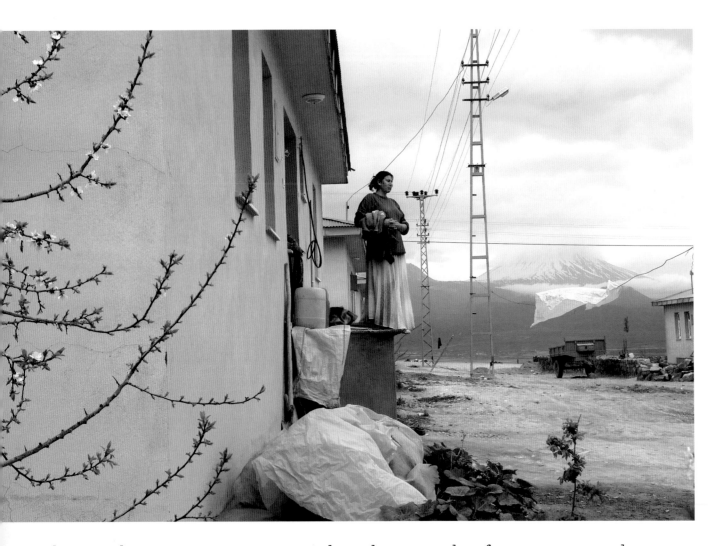

George Georgiou has spent most of the last decade in Turkey, the Balkans and Eastern Europe, photographing the seismic upheavals that economic and political change have brought to these ancient and proud societies. Deliberately avoiding news-agenda hotspots, Georgiou has persisted in documenting everyday life in unfashionable urban hinterlands with rare patience. 'To start to understand a place you need to spend a long time,' he says.

The pictures for *Fault Lines*, Georgiou's project about Turkey, were made over the four-and-a-half years he spent living in the country. 'Turkey is a strategically important nation poised geographically and symbolically between East and West,' he explains. 'A fierce struggle is taking place between modernity and tradition, secularism and Islamism, democracy and repression – often in unlikely and contradictory combinations.' Away from the holiday coastline and the Istanbul metropolis, Georgiou shows us a country that is both excited and threatened by the pace of change: 'landscapes, towns and cities reshaped, an extensive road network under construction, town centres "beautified" and large apartment blocks springing up at a rapid rate. The modernization is designed to handle the mass migration from village to city that is transforming Turkey, causing rapid disintegration of community in villages and towns. I have chosen to represent the changes by focusing on the quiet, everyday life that most people in Turkey experience.'

In 2008 Georgiou visited the Ukraine, a country he describes as 'plunging from one political crisis to another' following the Orange Revolution of 2004–5. He explored this state of transition by documenting cities and towns from the local transit systems, photographing people as they move from home to work, wait, chat, and buy and sell things around the country's transport hubs.

'I have chosen to represent the changes by focusing on the quiet everyday life that most people in Turkey experience.'

LEFT:
Near Dogubeyazit,
Turkey, 2007

OPPOSITE:
Mersin, Turkey,
2007

OVERLEAF:
Elazig, Turkey,
2007

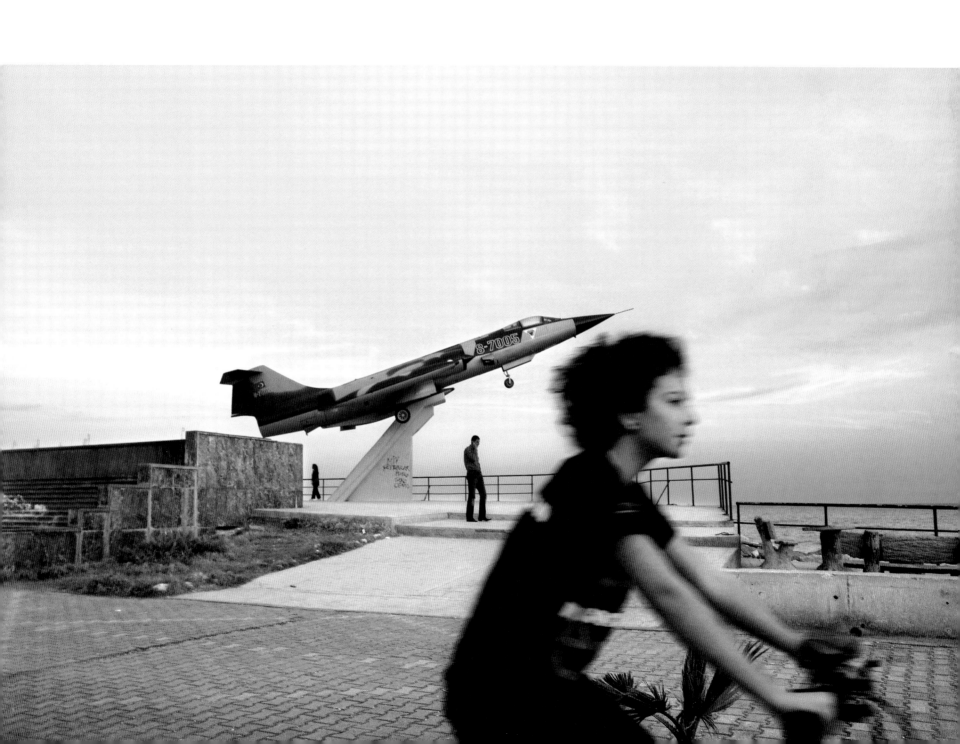

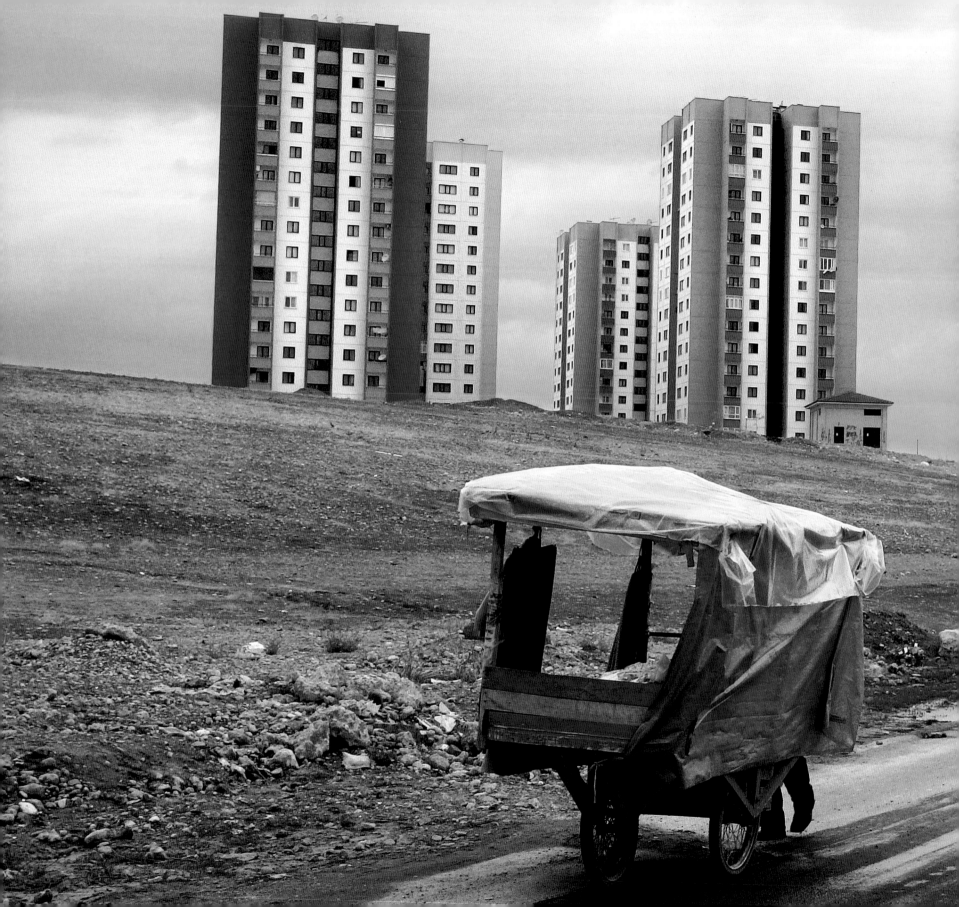

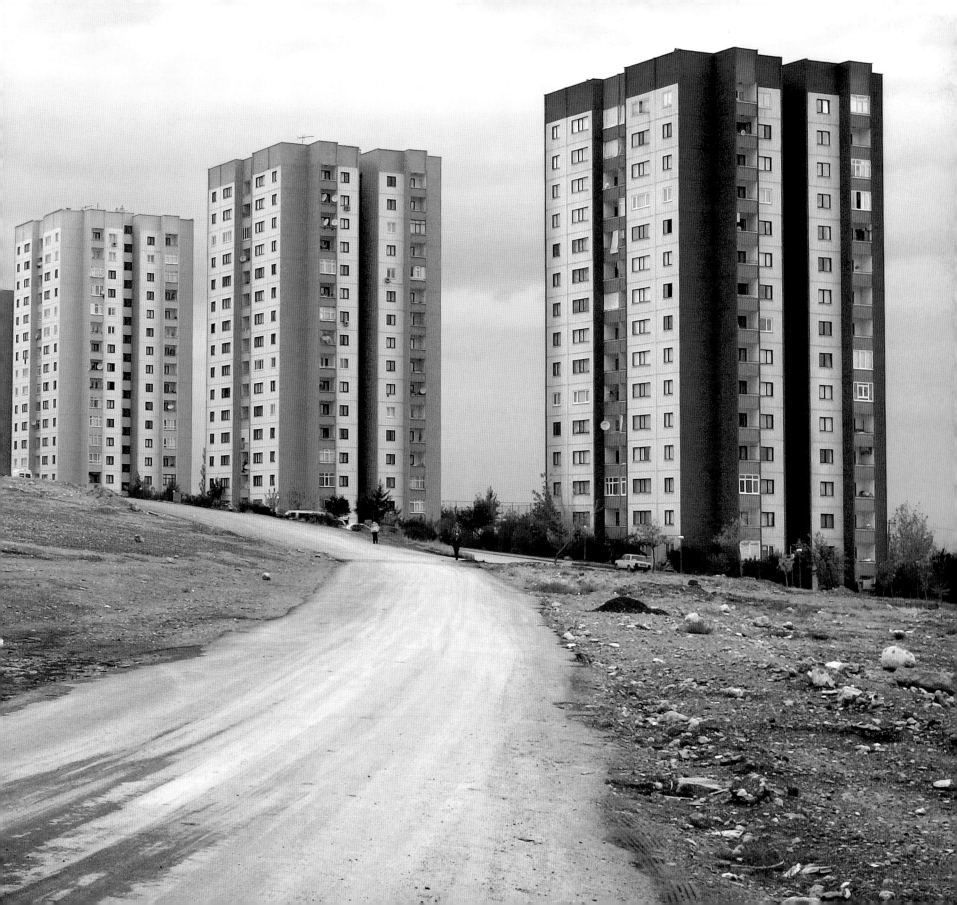

OPPOSITE LEFT:
Bus No. 2, Kiev,
Ukraine, 2004

OPPOSITE RIGHT:
Trolleybus No. 1,
Kherson, Ukraine,
2005

BELOW LEFT:
Bus No. 22, Kiev,
Ukraine, 2004

BELOW RIGHT:
Bus No. 6, Odessa,
Ukraine, 2005

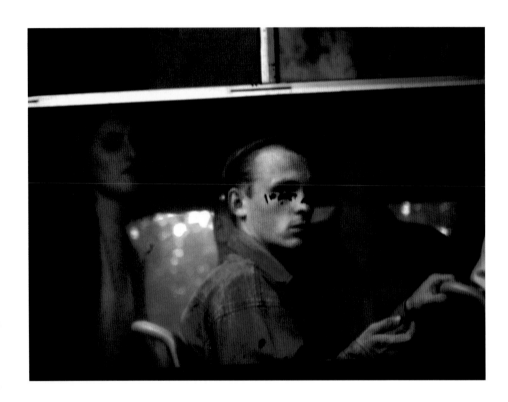

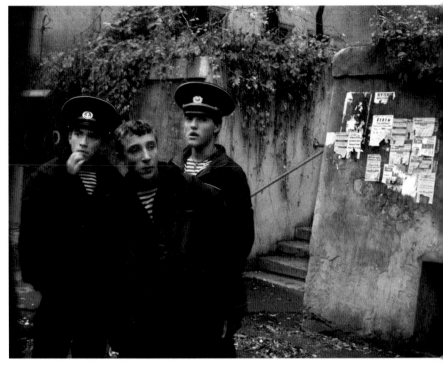

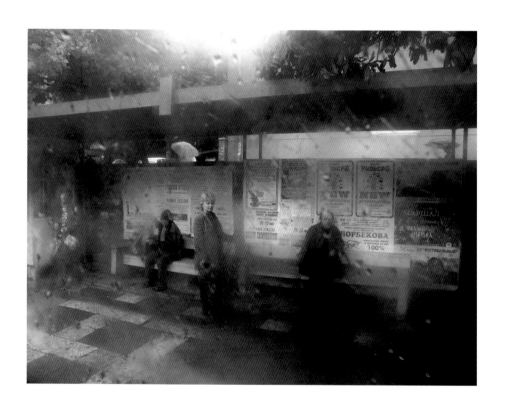

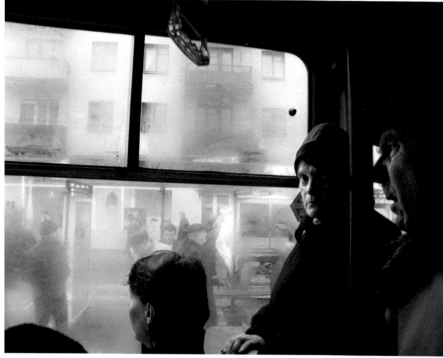

'The Ukraine is going through huge transition. I thought it would be appropriate to explore this by moving through the country on public transport, photographing as people move from home to work.'

'Above all, street photography communicates empathy. It shows the elegance,
and the occasional absurdities, which inhabit the lives of ordinary people.'

DAVID GIBSON

b. Ilford, Essex, UK, 1957, lives in London

British photographer David Gibson delights in the eccentric. London, seen through his eyes, is a place of oddity and dark humour, of human stories and graphic compositions endlessly creating and recreating themselves. His images capture 'the elegance, and the occasional absurdities, which inhabit the lives of ordinary people', he explains. 'I am one of those people; I'm just hiding behind a camera trying to make sense of it all as much as everyone else.'

Gibson has a particular love of word–image juxtapositions and clever visual puns. These have formed an ongoing theme in his work. 'If there is one sound piece of advice, which is to myself as much as anyone else, it is the potential of projects or prolonged themes. It's the equivalent of having a dog that needs to go for a walk. Projects need walking.'

Gibson took up professional photography comparatively late, after a first career as a social worker. He honed his ability to see the everyday world around him by carefully studying the work of past masters. 'I probably spend more time looking at photographs than I do actually taking them. My shelves at home are lined with photography books. The work of the so-called master photographers – and the less heralded – have always been a source of reassurance and stimulation for my own photography. Photographers such as Elliott Erwitt, Henri Cartier-Bresson, Mario Giacomelli, Robert Frank, Sylvia Plachy and Tony Ray-Jones, to name but a few.'

Gibson also acknowledges how much he has benefitted from being part of the In-Public street photography collective. 'There is a paradox with street photography because it is a singularly solitary pursuit, yet it has the potential to generate exceptional warmth and friendship amongst those who practice or appreciate it. The other photographers from In-Public, especially those in London, have constantly refreshed and challenged me.'

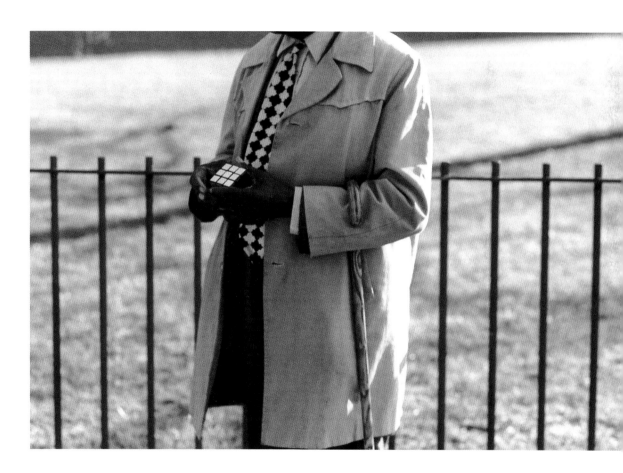

ABOVE:
London, 2003

OPPOSITE LEFT:
Stratford, London, 2000

OPPOSITE RIGHT:
London, 1997

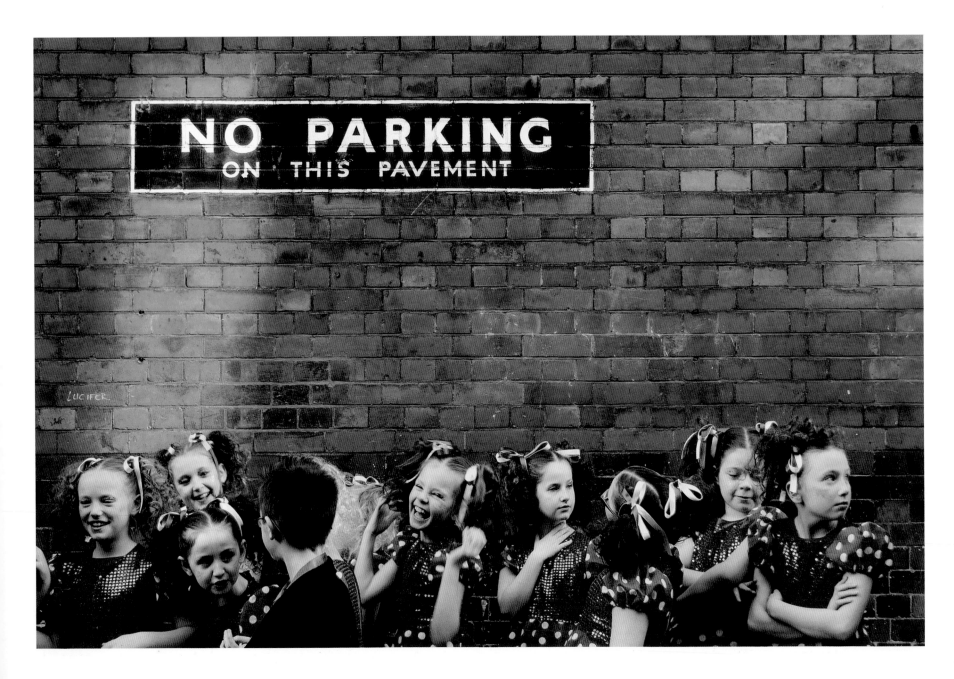

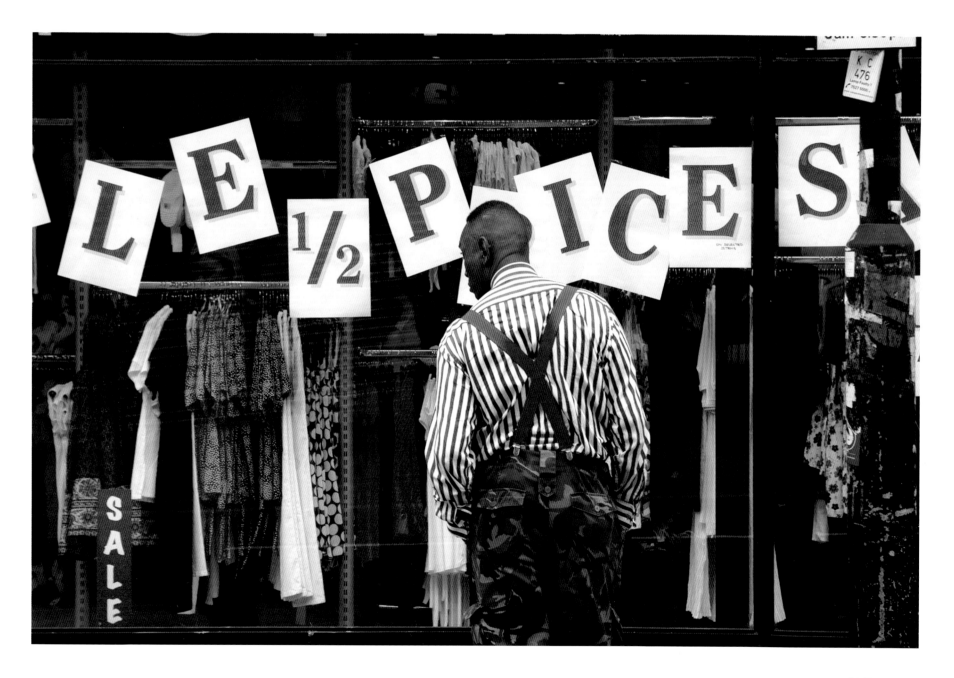

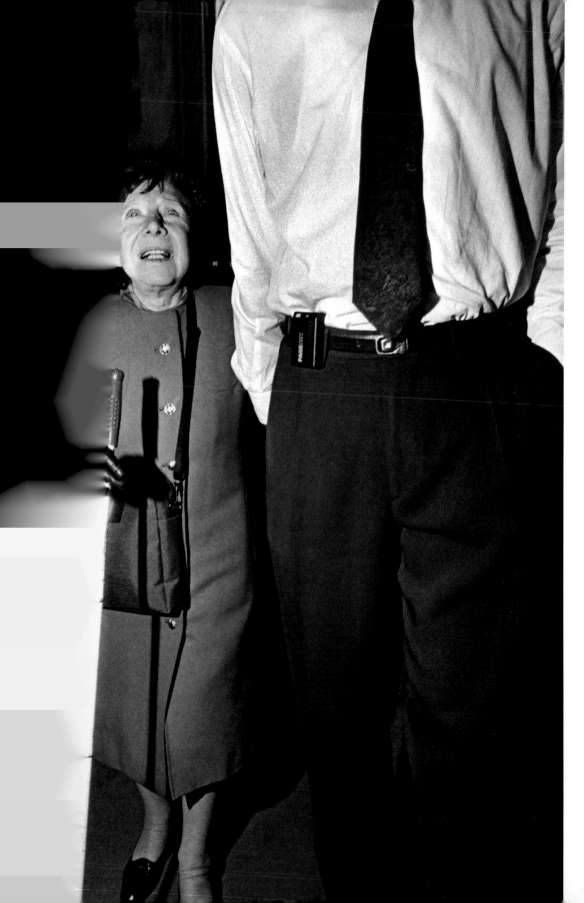

BRUCE GILDEN

b. Brooklyn, New York, 1946, lives in New York City

Bruce Gilden is a big presence in every sense. Tall, athletic and naturally confrontational, he grew up in a tough area of downtown Brooklyn and still thrives on the unruly energy of city life. Known for taking pictures very close-up and for his aggressive use of a flashgun, Gilden's street photographs are notoriously uncompromising. He exposes how the harshness of city life affects both body and mind, shining a raking light on a cast of citizens he regards as members of an endangered species. 'I am showing a slice of life that in several years won't be there any longer,' he has said of his New York portraits. 'Many of the people that I photograph are people who have a certain individuality in the way they walk, the way they dress, the way they look. But the world is getting smaller and smaller, so people are tending to look more alike, dress more alike. All of these differences are disappearing, and it's making it tougher to find people to photograph.'

Gilden insists that he is seeking a kind of raw beauty: 'a strong emotional punch in the gut and a picture that is beautifully composed'. Among his inspirations is film noir, with its visual drama and moral ambiguity. He also cites Robert Capa as a key influence. But even when he leaps out of nowhere to thrust a camera right into a stranger's face, whether in New York or Tokyo, his aim is not to reveal every secret of the human psyche. 'I think the most important thing someone can have in a photograph is mystery. If I can't allow the viewer to look at the photograph and make up a story about it then I think for me it is not a strong photograph.'

LEFT:
New York City, 1992

OPPOSITE:
Two members of the Yakuza, Japan's mafia, Asakasa, Japan, 1998

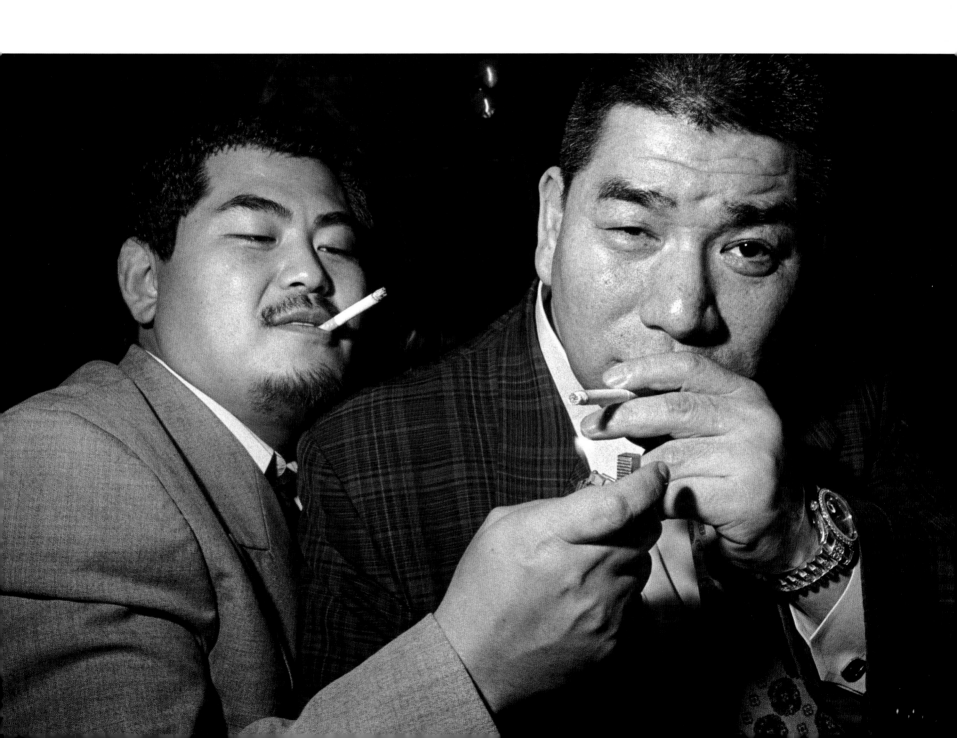

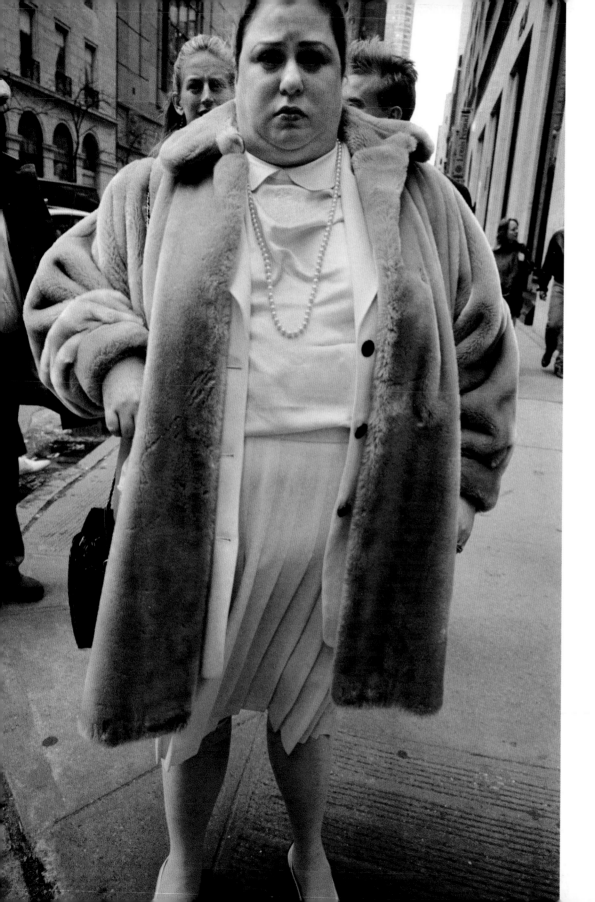

'The people that I photograph are people who have a certain individuality in the way they walk, the way they dress, the way they look. But the world is getting smaller and smaller, so people are tending to look more alike, dress more alike. All of these differences are disappearing, and it's making it tougher to find people to photograph. I believe I'm preserving the differences.'

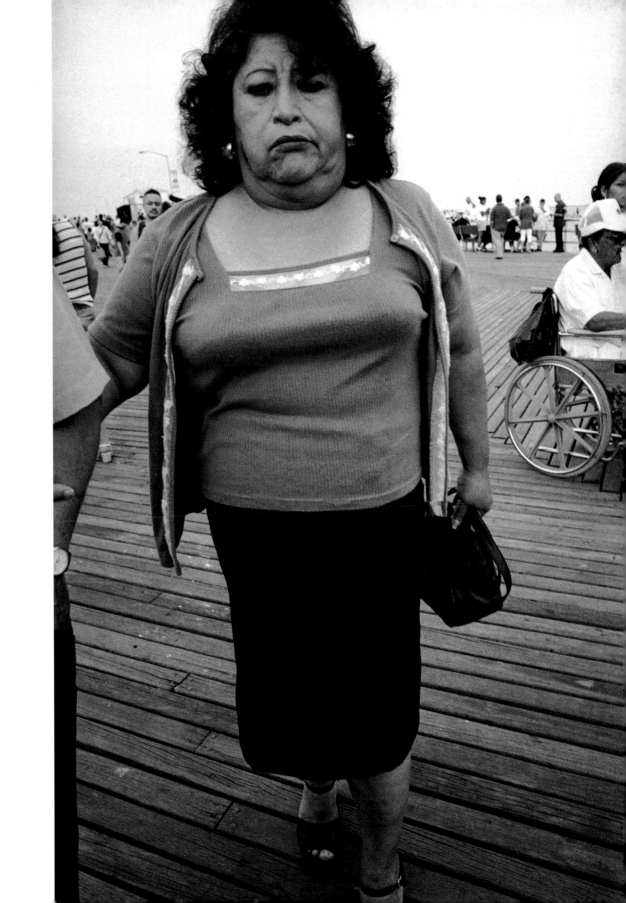

OPPOSITE:
New York City, 1996

RIGHT:
Coney Island, New York
City, 2001

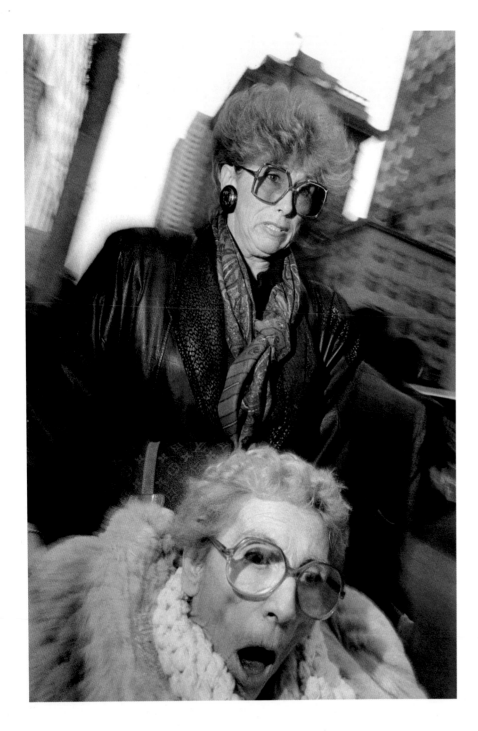

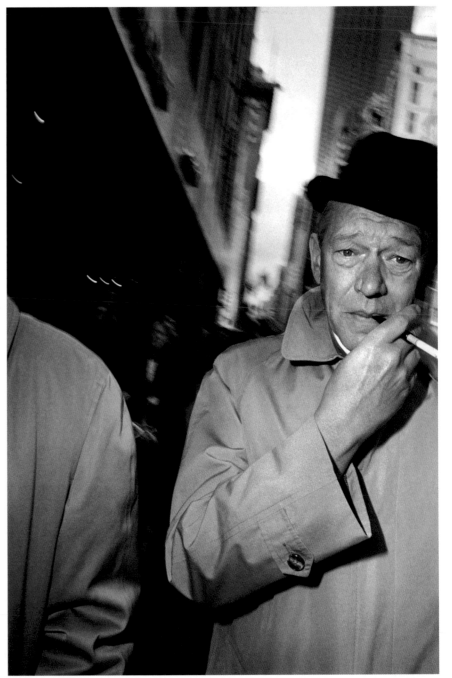

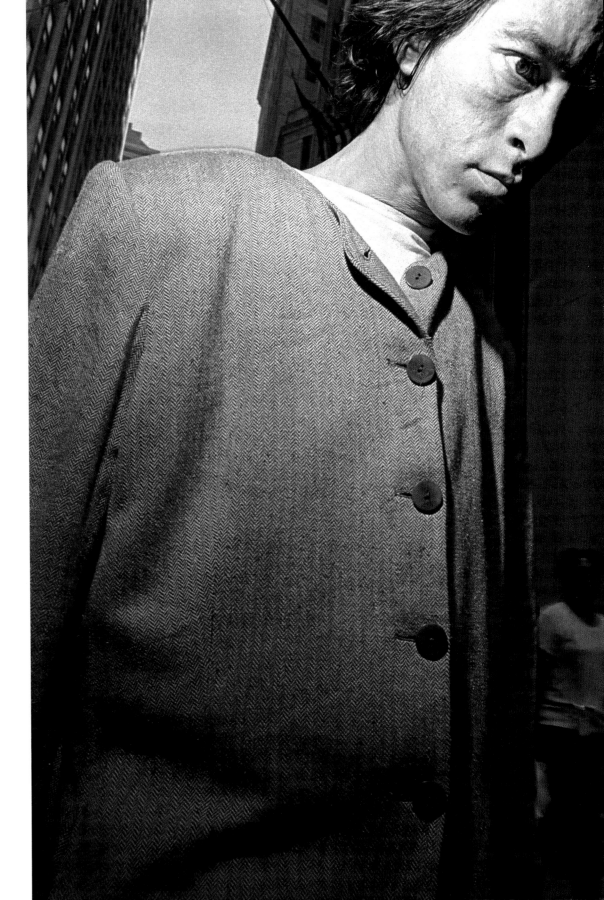

'If you can smell
the street by
looking at the
photo, it's a street
photograph.'

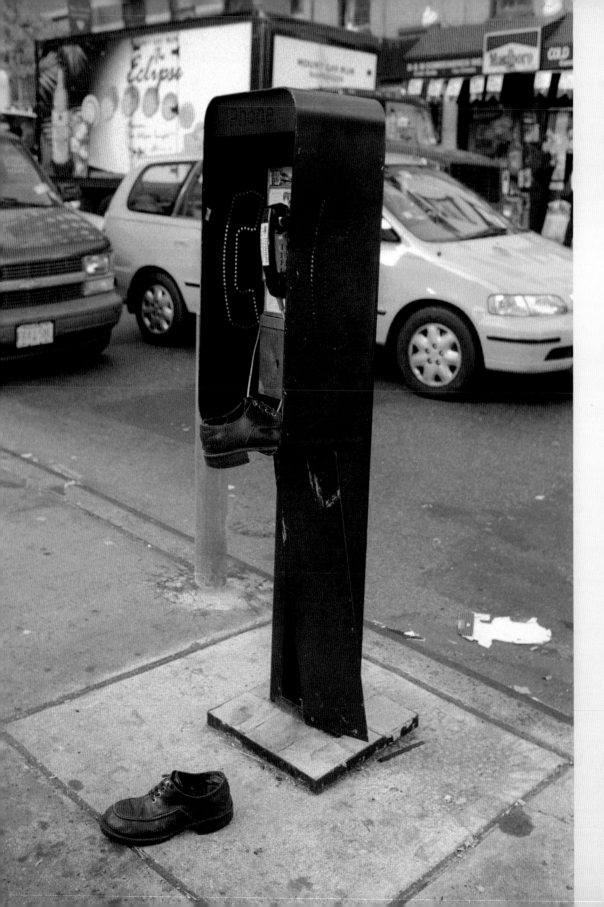

NO IDEAS BUT IN THINGS

02

All good street photographers have an eye for detail.
Amid the clamour of a teeming public square or a
swarming shopping centre, they are often able to pick out
a simple object and frame it in a way that imbues it with
new significance. This essay explores what we might
call 'still life street photography': images that poetically
document the things we buy, sell, fetishize, consume or
discard. Although they generally do not include people,
such photographs are nonetheless very human images
that focus attention on the material props of our everyday
lives. A single glove, an overstuffed sandwich, a car
advertisement or a 'For Sale' sign can speak volumes
about what we value and what we don't.

Many of the photographs discussed in this chapter
have a formal restraint that is reminiscent of William
Carlos Williams's famous poem 'The Red Wheelbarrow'
(1923). With exquisite economy – just the judicious
selection of words and unusual stanza breaks – Williams
manages to turn a single sentence into poetry and to
focus the reader's attention completely on an everyday
object: the red wheelbarrow, upon which 'so much
depends'. Just as the glaze of the rainwater and the
whiteness of the chickens heighten the redness of the
wheelbarrow in Williams's poem, our perception of
objects photographed in public places is always
determined by what else is around, and on the streets,
collisions of colour, line and form are often at their
most intense.

Williams famously summed up his aesthetic in the
phrase 'no ideas but in things', an epithet that seems
particularly apt for photography. Whereas painting,
sculpture or music can be *about* something, photography
must always be *of* something. No matter how much it
tends towards abstraction, a photograph is always an
image created by documenting the real world. The
images of objects by street photographers such as Nils
Jorgensen, Michael Wolf and Richard Wentworth have a
peculiar kind of honesty. They do not purport to be about
nebulous or grand ideas, but insist that we always begin

OPPOSITE:
Melanie Einzig,
Teletransport,
New York, 1999

BELOW:
Nils Jorgensen, London,
2006

with tangible things. This is street photography at its most essential, focused on the task of seeing the everyday world around us more clearly.

Still-life street photography has a long history, going back at least to Eugène Atget, whose extensive documentation of the street life of Paris largely comprised images of buildings and inanimate objects. In an era when exposure times were still long, objects were much easier to photograph than people, and for Atget they often said as much about human life. Atget's aim was simply to create 'documents for artists', and the pictures he took reflect his belief that 'a good photograph is like a good hound dog, dumb, but eloquent'.

This strange mix of eloquence and reticence is found in many of British photographer Nils Jorgensen's images. His picture of empty photograph frames inside a shop window could almost have been taken by Atget.

It's a display about appearances in which no one appears. The shop is 'closed', a sign tells us, so we assume there is no one inside. Nor are there any people inside the empty photo frames. And no one is reflected in the mirror which takes pride of place in the display. But all three – shop, photo frames, mirror – are intended to hold people (or at least their images) and as such everything in this photograph of absence calls to mind human presence.

Jorgensen's photograph of a pair of brand-new shoes abandoned by the side of a road, (*p. 89*) evokes a missing person in a different way. How did the shoes get here? Why have they been abandoned? Does it have anything to do with the rain? Will someone come back to collect them? The photograph begs a long list of questions but answers none of them. We are forced to accept what we cannot know and focus on what we can see: the shine of the shoes, the pattern of the bricks in the wall and on the pavement, the curve of the corner paving slabs, the uprightness of the street sign, and the yellow line whose sweeping brilliance animates the whole photograph.

Across the Atlantic, another pair of abandoned shoes has been discovered by New York photographer Melanie Einzig. One shoe is on the pavement, as if it has just been stepped out of, but its mate hangs by its laces from a nearby phone booth. It's a cryptic scene. Has someone just had a practical joke played on them? Has the wearer been told to leave his shoes behind by someone on the phone? Or has he just jumped barefooted into the cab behind?

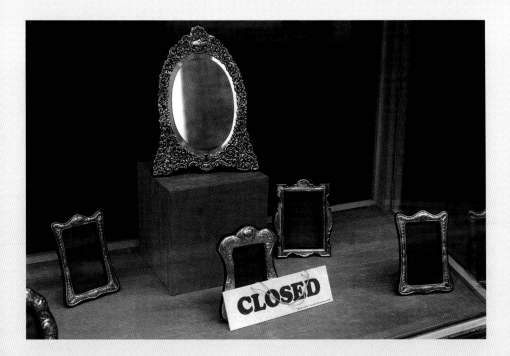

Both these enigmatic pairs of shoes would probably have been spotted by Richard Wentworth had they been lying near Caledonian Road in north London. For over twenty-five years Wentworth has been taking images of ordinary things abandoned or redeployed in unexpected ways in the streets near his home. The series of photographs collectively known as *Making Do and Getting By* began as a way of making notes for sculpture (Wentworth's main artistic practice) but have more recently been exhibited in their own right.

Wentworth is attracted to objects nearing the end of their useful lives. 'I grew up in a world that was held together with string and brown paper and sealing wax,' he explains in an interview with Kevin Henry for Core77. 'I slowly realized that this is the underlying condition of the world and there's nothing I like more than a NASA disaster where they say "If it hadn't been for the chewing gum...."' He prowls the city scouting for evidence of such makeshift intelligence: chewing gum stuffed into an alarm to stop it ringing, a melon used to prop open a window, a dog left to mind a handbag, a sandwich is held together in the craw of a tree. A recent photograph

shows a washing machine alongside a chest of drawers: with a bit of imagination and an electricity supply you could use it as an outdoor launderette. The ambiguous status of these objects as they hover between usefulness and obsolescence delights Wentworth. 'If something is discarded you can read that and see that it's been rejected. To me there is something terribly beautiful in that. I always see the crack in the glass before I see the window.'

German photographer Michael Wolf also has a keen eye for incidental street sculpture. Wolf, who has been living and working in Hong Kong since 1995, has created a portrait of one of the most densely populated areas in the world, not by showing us its actual inhabitants, but by documenting their belongings. He photographs mops, shovels, pots and pans tucked, propped and balanced into every available nook and cranny of this congested metropolis. His pictures are full of ingenuity and wit, testimony to the amazing capacity of Hong Kong's urban dwellers to adapt to their circumstances. A fish is laid out to dry alongside a pair of gloves, a metal Buddha peeps out from a plastic bag as if to collect some fruit nearby.

Street photographers' visual games with mannequins are part of a broader conceptual strand of the genre that plays on the slippage between fantasy and reality. Into this category we might put all those photographs involving street signs, adverts and graffiti. Some of these are witty one-liners; others are complex critiques of the increasingly fluid relationship between dreams, signs and real life. The godfathers of such photography are Walker Evans and Lee Friedlander, who both loved to photograph billboards, road signs, shop fronts and other found urban imagery, relishing the typography and graphic layout of the signs themselves as much as the visual puns they could make by juxtaposing them with real elements in a picture.

Matt Stuart's photograph of a peacock on London's Bond Street (*p. 189*) works in this vein. The exquisite bird appears on the hoardings hiding the refurbishment of an expensive jewelry shop. Directly in front is a skip covered by a tarpaulin that is almost the same colour as the bird. Stuart juxtaposes these two elements so that the skip becomes the peacock's body, a collection of traffic cones on the road serving as the bird's feet, completing the visual pun.

Nick Turpin's *Un-civil Aircraft* (*pp. 206–7*) also uses the interplay between signs and reality to create a witty but slightly sinister series of photographs in which people appear threatened by illusory airplanes. The series is, in Turpin's words, 'a personal project about the way the world looks different after the events of 9/11.' The

economic fallout from the attacks gives the photographs an additional significance; at least one of the shops we see has closed for business, others are surely threatened more by bankruptcy than misdirected aircraft.

Photography has long been associated with consumerism, the documentation of objects for sales catalogues being one of its most widely used, if least discussed, applications. Many street photographers are particularly fascinated by shop windows, markets and other spaces of buying and selling. Their documentation of commercial displays forms a playful and revealing counter-current to commercial product photography. From overstuffed American supermarkets to understocked Eastern European corner shops, Martin Parr is fascinated by consumer displays in sex shops, grocery shops, charity shops and tourist stalls around the world. In 2000 he documented the fake cherry blossom used every spring to adorn everything from tins of Spam to pocket calculators in Tokyo. In several pictures taken in the USA after 9/11 he shows foodstuffs decorated with the American flag to make purchasing them seem patriotic.

If ordinary shop displays are appeals to human desire, charity shop displays attempt to make objects we know have been rejected by one group of people seem desirable to another. Parr's photograph of a charity shop window in the British seaside town of Margate typifies the pathos of such efforts. The window display comprises a motley selection of items – a book of pasta recipes, two unfashionable pairs of shoes, a couple of ornaments,

BELOW LEFT:
Martin Parr, New York City, 2001

BELOW CENTRE:
Martin Parr, Tokyo, 2000

BELOW RIGHT:
Martin Parr, Margate, England, 2009

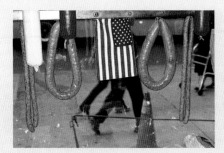

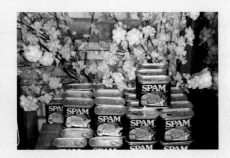

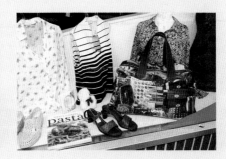

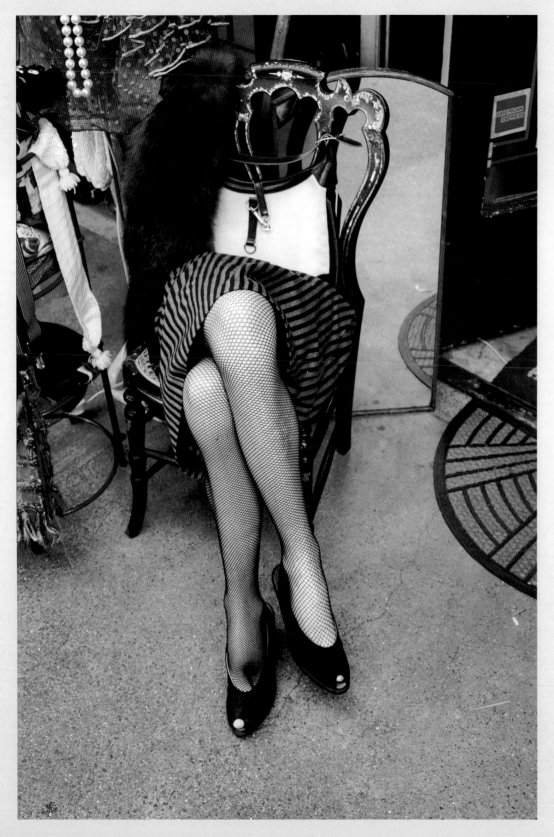

OPPOSITE:
Gary Alexander, East
Dulwich, London, 2003

LEFT:
David Gibson, London,
2004

BELOW:
Maciej Dakowicz, *Two
Mannequins*, Kashgar,
China, 2007

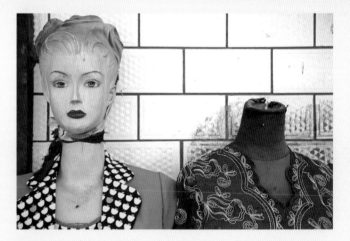

some ladies' tops and a weekend bag photographically printed with a further assortment of ordinary objects including, wittily, two cameras that point back towards Parr's lens. For the Surrealists, this was just the kind of miscellaneous selection of found objects that could suddenly appear to be 'as beautiful as the chance encounter, on a dissecting table, of a sewing-machine and an umbrella'.

The Surrealists delighted in objects found or recovered from flea-markets, junk shops and sidewalks, regarding their strange beauty as an indication of the conscious mind recognizing a desire of the unconscious. They particularly loved mannequins – playful, occasionally grotesque, stand-ins for the human body – which seemed to hover between the material and the dream world. No wonder they championed Atget's oeuvre, containing as it does so many haunting photographs of shop mannequins. There is something inherently disturbing about mannequins, which is exacerbated when they are missing limbs or other body parts. The Surrealists loved such perversit: Hans Bellmer and Dorothea Tanning were among those who developed extensive bodies of work based around the mangled and fetishized dolls. Damaged mannequins

also have a tendency to find their way onto the street, either because they have been discarded outright or because they are being used to model cheap wares. There they become a street photographer's bounty. David Gibson has photographed a glamorous pair of stockinged legs, elegantly crossed and accessorized with a fur muff, handbag and high heels, which emerge from a suitably stylish chair without being attached to any torso. Maciej Dakowicz captures a pair of female mannequins, one black, wearing a red dress and missing her head, the other white, heavily made-up and looking a little startled, as if she might be next up for a beheading. Ying Tang documents three undressed female mannequins apparently gossiping to one another from behind a clothes rail, their bare breasts peeping out indiscretely as an older Chinese woman walks past (p. 196).

Still-life street photography can help us take renewed pleasure in the visual adventure of simply being out in public. It's a genre brimming with humour: flick through the pages of this book to spot an alpine painting crossing the road in Rotterdam, a giant breakfast of egg and chips flying above the beach in Weymouth, and an undressed salad drying on a wire fence in Hong Kong.

Many of these pictures feel like clues to a mysterious global treasure hunt. 'Stop, Look, Laugh', they seem to instruct us, none more so than British photographer Gary Alexander's photograph of a pair of glasses stranded on a pedestrian crossing in London. Go slowly, wait, look closely and take pleasure in the small, unexpected things: these are its lessons.

THIERRY GIRARD

b. Nantes, France, 1951, lives in Île de Ré, France

French photographer Thierry Girard sees himself working in the tradition of writer–travellers such as Nicolas Bouvier and Bruce Chatwin, and describes the many photographic expeditions he has made around France, Japan and China as 'personal journeys'. The process of discovery, he says, is always 'as much internal as geographical'.

Girard has created two extensive bodies of work in China during the last decade. Several of the pictures were made on an expedition in which Girard followed a route taken through China in 1914 by French ethnographer, archaeologist and writer Victor Segalen. Girard drew inspiration from Segalen's travel notebooks, in which he recorded the daily weather conditions, logistical problems, uncertainties, distances between destinations, frustrations and joys of the journey, as well as the beauty of the landscape. However, rather than diligently visiting every place Segalen had been, Girard was interested in documenting China as it is today, a country in the throes of change, neither to romanticize nor to criticize, but to chronicle how changing social, economic and political circumstances play out in people's everyday behaviours. The process is one he describes as 'an intellectual and a physical confrontation with ordinary life'.

Precision is important to Girard. He works with a medium-format camera, usually on a tripod, taking time to frame and compose each shot. His methodical approach transforms the architecture of public space into a carefully prepared stage awaiting the entrance of the players.

LEFT:
Hangzhou, Zhejiang, China, from the series *Jours ordinaires en Chine*, 2001

BELOW LEFT:
Guangtong, Yunnan,
China, 2006, from the
series *Voyage au Pays du
Réel*

BELOW RIGHT:
Meixian, Shaanxi, China,
2003, from the series
Voyage au Pays du Réel

 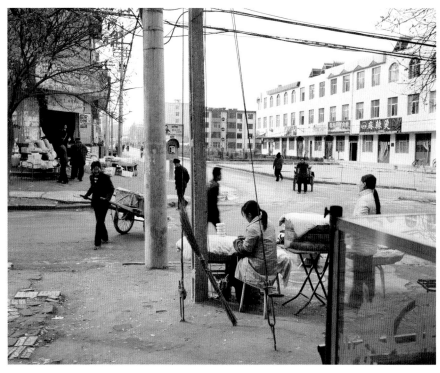

'I am not a reporter. I prefer indefinite situations.
My aim is to photograph the simple reality of things with both
distance and empathy.'

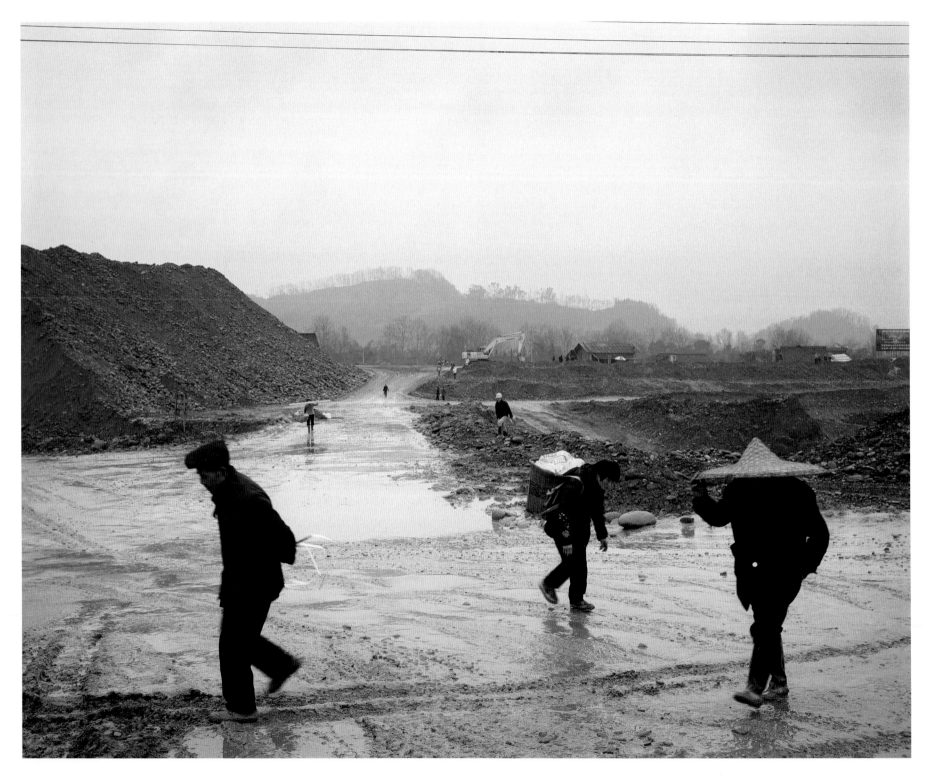

BELOW:
Xi'an, Shaanxi, China,
2003, from the series
Voyage au Pays du Réel

ANDREW Z. GLICKMAN

b. New York City, 1963, lives in Bethesda, Maryland, USA

Like many street photographers of recent times, Andrew Glickman took inspiration from Joel Meyerowitz. After viewing an exhibition of the renowned New York street photographer's work in 1995 he attended a photography class organized by Meyerowitz in Tuscany, where he found compelling subject matter in the vibrant street life of central Italy, as well as an inspiring tutor. '[Joel's] passion for and deep understanding of street photography had a transformative effect on me. I realized that the things street photographers were able to describe through their work were the things that I wanted to see and capture.'

Eventually Glickman found the courage to tackle a subject closer to home in Washington, DC. 'In my subway series, *Among Strangers Underground*, I am one of the people you see. I too am a commuter and this is my commute.' This helps him to stay unnoticed, another anonymous face on the train. 'I think there is an expectation by many viewers that if you're sitting across from someone on the subway who takes your picture, you'll probably notice them. In my experience, that isn't true. Even where people do notice me photographing, almost all of them turn back to what they were doing and pay me little attention.'

These two bodies of street work may seem very disparate in subject matter, but Glickman believes that their success comes down to the same factor: 'When I began to think of myself as a street photographer, I began taking more risks and chances. Photographing people, particularly people you don't know, is inherently an aggressive act. I had to break through my comfort zone to make some of the pictures I've made. You can't worry about whether you have permission or whether you may be inside your subject's comfort zone. Believing completely in what you're doing is critical.'

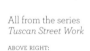

All from the series
Tuscan Street Work

ABOVE RIGHT:
Group of Women Tourists, Siena, Italy, 1996

RIGHT:
Man Holding a Boy's Head, Italy, 1996

OPPOSITE:
Preparing the Parade Route, Buonconvento, Italy, 1996

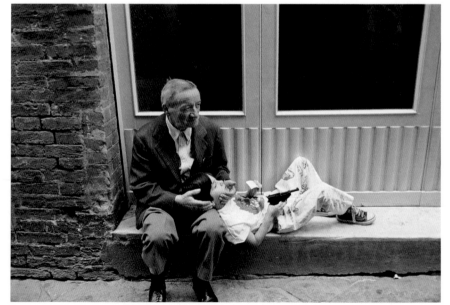

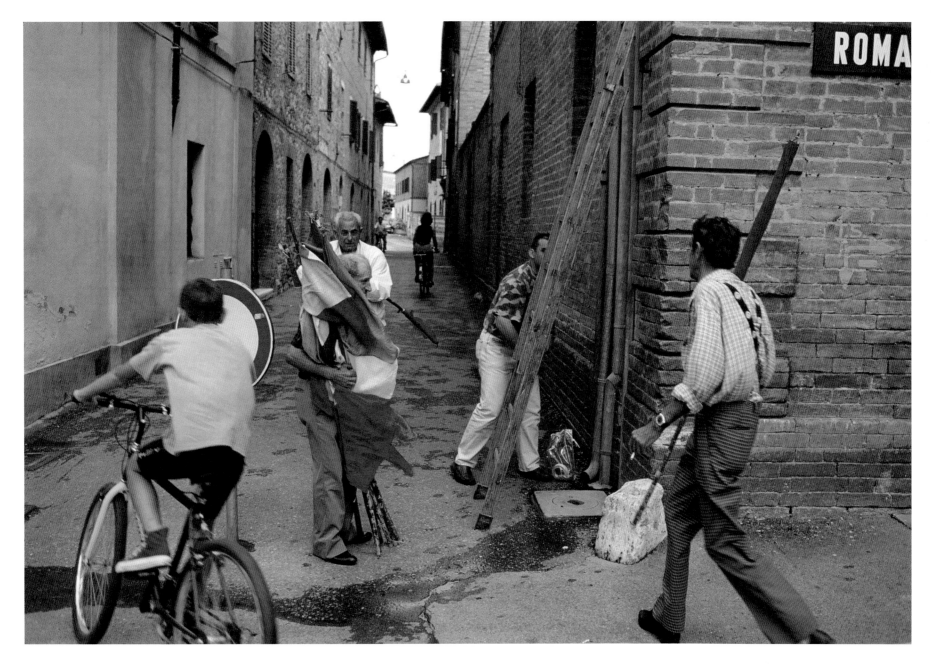

ROMA

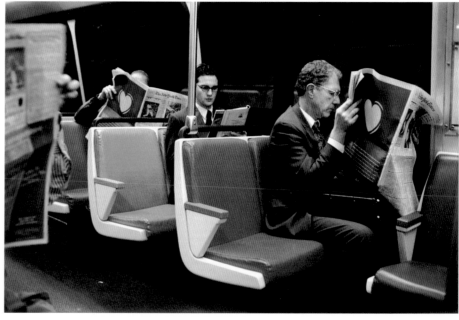

All from the series
*Among Strangers
Underground*

ABOVE LEFT
Man with Legs Up,
Washington, DC, 2000

ABOVE RIGHT
*Some New York Times
Readers*, Washington,
DC, 1999

OPPOSITE LEFT
*Standing Man, Seated
Woman*, Washington,
DC, 1999

OPPOSITE RIGHT
*Woman in a Fuschia
Coat*, Washington, DC,
2001

'Perhaps because I am comfortable in the space I find it relatively easy to work unobserved on the subway... I am one of the people you see. I too am a commuter and this is my commute.'

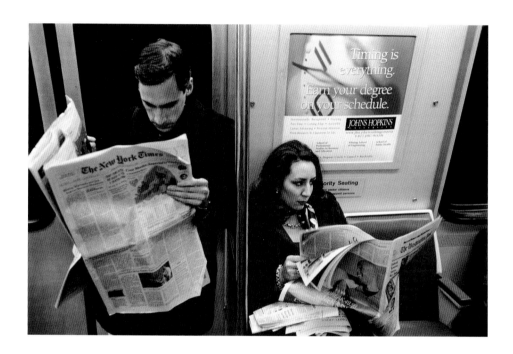

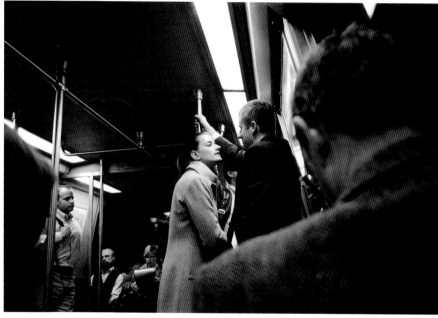

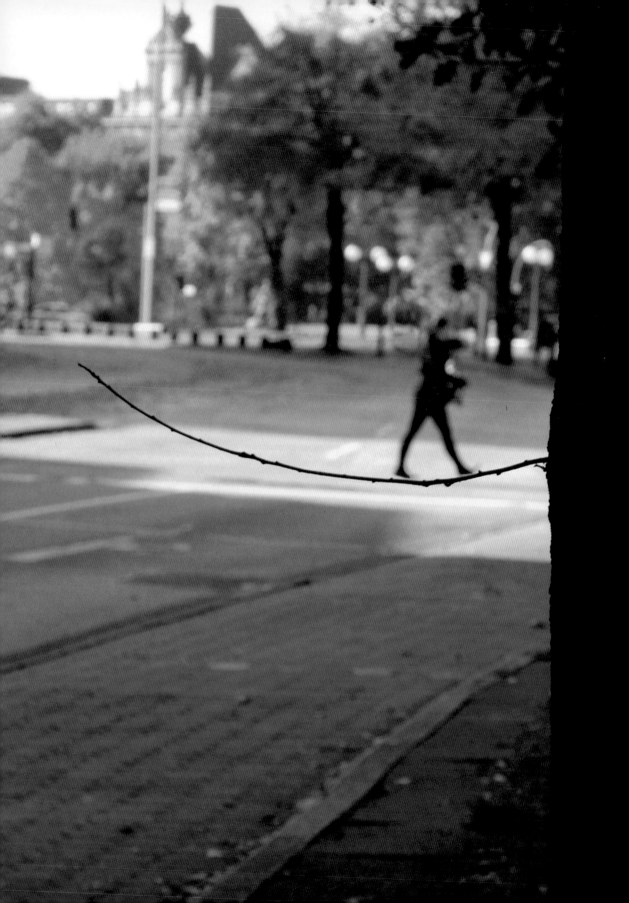

SIEGFRIED HANSEN
b. Hamburg, Germany, 1961, lives in Hamburg

Siegfried Hansen is a street photographer based in Hamburg. His background in graphic design enables him to get maximum visual effect from his shots. 'I am looking for the little absurdities of life,' he explains. 'Normally I see the street scene as a stage, where the costumes and the stage design is ready. So I only have to wait until a protagonist crosses the scene.'

Much of Hansen's work is made in West German cities and towns that were bombed during the Second World War and subsequently rebuilt with bland concrete architecture and metal street furniture. These ostensibly staid environments are not obvious places for street photography. But Hansen has an eye for the surreal, and manages to extract delicate moments of balance and poise, enchantment and humour from even the most disciplined cityscape.

LEFT:
Hamburg, 2008

OPPOSITE LEFT:
Hamburg, 2006

OPPOSITE RIGHT:
Hamburg, 2008

'To see the complexity of life on the street is for me a kind of meditation.'

‘I often try to look at things through the eyes of Don Quixote.’

CRISTÓBAL HARA

b. Madrid, 1946, lives in Cuenca, Spain

Cristóbal Hara is one of the most widely published and exhibited contemporary street photographers, though, unusually for a photographer of his stature, he seems content not to have an online presence. He spent his childhood in the Philippines, Spain and the USA before settling in Germany and the UK. Although his work deals with quintessentially Spanish subject matter, he did not become a Spanish resident until the age of thirty-three.

Hara is renowned for his highly evocative images of a traditional rural life that is increasingly marginalized in modern Spain. Many of the people he photographs could still be described as peasants. They cling to the formalities and pageantry of their religious beliefs, continue to work the land and coexist, often uneasily, with their beasts of burden. Hara never asks us to pity his subjects; they remain vigorous and proud people with a lust for life and a passion for the *fiesta*.

Hara's ability to record the tumultuous highlights of *pueblo* life, where the demonic and demotic are never far apart, is remarkable, given that he remains an outsider in these close-knit communities. 'I go to places to take pictures, not to socialize; but there are places where I go every year and, because of this, I am no longer a total stranger.' Although Hara's presence is accepted, it is difficult for him to pass unnoticed in his street work. 'It is very important to me to work candidly but it is not always possible...while I was taking the picture of the gypsies...they were ripping my shirt and T-shirt to shreds'.

Hara acknowledges the influence of many other art forms on his photography: 'Colour images of the type I do would not be possible without the discoveries of Cézanne and I use things from abstract expressionism, from surrealism, and from de Chirico for the urban landscapes. Avant-garde jazz helps me with dissonance, jaggedness, texture and especially with unconventional structures, which I can use in my books. Literature provides an atmosphere within which to work. I often try to look at things through the eyes of Don Quixote.'

ABOVE:
Villar de Domingo
Garcia, Spain, 1993

OPPOSITE:
Beas de Segura,
Spain, 1996

OPPOSITE:
Atienza, Spain,
1993

BELOW:
Cabra, Spain,
1991

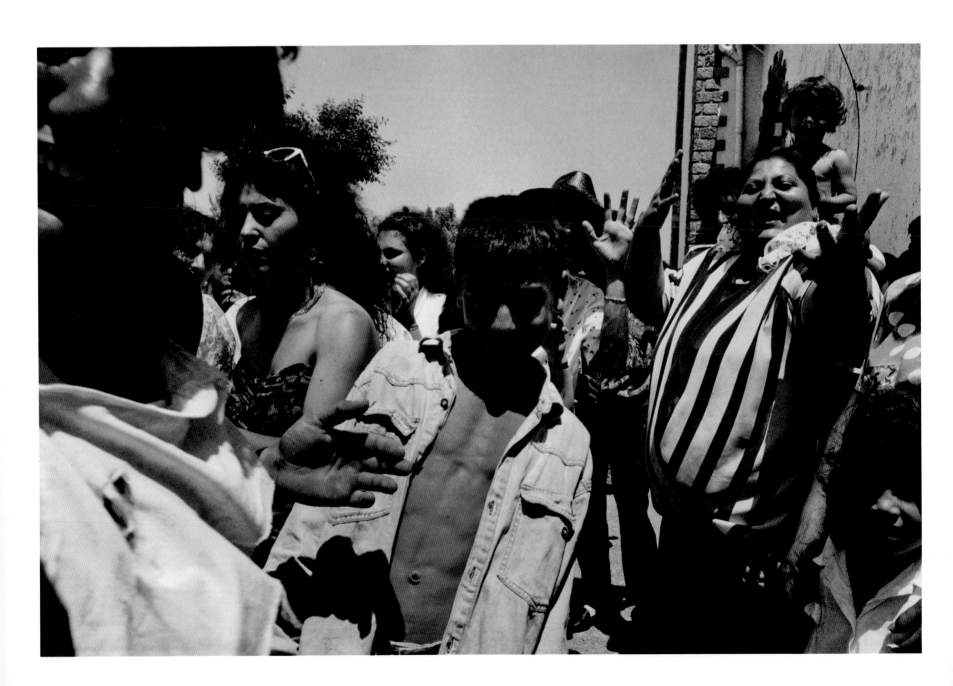

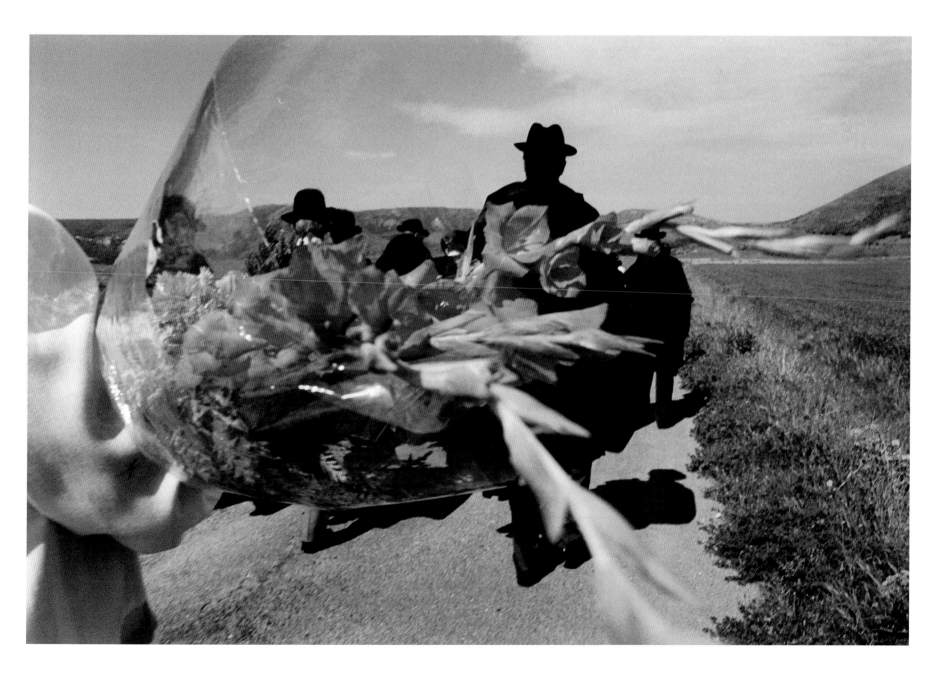

OPPOSITE:
N1, Álava Province,
Spain, 1995

BELOW:
Villanueva del
Arzobispo, Spain,
1996

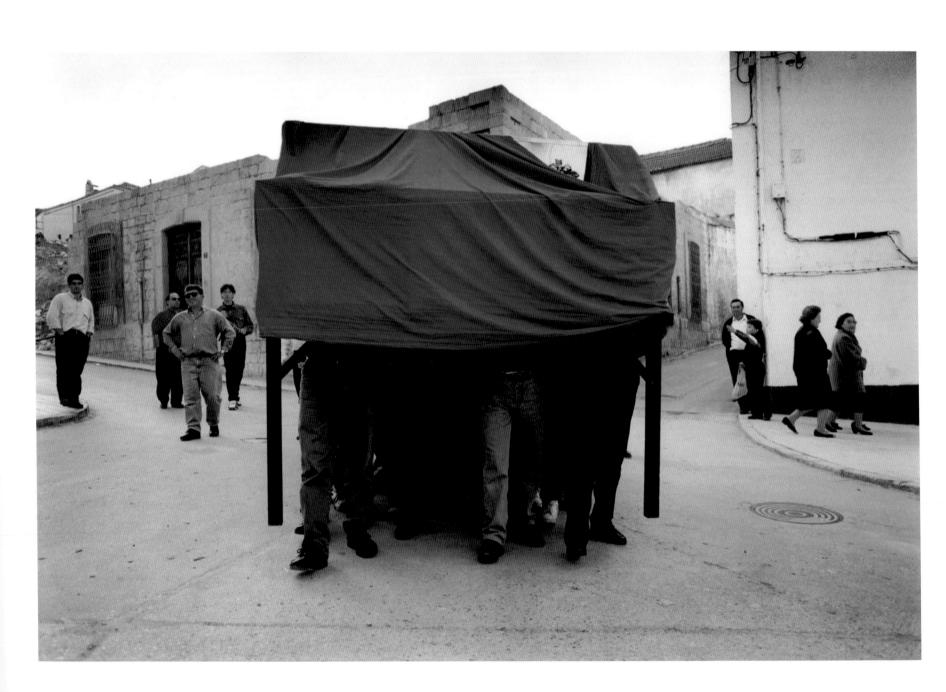

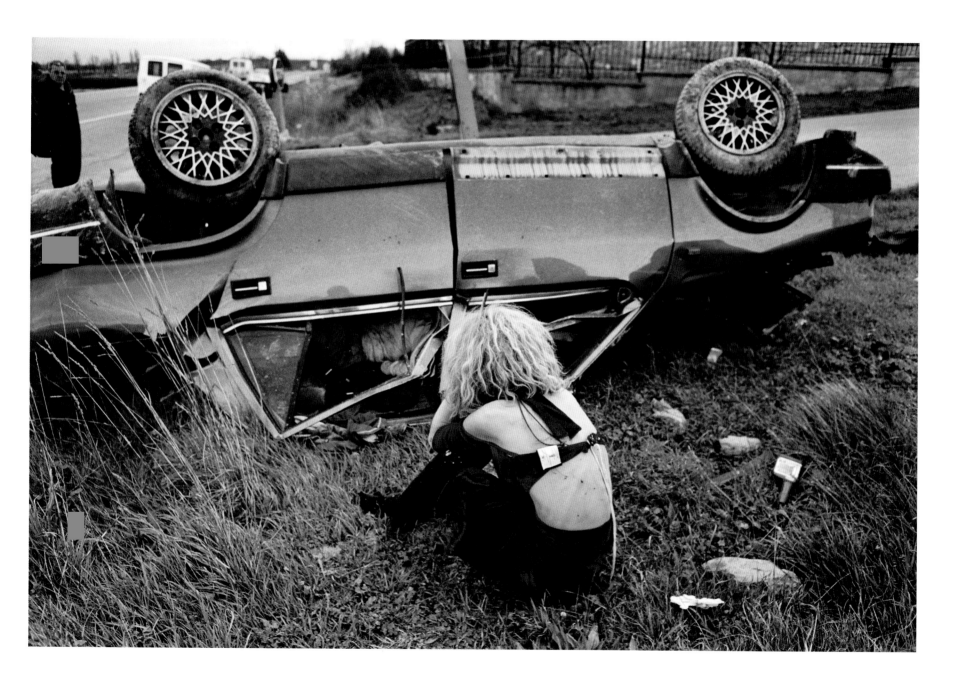

MARKUS HARTEL

b. Duisberg, Germany, 1970, lives in New York City

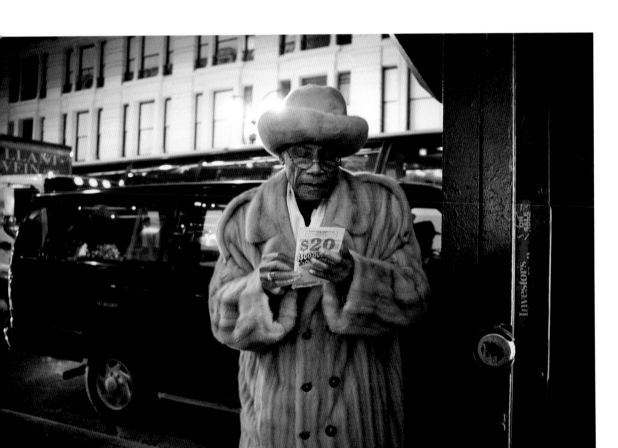

Markus Hartel is the quintessential New York street photographer. He stalks the sidewalks of Manhattan on the lookout for what he describes as 'the out-of-the ordinary within the ordinary'. His photographs are at once raw and tender, honest depictions of often-hardened city dwellers.

'Street photography just hit me by accident,' says Hartel. 'In 2002 I moved to New York and simply started to take photographs of strangers in the streets. Later on, I learned about Henri Cartier-Bresson and Garry Winogrand and realized I was working in an established tradition.'

Describing his working methods, Hartel explains: 'I have my eyes 10–20 feet ahead and watch for something to happen…Sometimes it's anticipation, and sometimes it's luck. I blend in with the scenery and catch a moment where people are so involved with what they're doing that they don't notice me with my camera. The photographer needs to be pretty ballsy, or simply quicker than the subject.'

Like so many talented street photographers, Hartel is a 'professional amateur'. In his day job he works as a graphic designer and photo-retoucher. Although he wishes he had more time for street photography, he appreciates the variety in his dual career: 'one cannot be creative 24/7 and a street photographer deserves a break every once in a while. It's always a good thing to refresh your batteries and look at things from a new angle.'

'Street photography is like gambling.
 You get lucky or you get nothing...'

LEFT:
$20 Investor, 34th Street,
New York City, 2006

OPPOSITE:
Vacuum, 7th Avenue,
New York City, 2006

'My pictures are not necessarily pretty, but they do show beautiful moments
of the urban jungle.'

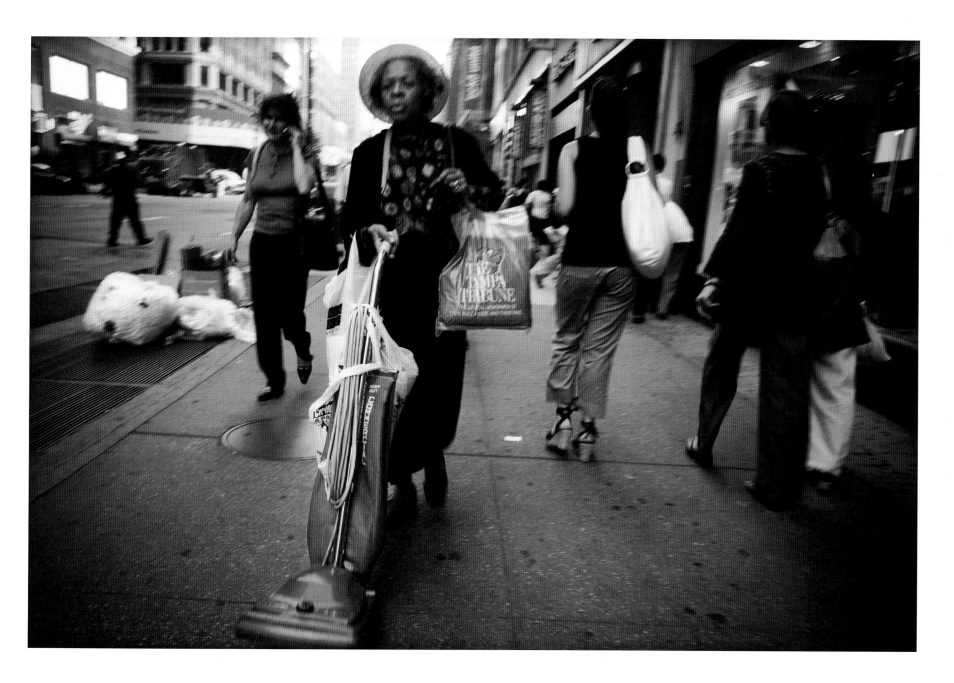

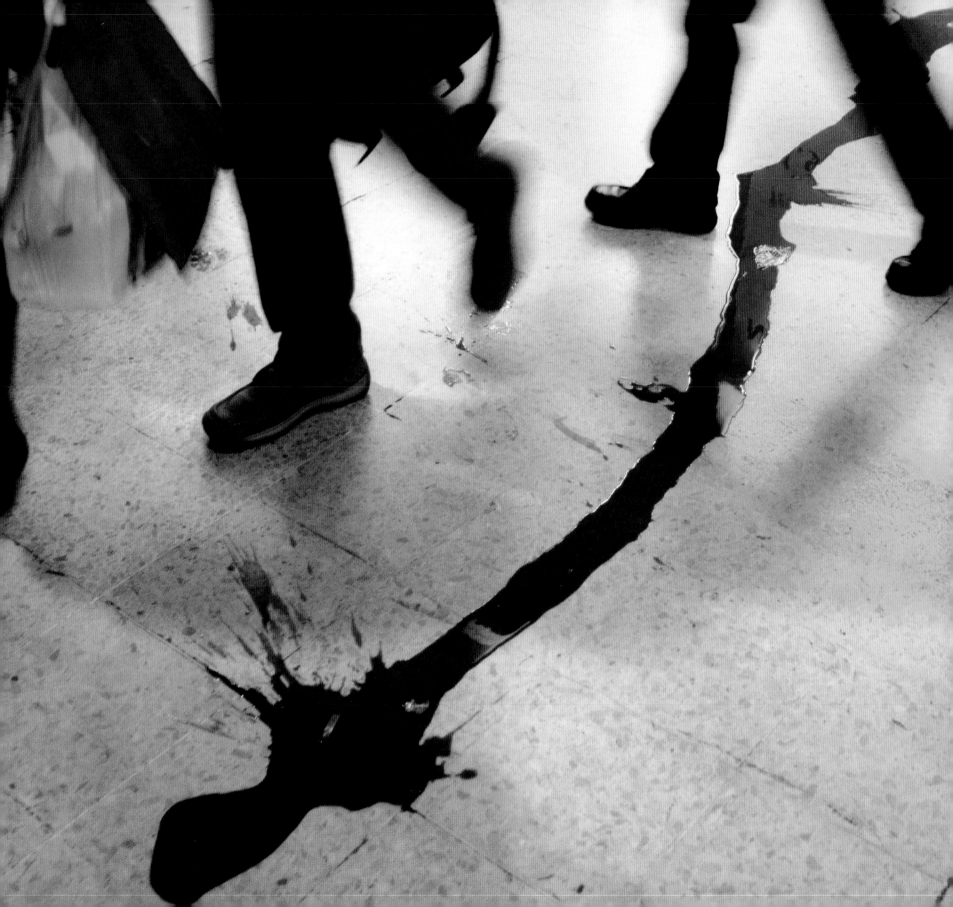

NILS JORGENSEN

b. Hørup, Denmark, 1958, lives in London

London-based photographer Nils Jorgensen has an instinct for finding low-key, easily overlooked beauty. He spots unlikely patterns and picks out exquisite collisions of line and form in the most ordinary places: 'A shadow on a wall is more interesting to me than a fight', he says.

Jorgensen makes his living as a news and celebrity photographer. 'Working full time covering news, celebrities, meeting deadlines and so forth can make it hard to switch back to taking photographs of small random moments which have no obvious news or commercial significance,' he admits. 'It requires a different way of thinking and working.' Editing, in particular, is a much more leisurely and considered process with his street photography. 'I will often not look at my street photographs for many months after taking them – years even – only coming back to them when I want to and feel it is right. In my press work it is a bit different. It is important to edit and wire photographs within minutes of taking them.'

Jorgensen cites Elliott Erwitt and Tony Ray-Jones among his influences, both of them photographers known for their humour. His own wit is warm, with a celebration of everyday quirkiness that never slips into mockery. 'I like taking photographs with humour,' he explains. 'And I like the reaction from people when they see them too, so maybe this is in part a motivating factor. But I don't think it's a good idea to go out and look for funny photos. This mostly results in failure for me.'

Poetry has been an important influence for Jorgensen, in particular the work of Philip Larkin, whose understated lyricism and fascination with ordinary things is paralleled in Jorgensen's photographic style. 'Nothing, like something, happens anywhere,' Larkin wrote at the end of his rather melancholy *I Remember, I Remember*. It's also an apt description of much of Jorgensen's photography, but under the photographer's lens the many unremarkable and undistinguished incidents of the street are imbued not with sadness, but with a quiet joyfulness.

Waterloo Station,
London, 2005

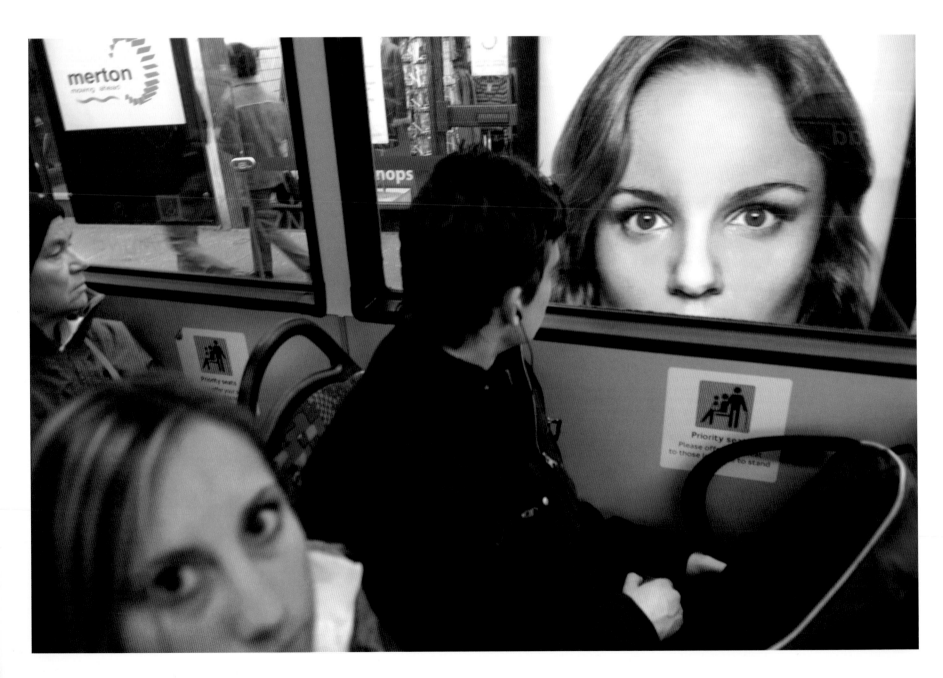

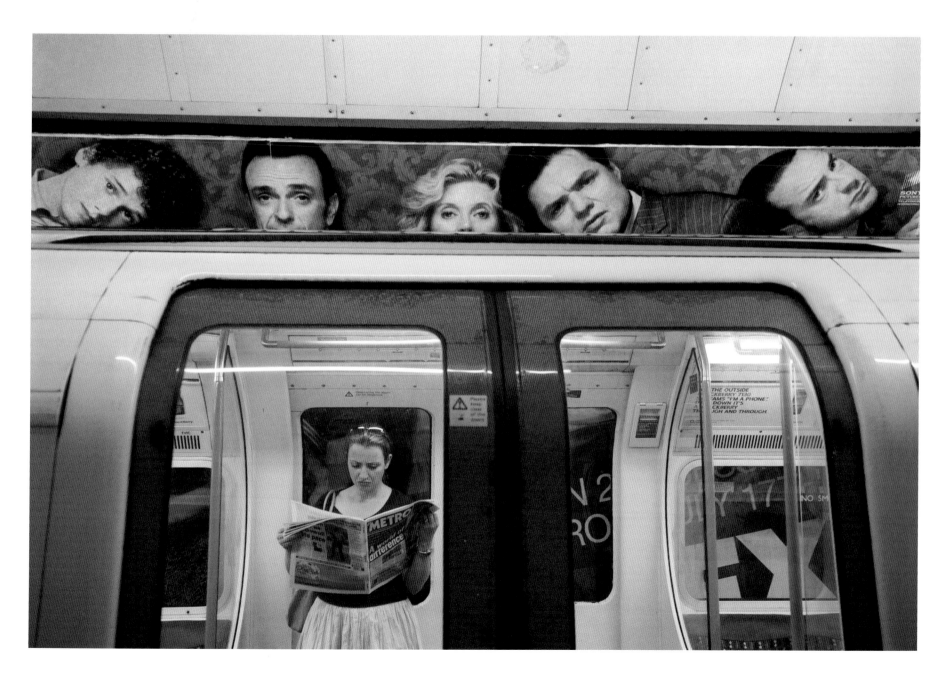

RIGHT:
Knightsbridge,
London, 2004

BELOW:
Notting Hill, London,
2007

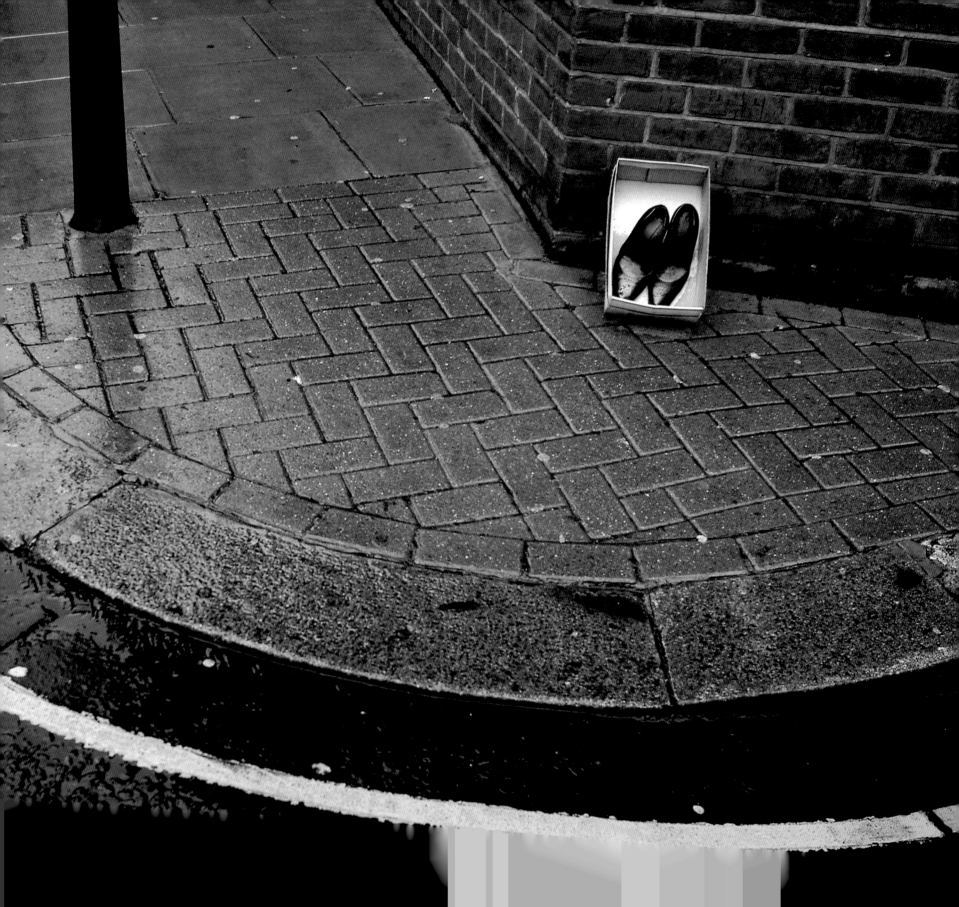

American photographer Richard Kalvar has been a member of Magnum Photos since the 1970s. An extended European trip with his camera in 1966 convinced him to become a photographer. He moved to Paris shortly afterwards and has spent most of his career shooting black-and-white images in the cities of Europe.

Kalvar resists identification with the street-photography genre, arguing that his work is 'not necessarily done on the street. The pictures can be taken on a farm, at the zoo, in an office, and so on.' He prefers to describe his work as 'unposed pictures of people with nothing particularly important going on'. Nothing particularly important may be going on in any one of Kalvar's pictures, but viewed collectively, they leave us wondering what a strange and beguiling planet we live on. In his 2007 book *Earthlings*, a stranger creeps through park foliage, a naked man staggers over a suspension bridge and pigeons fight atop an old lady's hat. Kalvar recognizes that his photographs can never tell the full story of what his camera has witnessed. 'There's a tantalizing, asymptotic convergence between reality and a photograph, but the two never seem to get together. A picture looks like reality but is completely abstracted from it: it's frozen in time, flat, silent, and ignorant of everything outside of the frame. The odor is gone, and sometimes even the color.'

Kalvar's sneaky voyeuristic confections may toy with the notion of reality and representation but he also knows that getting this close and personal to people is bound to arouse suspicions. His method of putting his Earthling subjects at ease is as original and unexpected as the scenes he captures: 'It's slightly dishonest, but I say I'm collecting photons that would disappear anyway.'

'These pictures are about Earthlings, but I'll let you in on a secret: I'm an Earthling myself.'

LEFT:
Luxembourg Gardens,
Paris, 2000

OPPOSITE:
Boulevard Sébastopol,
Paris, 2000

'Let's say we consider the general category of "unposed pictures of people" (or sometimes animals or even inanimate objects when they happen to be possessed by human souls), and then the subcategory "with nothing particularly important going on". If we further narrow it down to the "play" sub-subcategory, we get into the domain I've worked in for forty years. That's what I like to do: play with ordinary reality, using unposed actors who are oblivious to the dramas I've placed them in.'

ABOVE LEFT:
Place de la
République, Paris,
2000

LEFT:
Gare Saint-Lazare,
Paris, 2001

OPPOSITE:
Hôtel-Dieu, Paris,
2000

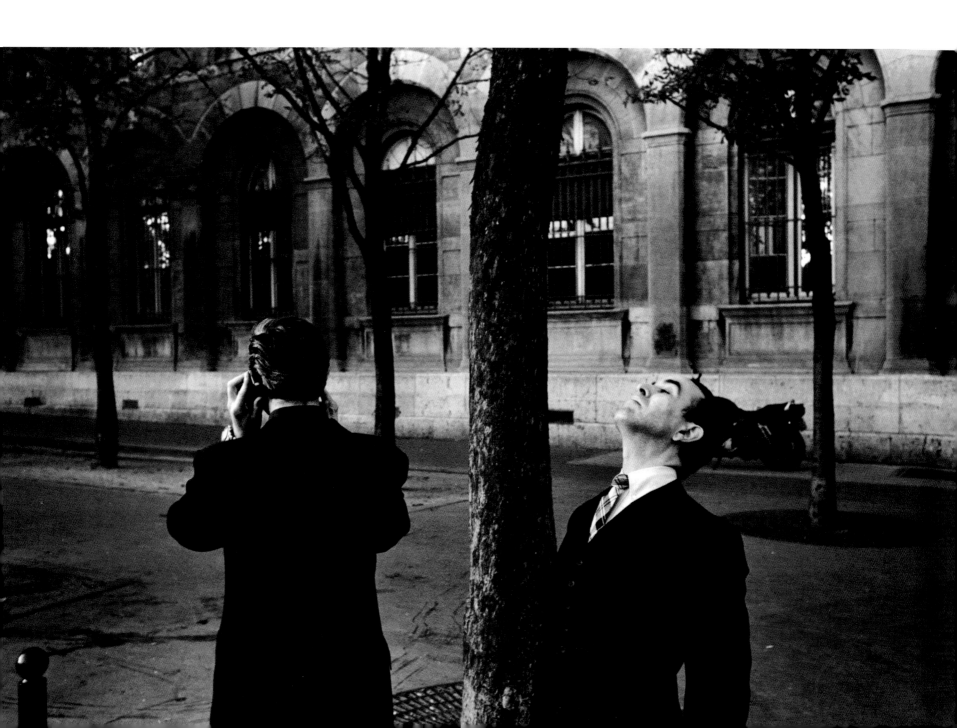

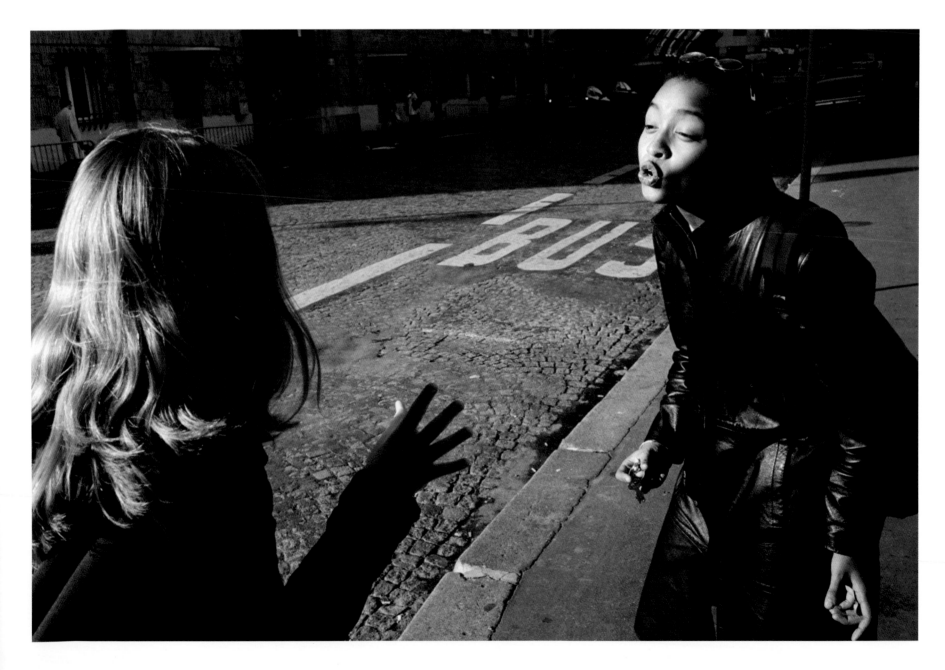

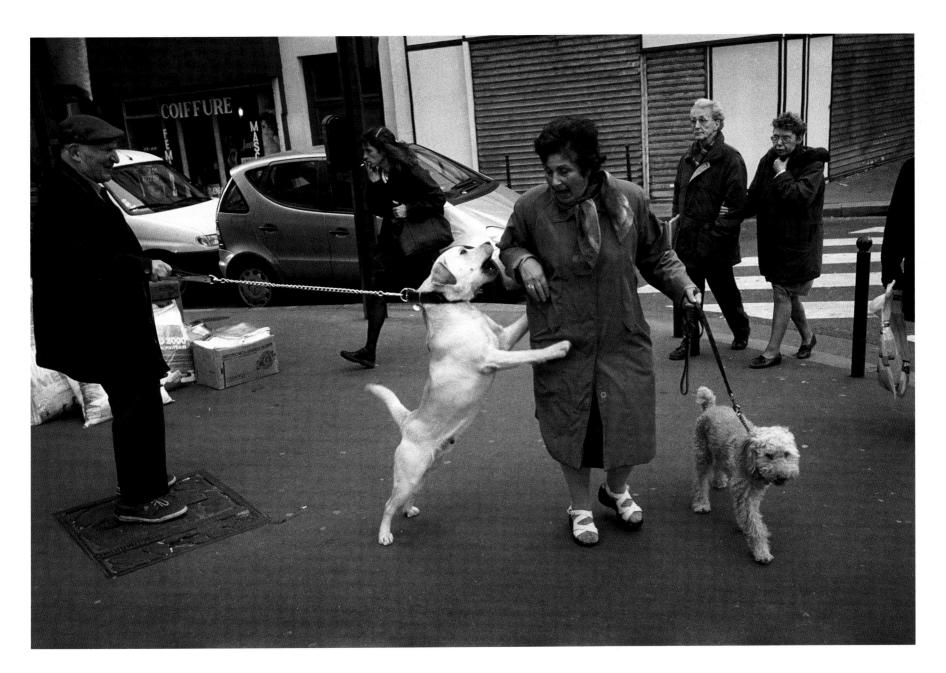

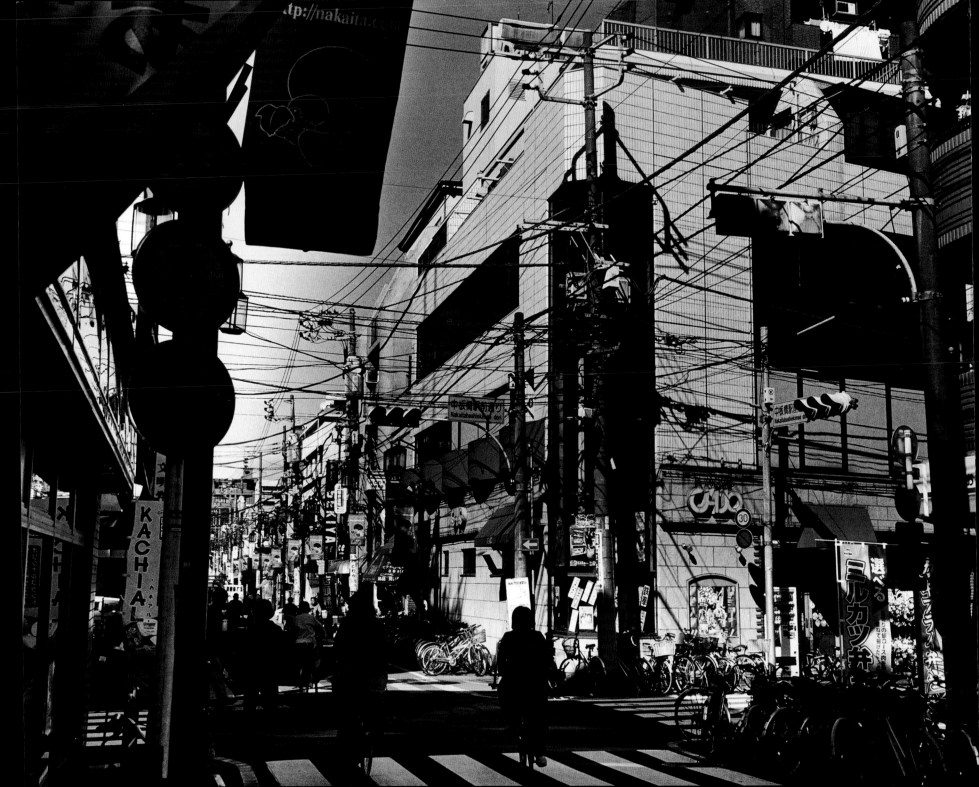

OSAMU KANEMURA

b. Tokyo, 1964, lives in Tokyo

Japanese street photography is a highly evolved artistic tradition that has thrived for thirty years or more within a fertile book-publishing and art-exhibition scene. Internationally renowned figures such as Daido Moriyama have roamed the country's cities bringing back intensely personal and artistic impressions of possibly the most urban-oriented society on the planet.

Osamu Kanemura's monochromatic, hallucinatory images of Tokyo explore the problem of 'knowing' a city that was half-destroyed in a world war and then, in the headlong rush to rebuild, became the largest metropolis in the world. Is Tokyo an architectural entity, a geographical accident or something much more complex?

The dense urban weave that Kanemura's high-contrast photography records may be almost bereft of human subjects but it is saturated with human presence. There is no centre to these pictures, and the large depth of field forces the eye to roam around them trying to work out how each line or form is related to another. The series *My Name is Shockhammer* revels in the information overload and unplanned flux of elements that make up modern Tokyo. Adverts and signage compete with telecom poles, cables and street furniture for our attention. These images depict the city as a web of human relationships, both physical and technological.

Kanemura acknowledges the influence of French photographer Eugène Atget, whose images detailed early twentieth-century Paris. 'I learned from Atget that the camera is a device which will produce something that the photographer cannot control.' Whereas Atget portrayed a historic city centre in the process of being destroyed, Kanemura attempts to capture a city in a constant state of becoming.

RIGHT AND OPPOSITE:
From the series
*My Name is
Shockhammer*,
2007

MARTIN KOLLAR

b. Žilina, Czechoslovakia (now Slovak Republic),
1971, lives in Paris

Nothing Special is the photographic project
that resulted from a mammoth tour around the
'New Europe' by Slovakian photographer and
cinematographer Martin Kollar.

As a photographer with the highly regarded
agency Agence Vu, Kollar has reported from various
parts of the world, but with this project he was
looking for truths closer to home. In his campervan
and on foot he traversed countries like Hungary,
the Czech Republic and Romania, which left the
Soviet Empire after the fall of Berlin Wall and
became members of the European Union.

Kollar wanted to know what this new political
landscape meant for the millions of people whose
everyday lives had been closely proscribed by
the state for decades. How would new economic
opportunities and liberties affect these people,
what would they do for fun, what would their
weekends be like?

Focusing on 'ordinary people during their
nothing-special moments when they are released
from their professional responsibilities', Kollar found
his subjects overwhelmed by the deluge of Western
capitalist culture, yet still able to reinterpret it for
themselves. 'Bombarded with advertising they
never used to have, the people dream of more of
everything, more capitalism, more body-building...
they copy new things, but with their own traditions.'

Led by his instincts along the highways and
byways, Kollar pitched up at sports events, cultural
gatherings and new shopping centres, always on
the lookout for the off-kilter moments that revealed
the changed realities for Europe's newest citizens.

Kollar returned from his journey with a collection
of uproarious slices of life that reveal how people
discovering new freedoms, left to their own devices,
will fill their time in myriad and unpredictable ways.
'Irony is provocative, since it often uncovers the
hidden meanings,' he explains. 'I like merry and
bizarre situations that form a part of everyday life.'

ABOVE LEFT:
Kuks, Czech Republic,
2003

LEFT:
Brno, Czech Republic,
2003

OPPOSITE:
Bratislava, Slovakia,
2003

OPPOSITE:
Čadca, Slovakia,
2004

BELOW:
Nădlac, Romania,
2001

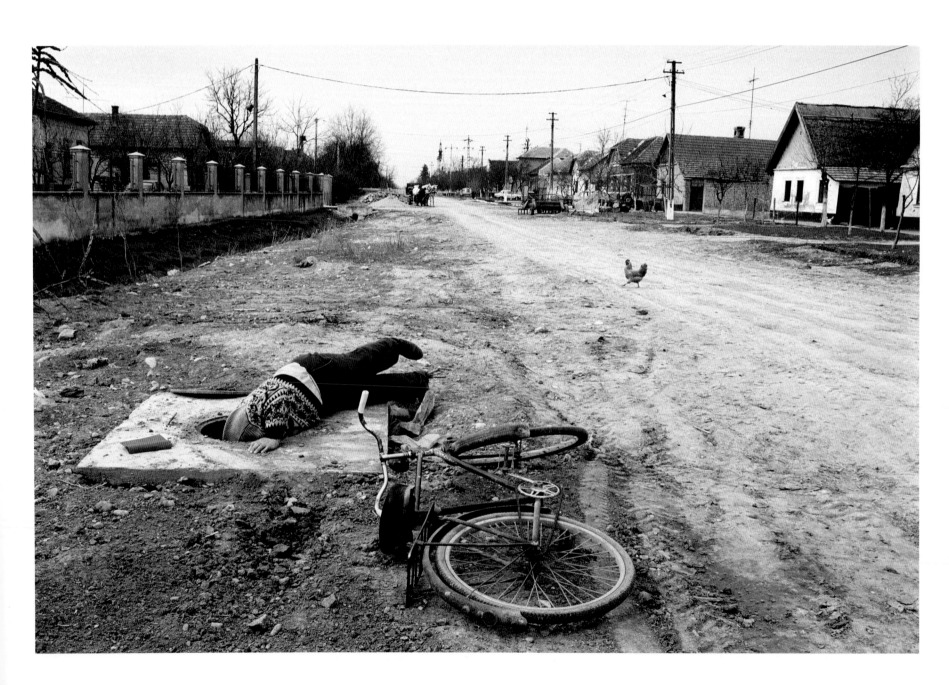

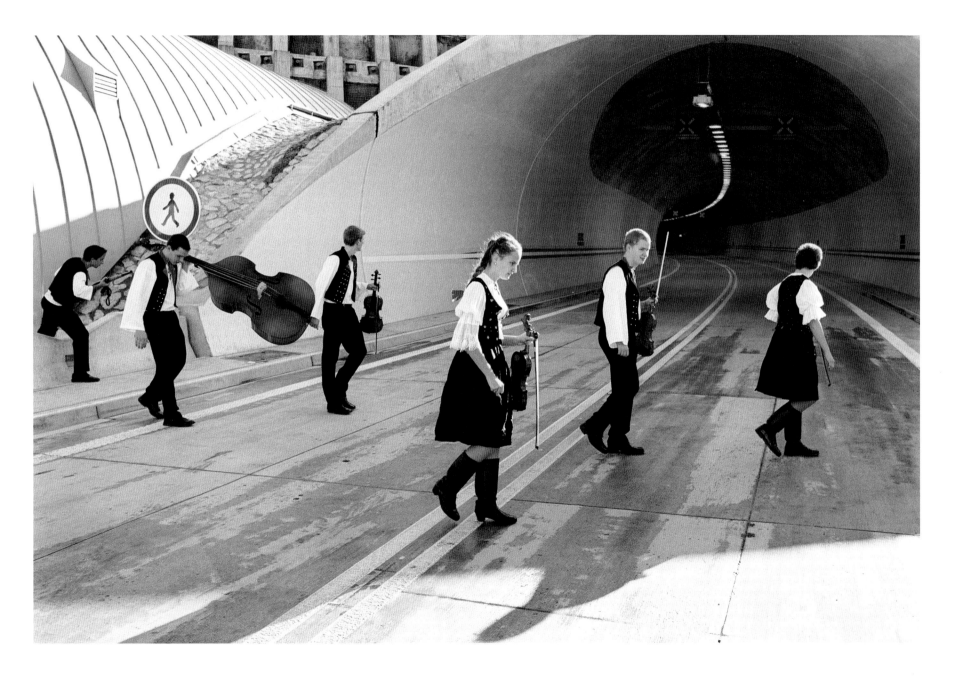

JENS OLOF LASTHEIN

b. Sweden, 1964, lives in Stockholm

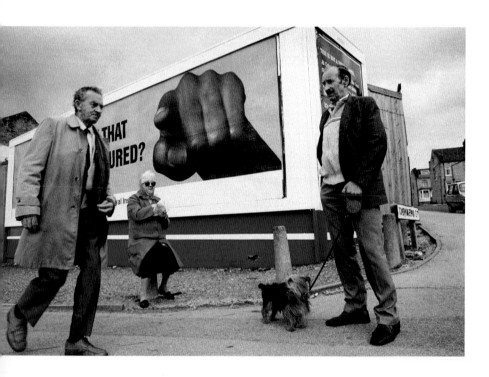

For the last twenty years, Swedish-born photographer Jens Olof Lasthein has immersed himself in some of the most neglected and crisis-riddled regions of the European hinterlands. Whether in the battle-scarred former Yugoslavia, or the post-Soviet Black Sea region, his panoramic-film camera has brought him into close contact with a cross-section of everyday people.

Lasthein's raw and unflinching photographs are the result of long periods of investigation. 'I tend to engage in long-term projects. I like to work slowly and have time to reflect and let things change along the way.' He avoids the smash-and-grab approach of much candid street photography. 'Not many of my pictures are snapshots, most of them will develop during the time I spend with the people I meet, be it fifteen minutes or several hours, or sometimes days.'

Invisibility, that state of grace wished for by many street photographers, is not an option for Lasthein. Even though his subjects seem at ease in his presence, his camera makes it impossible for him to hide what he is doing. He sees this not as a handicap, but a good icebreaker. 'Normally I will approach people by photographing them right away, not talking at all. I need to make my role as a photographer clear both to them and myself. From there the situation can develop in any direction. Sometimes not many words are spoken, and I often find that a good way of maintaining kind of a magic between us. At other times it is of course necessary to talk and then I do. I enjoy hearing the stories of the people I meet.'

Lasthein's panning lens works despite the horizontal limitations that the panoramic format places on his field of view. Sometimes people, or parts of them, will intrude at the bottom or top of a picture and suggest a mysterious event away from the main action. Although these quixotic visual puzzles thrill, it is their lucid moments that elevate them into a serious and emotionally engaging body of work.

'I try to maintain the belief that just what I'm doing right now is the most important thing to do ever. There's no better source of energy than when you feel you have something exciting going on!'

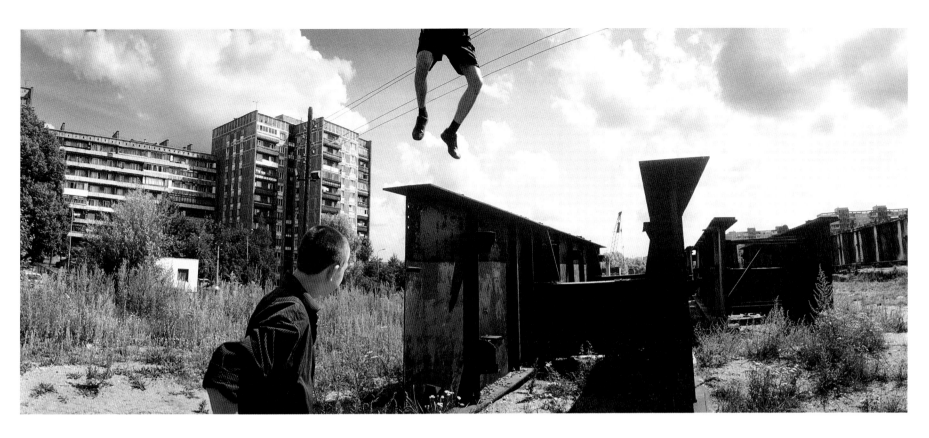

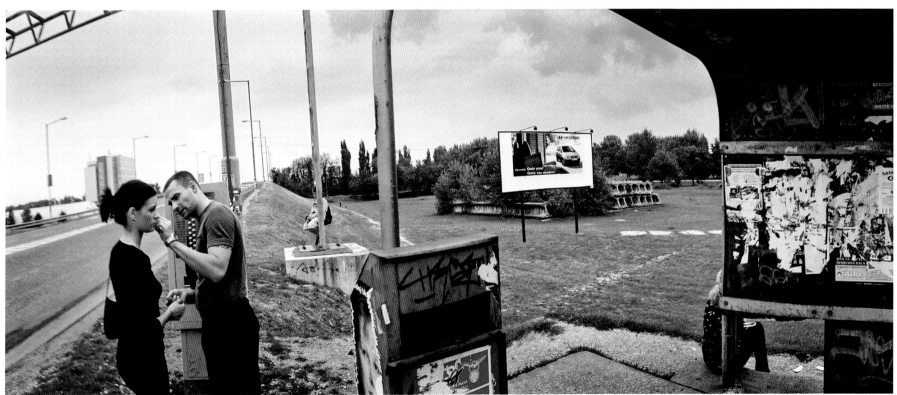

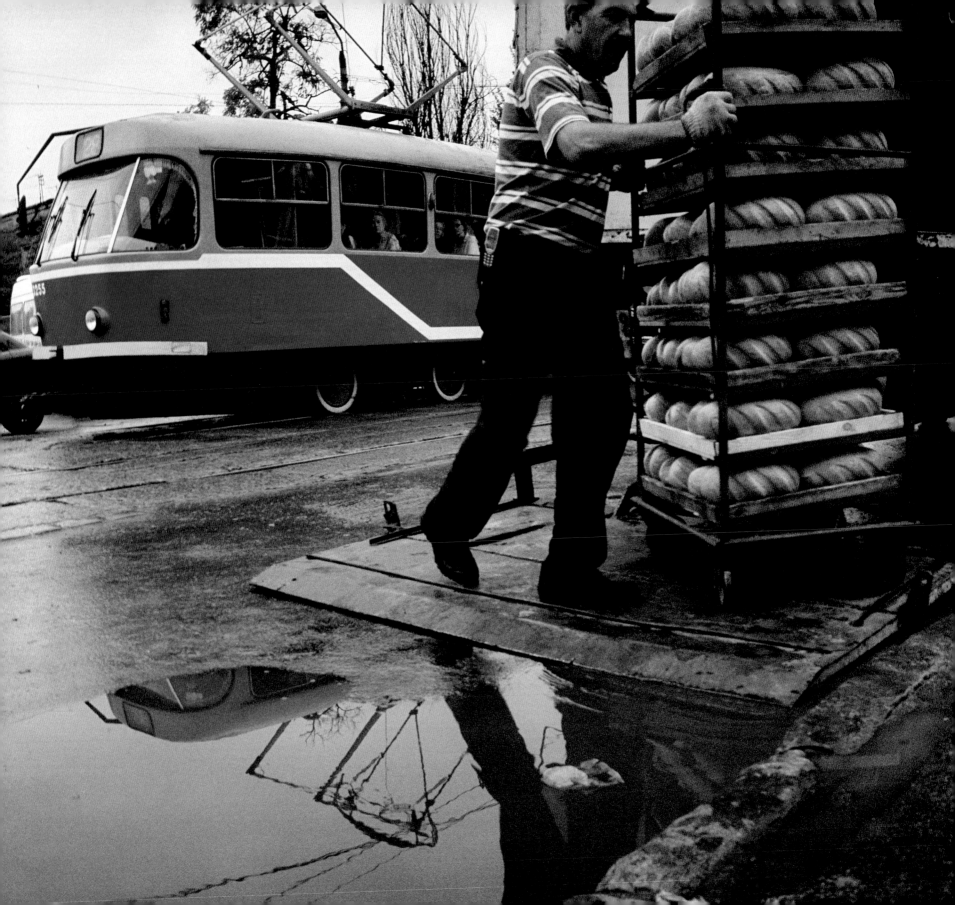

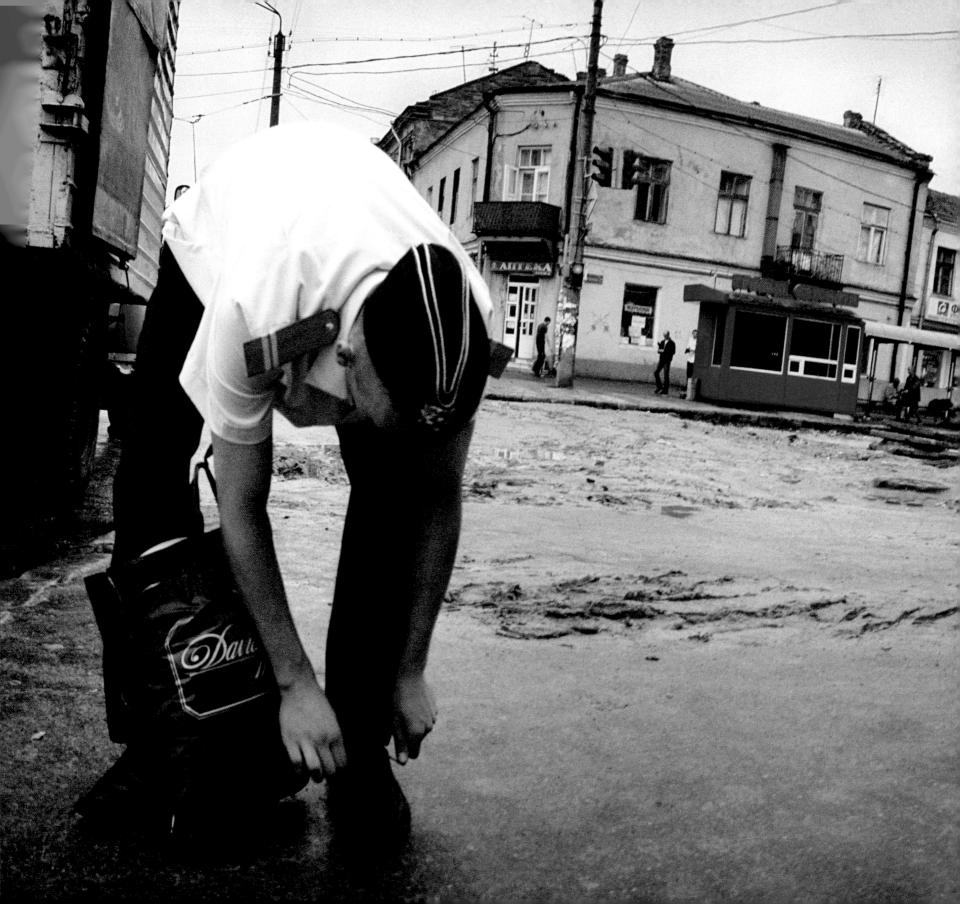

JENS OLOF LASTHEIN: PUTTING YOU IN THE PICTURE

'I TOOK THIS PICTURE AT A PARTY being held by devoted bikers in the Kaliningrad region of Russia. All over the place there were old World War II helmets, Confederate flags, fox tails, plaited beards, you name it. The feeling of being brought back to the 1960s to a real-world scene from *Easy Rider* was overwhelming, and I couldn't help looking around, carefully listening for police sirens, as I couldn't comprehend that this was taking place in Putin's Russia. We drove in a convoy out through the city into the countryside, finally ending up at this ruin, where everything had been prepared for performances of music and theatre. At the gate I met the caretaker of the castle, a sinister and wiry old man with sticky eyes, dressed in a straw hat and Hawaiian shirt, along with his white horse. He just had to be part of some picture.

The music started, and I was soon busy photographing, trying to get some shape out of all of it. And while the situation and the mood was just too fantastic, I knew all the time that I would have a real hard time making good pictures. That is pictures of the kind that I generally want to make, pictures that will tell stories not only about the actual situation in which they are made, but more importantly stories that will lift themselves over that concrete place and situation. In fact the

pictures I am most satisfied with are those where it's not possible to determine where and under what circumstances they were made. Because that's when the mind will start wandering, finding its own interpretations.

I had been photographing the caretaker and his horse in different positions – he had shown me around and we had gradually become friendly – but I wanted to juxtapose him with something else, I just hadn't found out what yet. Then suddenly he came riding across the courtyard, evidently furious that one of the bikers had tried to take control of his precious horse. I tried to follow him but he was too fast, and I was just about running after him again when I noticed that one of the guys I liked the most had grabbed his friend's girlfriend and thrown her over his shoulder. That was a situation I could never have predicted, and it being so ironically barbaric in its own playful way I ran after them instead. And looking at my contact sheets when I came home I realized I must have had some presence of mind left, or at least some intuition, because there in the middle he is, my caretaker on his white horse! And luckily enough I got the girls to the right to give it all some extra perspective.'

Kaliningrad,
2007

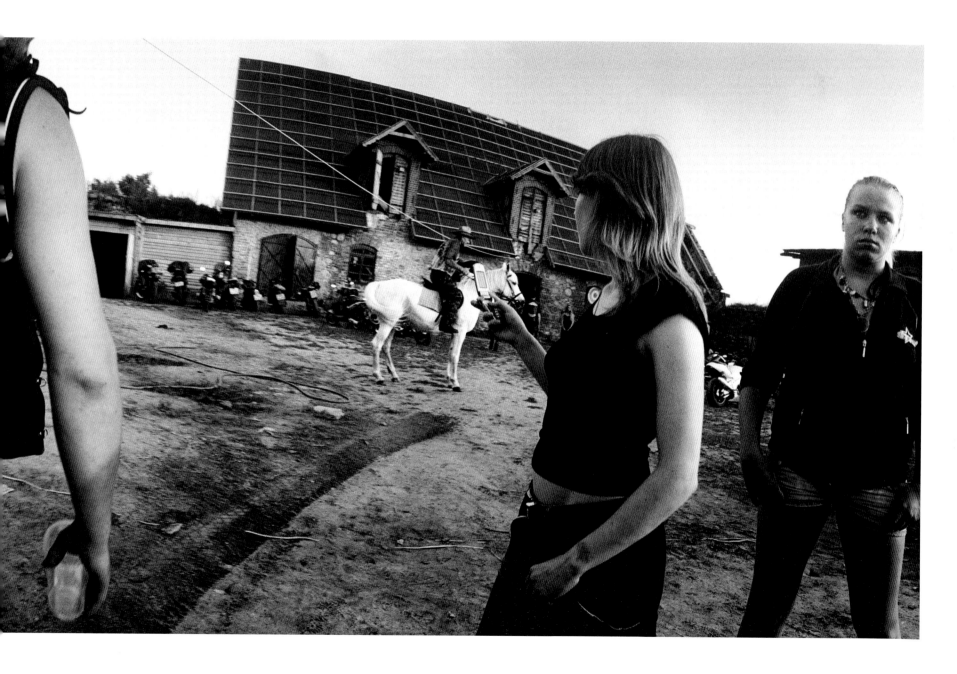

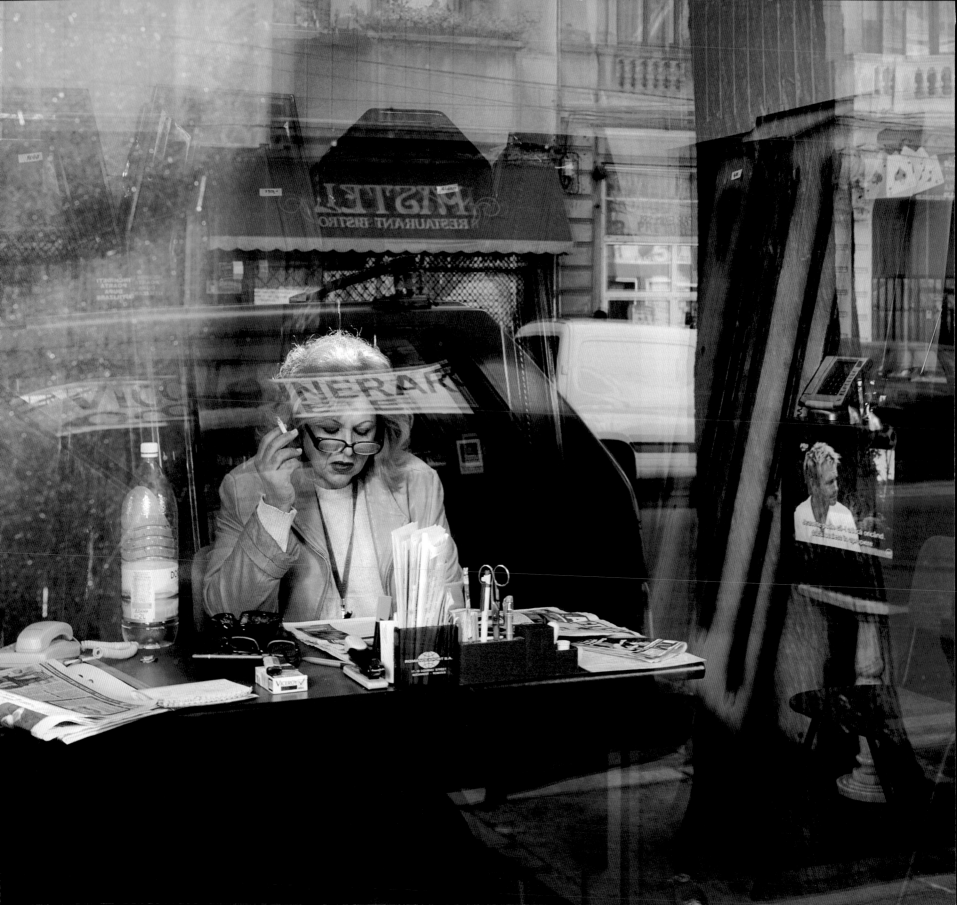

FREDERIC LEZMI

b. Lahr, Germany, 1978, lives in Cologne

'The eye of the passer-by is bluffed at every turn: real and imaginary street scenarios merge'.

Frederic Lezmi's street photography can be understood as a quest to make sense of his own identity. Raised in Geneva, Dakar and the Black Forest by a German mother and a Lebanese father, he is fascinated by the interplay and tensions between Western values and Eastern traditions. In 2003, he set off on a personal pilgrimage with his father to Jordan and Lebanon. It became the first of many journeys that have inspired a body of photographic work exploring how conflict, adjustment and change play out in the streets of Middle Eastern cities. Lezmi has collected this work under the title *Arabian Prospects*, a reference to *American Prospects*, Joel Sternfeld's landmark photographic book from the 1980s.

Arabian Prospects focuses on the urban topography of architecture and public space to show how everyday life is moulding itself in response to economic and social developments in the region. Western values clash with Eastern traditions, but the two are also shown to influence each other in a positive way. 'They are multicoloured, fragmented impressions, like looking through a kaleidoscope,' Lezmi explains of these images. 'The viewer's eye is being multiplied, inverted and divided in order to put on trial and call into question the perception of cultural differences and their importance for the present and the past of our society.'

In 2007 Lezmi continued his work on *Arabian Prospects* in Dubai. The infamous artificially created metropolis was in many ways an obvious destination for his project. 'Dubai seems to me an illusionary promise somewhere between a utopian mirage and the beginning of a globalized nightmare, where an oriental identity is on the verge of getting lost in ultimate high-tech extravagances.'

ABOVE RIGHT:
Urfa, Turkey,
2008

RIGHT:
Sarajevo, Bosnia
and Herzegovina,
2008

OPPOSITE:
Bucharest,
Romania, 2008

JESSE MARLOW

b. Melbourne, 1978, lives in Melbourne

Jesse Marlow is a Melbourne-based photographer whose interest in street work was seeded young. He began taking pictures at the age of seven, collecting images of the brightly coloured graffiti walls that were starting to appear in Melbourne. 'I've always loved the element of chance and the spontaneity of street photography,' he recalls. 'The idea that you can leave the house with nothing one morning, and by the end of the day have a photo that will be with you forever excites and drives me.'

When he found himself with a broken arm after an accident playing football, and temporarily unable to operate his camera, Marlow started to notice how many people were navigating Melbourne with injured limbs. His bandage-bound book *Wounded* was the result of this acute piece of social observation. 'I became an expert at spotting someone in a crowd with a broken arm or some such injury. My aim with the project was to show that despite people suffering obvious superficial injuries, human beings dust themselves off and get on with life. It became an unhealthy obsession for the rest of my photography, as for two years all I saw when I left the house was injured people.'

Marlow then took his photography in a radically different direction. 'After spending two years shooting the *Wounded* series, which was black-and-white and somewhat confrontational at times, I've stepped away from busy scenes of people. My latest series has become more graphic and simplistic in my use of colour and I find I'm aiming for more complex photos in their interpretation.' In addition to his switch to colour photography, Marlow is now looking for something different and more elusive in his Melbourne walkabouts. The images in his ongoing project, *Don't Just Tell Them, Show Them*, are much harder to decipher than the *Wounded* series. Melbourne's harsh sunlight is used to maximum effect to create images with deep shadows, and heavily saturated colour backdrops often reveal people behaving in ways that can only be described as suspicious. Under all that solar-flaring technicolour a sense of implausibility radiates from these scenes, encouraging the viewer to ask: 'Am I seeing things?'

ABOVE:
Wounded #37,
Melbourne, 2005

BELOW LEFT:
Wounded #4,
Melbourne, 2004

BELOW RIGHT:
Wounded #17,
Melbourne, 2004

BOTTOM LEFT:
Wounded #28,
Melbourne, 2005

BOTTOM RIGHT:
Wounded #23,
Melbourne, 2004

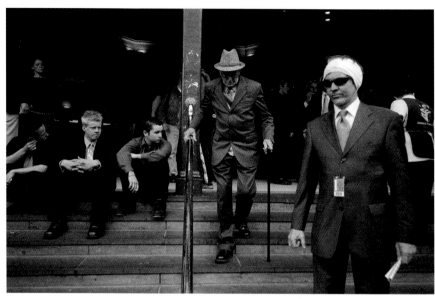

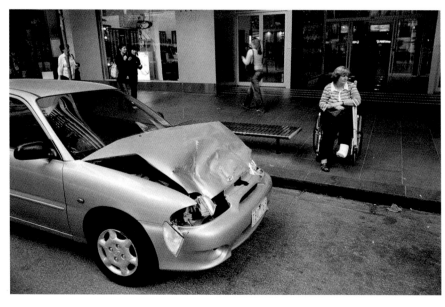

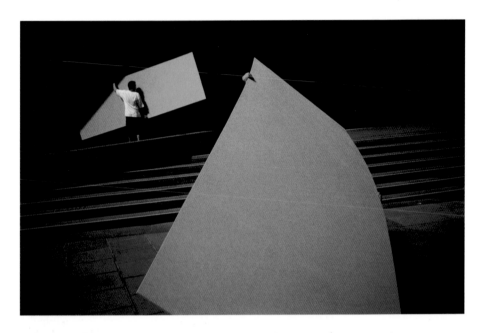

'Street photographers
never switch off. You
have to be constantly
on the lookout for the
unreal moment in the
everyday.'

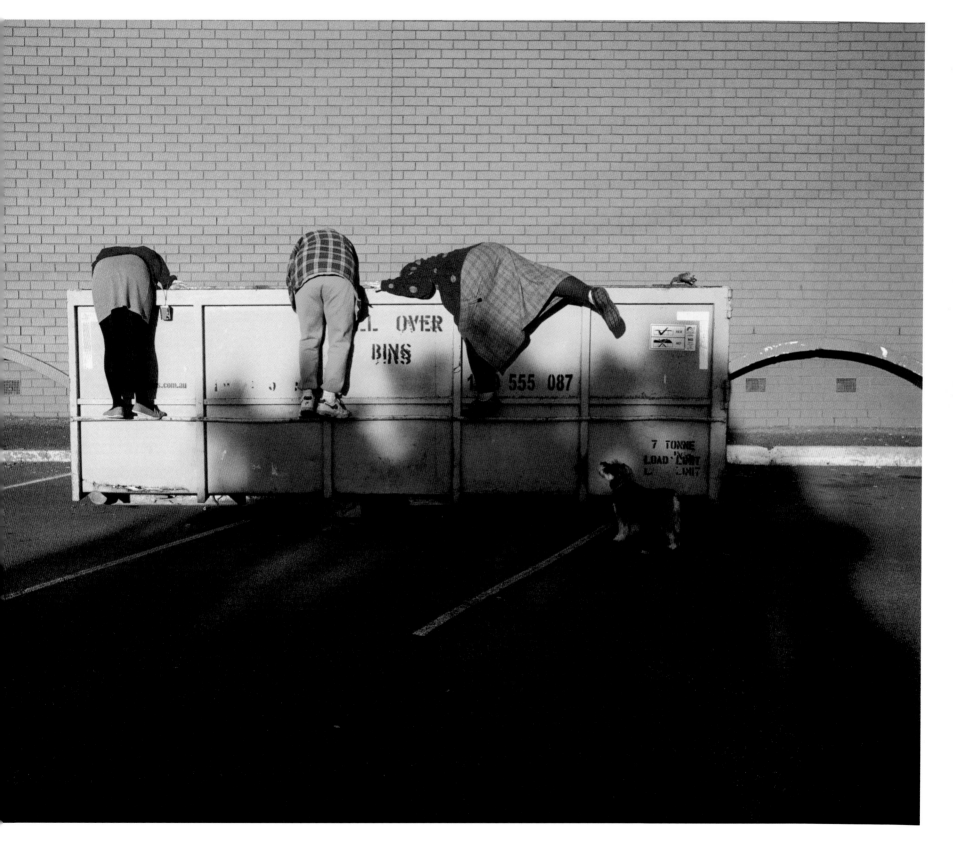

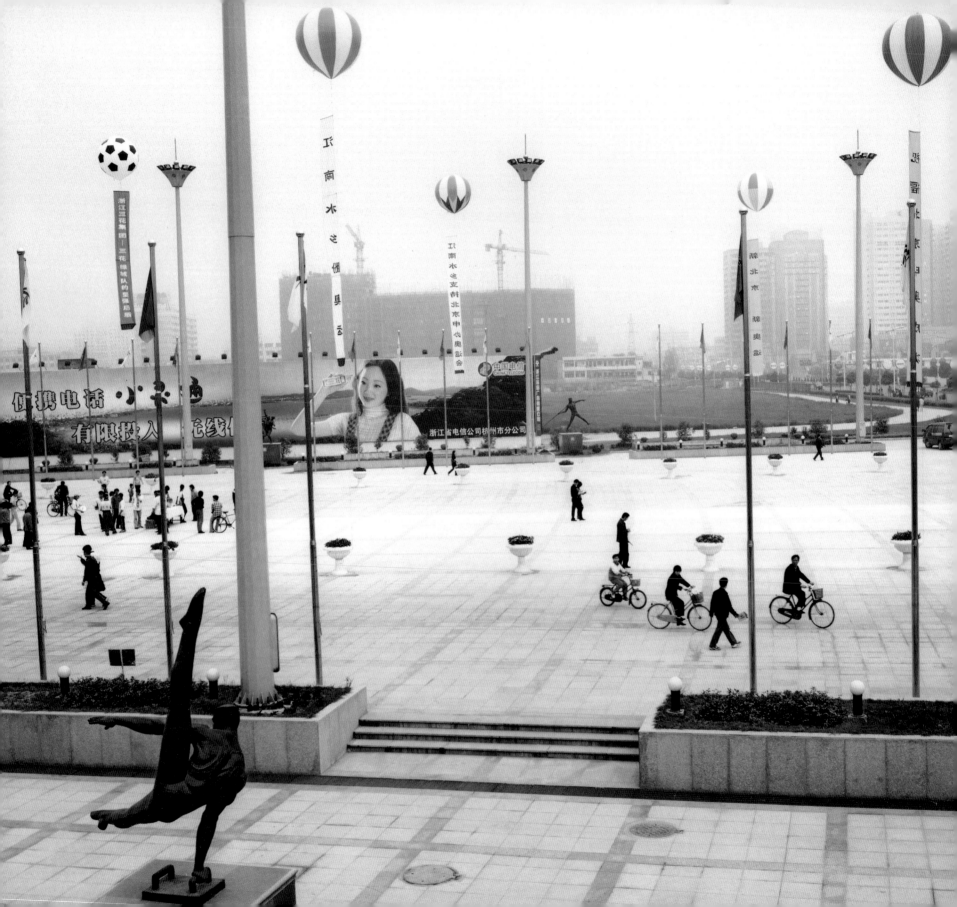

HALF OF THE WORLD'S POPULATION NOW LIVES IN CITIES

For much of the twentieth century street photography's soul seemed bound up in just two cities: Paris and New York. At the start of the twenty-first century, as many of the world's oldest cities adapt at breakneck speed to the effects of international migration and new technology, and new cities rise up almost instantaneously from deserts and floodplains, the practice of street photography has become a global phenomenon.

In 2008 the United Nations estimated that for the first time in human history more than half of the world's population lived in cities. That proportion is expected to reach 70% by 2050. As the American sociologist Richard Sennett observes, modern cities are more often than not badly run, crime-infested, dirty and decaying, yet they exert a seemingly inexorable magnetism.

Armies of architects, planners, investors, academics and politicians are busy creating master plans for today's cities, drafting laws and coming up with new ways to tackle increasingly complex issues around urban transport, housing, pollution, tourism and social inclusion. Street photographers take a different, more oblique approach than these professionals. As inveterate people-watchers they demonstrate exceptional insight about the way we behave in public spaces as well as how cities are adapting – by accident or design – to our behaviour. They are among the keenest observers of how problems such as overcrowding or racial intolerance play themselves out on city streets. Their images offer power evidence about the kinds of environments we are creating for ourselves.

The street photographer is the archetypal *flâneur*, an urban type popularized by the French poet Charles Baudelaire in the mid-nineteenth century, around the same time that photography itself came into popular circulation. Baudelaire defined the *flâneur* as 'a botanist of the sidewalk', an apt description for most of the photographers in this book. Often juiced up on caffeine and invigorated by the contingencies of life on the pavement, street photographers collect visual samples from pollution-ravaged intersections or quiet back alleys, returning home to review, order and sequence them.

There have always been street photographers whose hometowns are their main source of inspiration. Bruce Gilden, Matt Stuart, Jesse Marlow and Osamu Kanemura are among those who make their best work in the streets most familiar to them. Bangladeshi photographer Munem Wasif explains of the images he has made in Dhaka, 'I live here. It is almost like trying to find the unseen within the everyday.' Dutch photographer Otto Snoek expresses a similar sentiment: 'The Netherlands happens to be my native country and Rotterdam my hometown. A rough modern harbour town, a turbulent past and present: although it all is well-known to me, it is still fascinating.' But for other photographers, such as Alex Webb, Mimi Mollica, Frederic Lezmi and Thierry Girard, being an outsider in a city enables them to look at it with fresh eyes. 'I only work on projects when I travel,' explains Lezmi.

Paris and New York

For many years Paris and New York were the urban centres of street photography. Photographers such as Henri Cartier-Bresson, Brassaï, Robert Doisneau, Lee Friedlander, Garry Winogrand and Helen Levitt created the definitive visual impressions of these cities. Cosmopolitan in very different ways, Paris and New York provided both fertile hunting grounds and elegant backdrops for people-watching. Their city centres were stylishly designed – Paris as a series of radiating grand boulevards, New York as a modernist grid – and dense enough for public life to flourish at street level. Both cities exuded confidence, Paris sure of its status as one of the most beautiful cities in the world, New York proud of its cultural diversity and architectural daring. These were cities that knew how to pose and seemed to enjoy having their portraits taken. But their dominance in street photography has since waned. For many photographers, Paris by the 1960s had become a pastiche of itself, a city

OPPOSITE:
Thierry Girard, from the series *Jours ordinaires en Chine*, 2001

BELOW:
Gus Powell's business card

Visual Entrepreneur International Flâneur

Mr. Gus Powell

59 Warren Street, 6th fl.
New York, NY 10007
www.guspowell.com gus@guspowell.com

so self-consciously chic and weighed down by photographic history that it seemed almost impossible to make original images there. New York, whose photographic heyday came later – from the late 1950s to the mid 1970s – fared somewhat better. Confidence seeped from the streets in the 1980s when crime rates soared and many wealthier citizens retreated to the suburbs in search of a better quality of life, leaving behind a city thick with hard-bitten characters, a place where you could thrust a camera right up into someone's face and only be accused of being as irritating as the next guy. For the likes of Bruce Gilden, Jeff Mermelstein, Melanie Einzig and Gus Powell, working as a street photographer in New York today means confronting an

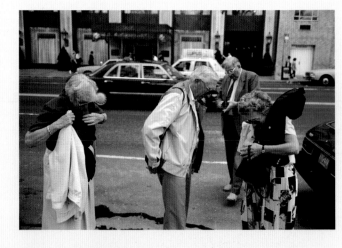

awesome photographic legacy, but all four insist that there is still no other city in the world that can compete with the diversity of its inhabitants and the density of unexpected incidents unfolding on its streets. 'Like members of a secret society, teeming pedestrians march in a parade of broken cadence to countless tunes, in all directions, for every reason,' says Gus Powell.

London
The city that decisively took up the mantle of street photography from Paris and New York was London. Throughout the twentieth century London was home to a number of extraordinary street photographers, including Bill Brandt, Nigel Henderson and Roger Mayne, and was documented by many others, including Robert Frank and Sergio Lorrain, who passed through it, although a street photography community as such never established itself. London is a tricky city to pin down visually: it is vibrant but not elegant, functional but not coherent, a global metropolis without the immediately recognizable 'look' that Paris and New York have. For many of the photographers working in the British capital, its resistance to cliché is a considerable part of its photographic appeal.

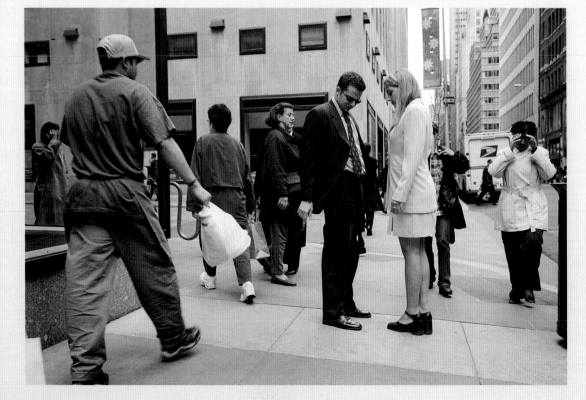

'Cities can be badly run, crime-infested, dirty, decaying. Yet many people think it worth living in even the worst of them. Why? Because cities have the potential to make us more complex human beings. A city is a place where people can learn to live with strangers, to enter into the experiences and interests of unfamiliar lives. Sameness stultifies the mind; diversity stimulates and expands it.' **Richard Sennett**

Today London is reaching for the stars but creaking at the seams. It is a city of global financial and political importance and an international centre of artistic and celebrity culture, but its Victorian sewers and turn-of-the-century subway system stagger along in a perpetual state of crisis. It is estimated that London will attract 800,000 more people over the next ten years, and the ways in which these newcomers accommodate themselves within a city whose original walls are over 2,000 years old is certain to be a source of fascination for photographers. Nick Turpin's image of a man walking down Broadgate carrying a giant stress ball (p. 211) and Matt Stuart's close-up of a worn blonde shielding her eyes from the sun (p. 190) suggest that many of London's residents, like the city itself, seem to be both suffering from the pressure and thriving on it.

London's exceptional ethnic diversity, coupled with the infamous British reserve, makes for a curious mixture of difference and indifference among the city's twelve million residents. Nils Jorgensen takes unique advantage of this characteristic in three images taken at various train stations across the capital. In the first a man in a poncho and sombrero queues up to buy a ticket, the stripes of his clothing echoing the barrier tape to form

a striking graphic composition. This character seems absurdly out of place – as if he's just arrived from Mexico by magic carpet – yet no one in the queue bats an eyelid. The confusion, energy and alienation of urban life find more abstract form in a photograph taken at Waterloo Station in Central London (p. 84). At first glance the scene appears much more dramatic than it is: strange colours reflected from the station's artificial lights make a broken bottle of red wine look like spilt blood. As the rush-hour crowds carefully step over the mess, their indifference seems peculiarly heartless.

The third photograph shows urban indifference in a more positive light. Centre stage are a young woman chewing her hair and a well-dressed man kneeling to use the station concourse as a temporary desk as he writes down information given to him on his mobile phone. Behind him a middle-aged woman rummages to find something in her handbag. Between these three is a sign advertising 'excellent job opportunities'. Here are six urban characters who share the same public space for a split second but whose lives never meaningfully cross. It's a photograph about anonymity and the possibility of finding solitude in the crowd; as such, it sums up the best and worst aspects of cosmopolitanism.

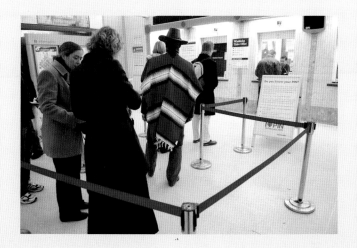

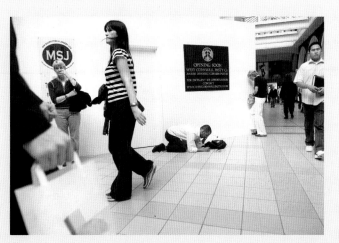

LEFT:
Nils Jorgensen, Fulham, London, 2006

FAR LEFT:
Nils Jorgensen, London, 2006

119

RIGHT:
A computer-generated
poster advert for a new
suburb in Istanbul,
2007

OPPOSITE ABOVE LEFT:
George Georgiou,
Istanbul, 2007

OPPOSITE ABOVE CENTRE,
OPPOSITE ABOVE RIGHT AND
OPPOSITE BELOW:
Frederic Lezmi Dubai,
from the series *Arabian
Prospects III*, 2007

Jorgensen, Stuart and Turpin are all members of the
In-Public street photography collective, whose London
membership is particularly strong. Turpin, who founded
the group, explains the allure of the British capital from
the photographers' perspective. 'London is one of the few
cities in Europe big enough and varied enough to provide
an endless supply of subject matter for the street
photographer. My heart races when I step onto a London
pavement. You can immediately sense the photographic
potential, every corner and square is rich with
possibilities.'

Istanbul

Like London, Istanbul has a long photographic history.
Since the nineteenth century, photographers have been
attracted to the elegant patchwork of waterfronts,
alleyways and minarets that characterize this ancient and
strategically placed city. Although Istanbul is the capital
of a Muslim country, with all that implies for concerns
about public modesty and restraint, candid photography
has been tolerated for decades. Ara Güler's moody
pictures of street life in his home city were widely
published in the 1950s and 1960s, earning him the
nickname 'the eye of Istanbul'. Building on Güler's
legacy, American photographer Alex Webb and Turkish
native Arif Asci are among those who have recently
explored the rich photographic possibilities offered by
Istanbul's many layers of history and culture. Their
images show a progressive, increasingly international
metropolis where beasts of burden still tramp the ancient
streets and the world's oldest shopping mall, the Grand
Bazaar, remains proud to operate on the basis of barter.
For Webb, Istanbul's many layers make it endlessly
alluring, yet difficult to fathom: 'It's a border city that
encompasses both Asia and Europe, the ancient and the
modern, the religious and the secular. As I wander the
narrow twisting streets of the Fatih district, I feel like I
am in the realm of the Ottomans. On the western edge of
the city, in the bitter rain and snow of winter, I seem to be

in Barcelona. And around the Eyüp mosque, the burial
place of Muhammad's flag bearer, I am immersed in
Islam. Istanbul's blend of civilizations and its cacophony
of images fascinate and inspire me.' Webb's book
Istanbul: City of a Hundred Names presents a dynamic
portrait of a city in flux. Many of the photographs show
children – pointing, jumping, playing with toys or
dangling precariously from makeshift climbing frames.
Other images hone in on groups of men or women
chatting, smoking, waiting for buses or ferries, or eyeing
up the latest fashions. Women in headscarves share
the same public space with boys wearing only their
swimming trunks, while cinema posters, clothing ads
and pizza signs cover the crumbling walls of historic
buildings.

In recent years there has been a huge population
influx into Istanbul from rural Turkey. George Georgiou
has documented the city's developing suburbs, represented
by mile after mile of unprepossessing concrete apartment
buildings. A far cry from the architectural splendour
of the historic city centre, such places offer a pathetic
backdrop to the hopes of so many who arrive there.
Although computer-generated images of the promised
new developments show members of the community

collectively enjoying vibrant public spaces (*opposite*) the reality (*above*) is often eerily bland.

Dubai

Like its predecessor Las Vegas, Dubai has reimagined itself as a destination for international visitors with cash to burn in its air-conditioned pleasure domes. It is no coincidence that Dubai, like Vegas, arose in a desert, where the arid ground is perpetually ripe for scorched-earth redevelopment.

The extreme artificiality of Dubai presents an unusual challenge for street photographers. The hallmark of the genre has always been its honest documentation of public life, but when cities become little more than branded constructions designed to attract investment, the search for authenticity on their streets can seem futile. Dubai, although among the fastest-growing cities on the planet, has produced few if any home-grown street photographers. But German–Lebanese Frederic Lezmi has

taken on the challenge of documenting the ersatz public realm that has been conjured out of the sand. 'The structures of metropolitan life in Dubai are solely created in think-tanks, design labs and architecture studios,' he explains. 'They no longer result in the natural use of public spaces. Formal structures replace social ones.' Lezmi's photographs emphasize the smoke-and-mirrors character of the city by focusing on half-constructed environments, reflections, hoardings and advertisements. Lezmi also goes 'backstage' to show the transient communities of migrant labourers who toil for minimal pay in extreme heat to propagate this concrete and glass confection.

Shanghai and Shenzhen

No country in the world has experienced such dramatic urbanization in the past twenty years as China. Following the introduction of a market economy in the 1980s, both new and old cities have grown at an unprecedented rate, with high-density skyscrapers sprouting up beside gargantuan traffic intersections. Photojournalists working in China tend to favour epic images of colossal shipyards, mass-transit systems and teeming workforces, but the street photographs of Ying Tang and Polly Braden offer more intimate glimpses of ordinary life.

In 2008, Braden was commissioned by *Icon* magazine to document the new Chinese city of Shenzhen, which in just thirty years has evolved from agricultural landscape to industrial powerhouse to post-industrial city, and now boasts a population of over thirteen million. Shenzhen is a parasite city, sitting just across the water from Hong Kong and feeding the capitalist wealth of its neighbour. As architectural critic Justin McGuirk has written: 'It is a metropolis with a human lifespan, maturing at the same pace as its citizens. And those citizens are young, like the city itself – the average age here is under thirty. In the commercial hive of Dongmen, the streets teem with urbane, Converse-wearing teenagers. In a sense,

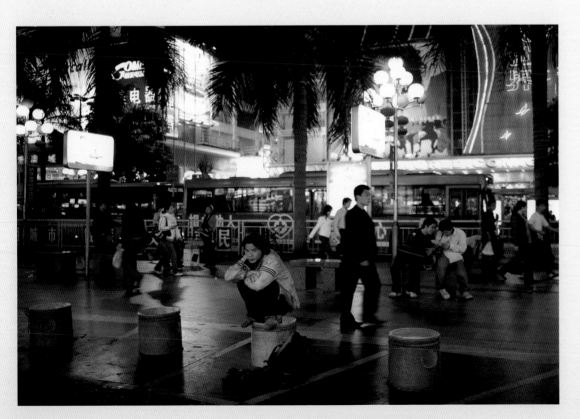

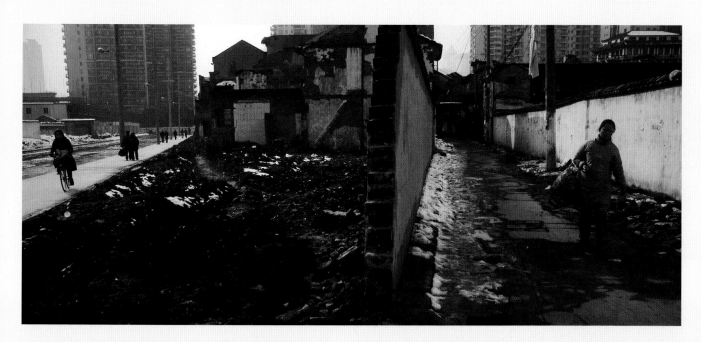

Shenzhen is a hormonal teen, changing in real time.' As part of the commission, Braden photographed the Window of the World leisure park in the west of Shenzhen. Here, the leisure classes of the new city can enjoy what the brochure calls 'the cream of world civilization', wandering from the Eiffel Tower to Angkor Wat, picnicking outside Dutch gabled houses and having their pictures taken in front of the Egyptian pyramids or the Taj Mahal. Shenzhen residents, it seems, need no longer travel to the great cities of the world – those cities have travelled to them.

Tang explains why in the throes of so much change Shanghai lends itself so well to street photography: 'People aren't concerned about what they should or shouldn't do in public. Many of them live in very small spaces, they spend a lot of time on the street, playing, studying, eating, sleeping and socializing. Life here is like an open book.' Her Shanghai project *Building The Future* depicts the constant construction as a backdrop to everyday comings and goings. Residents walk, cycle, talk

or rest in the shadow of vast new developments; hard hats sit alongside bundles of laundry. The impression is of two very different worlds, which coexist but barely interact.

Half of the World's Population Now Lives in Cities

Where communities once measured themselves against the rival across the valley, vast modern conurbations now compare themselves to metropoles across the ocean. They are increasingly surveyed by CCTV or navigable on Google Street View. In contrast to such impersonal visions of cities, the view of urban living offered by street photographers is deeply personal, shaped by the contingencies of curiosity and emotion, by confidence or fear when walking out in public, by enthusiasm or fatigue depending on the time of day, by a sense of belonging or alienation, influenced by race, gender and nationality. It is a uniquely human way of looking at the world, and cities, we sometimes need to remind ourselves, are designed for humans to live in.

ABOVE LEFT:
Ying Tang, Yu Garden,
Shanghai, 2008

ABOVE RIGHT, TOP:
Ying Tang, Qibao,
Shanghai, 2007

ABOVE RIGHT:
Ying Tang, near Suzhou
Creek, Shanghai, 2007

BELOW:
Untitled,
New York City,
1992

OPPOSITE:
Untitled,
New York City,
1995

JEFF MERMELSTEIN

b. New Brunswick, New Jersey, USA, 1957,
lives in New York City

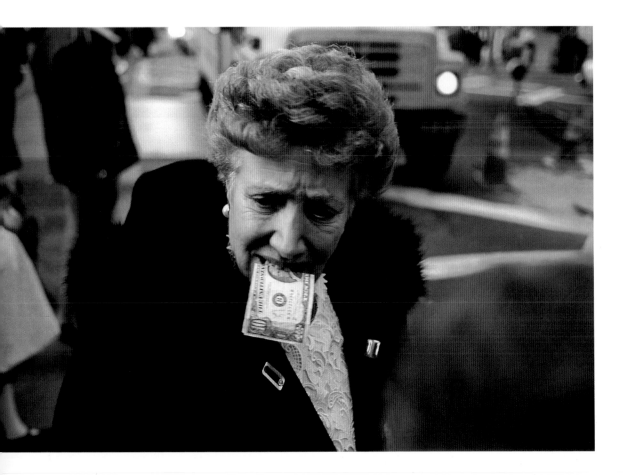

'It's exciting to make something
extraordinary out of the banal.'

'Ugly can be beautiful,' Jeff Mermelstein asserts.
'Paris may be beautiful but I prefer New York
because there's a certain kind of craziness,
neuroses in the air, a temperament on the street:
it's just an endless vat of information.' It's hard to
imagine him ever tiring of the city that he has made
his home for nearly thirty years. He's still out every
day, pacing the length of the big avenues, sniffing
out moments of everyday life both ordinary and
bizarre. 'It's exciting to make something
extraordinary out of the banal. I'm not the kind
of photographer who needs to travel to make
pictures. If I went to Gaza I'd probably get sick
and be scared.'

Though he grew up only an hour away, in
suburban New Jersey, Mermelstein describes his
arrival in New York City as having been like landing
on Mars. He was suddenly surrounded by an
endless cast of characters – tourists, vagrants,
dog walkers, protestors – crammed into the same
public spaces. Far from being an outsider,
Mermelstein now sees himself as a signed-up
member, part of the whole mess. He is alert to the
catalogue of small gestures – a girl twirling her hair,
a man pulling up his trousers, a woman clutching a
ten-dollar bill in her mouth to free up her hands –
that speak volumes about the kind of society New
Yorkers have made for themselves.

The turbulence of Manhattan affords
Mermelstein a crucial anonymity. He can thrust
his camera in people's faces and get away with it
knowing either he or his subject will have melted
into the crowd before any dispute can erupt.
He works on instinct: 'I don't think too much.
I just take pictures. I've got to be quick. Because
if I'm not quick, then it's gone. I don't get releases
on the street. You couldn't do the kind of
photography I do by speaking to the people before
you take the picture.'

Mermelstein never crops an image in the editing
process and continues to work exclusively with film,
rather than digitally. He likes the element of surprise
that comes from having to wait until the rolls come
back from the developer before he knows whether
he's got something good. 'When I'm looking at the
rolls of film on the lightbox, it's like taking the
picture for the first time again.'

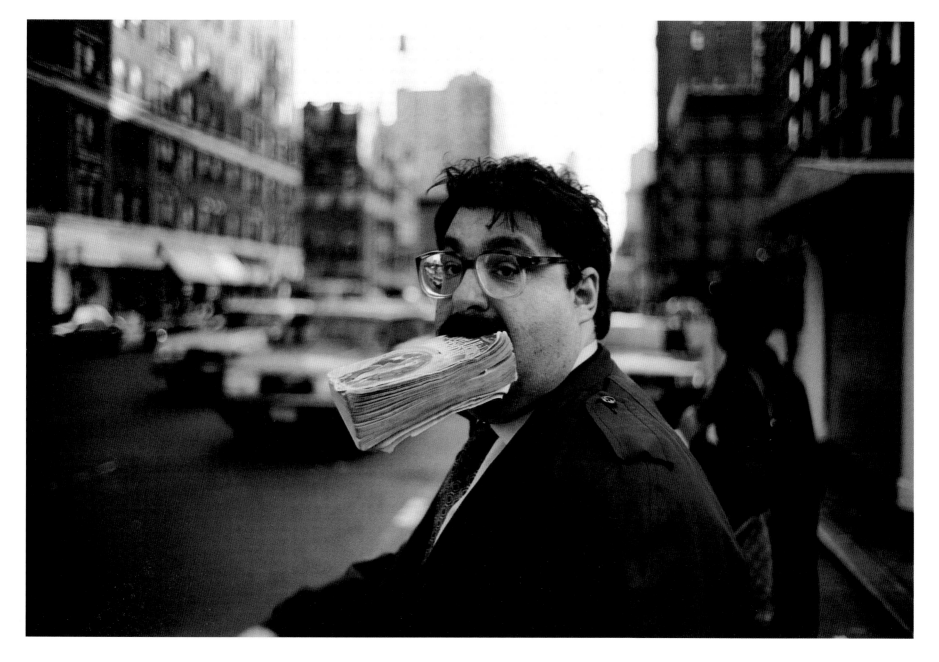

OPPOSITE:
Untitled,
New York City,
1997

BELOW:
Untitled,
New York City,
1995

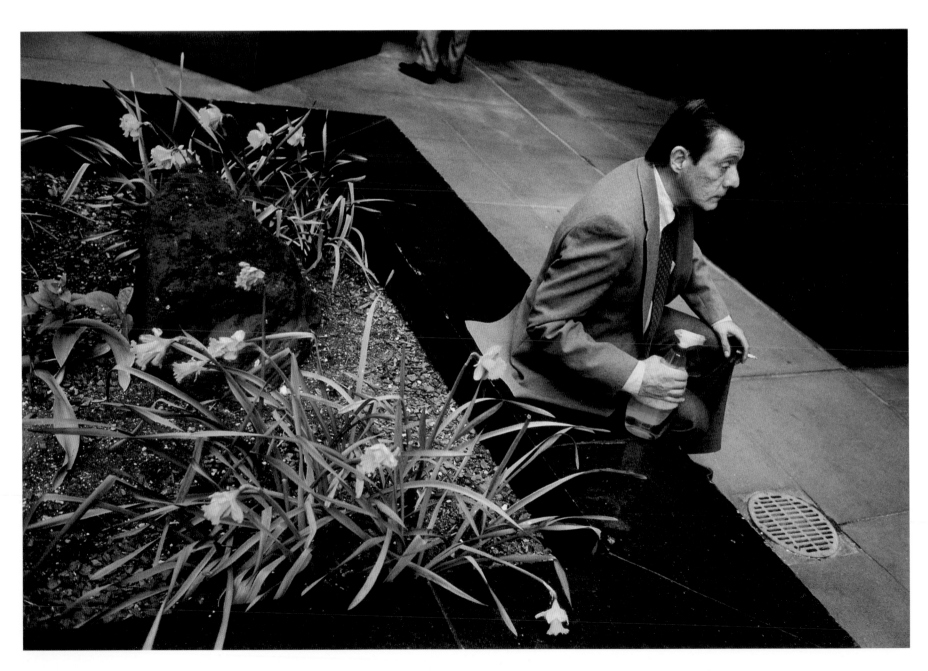

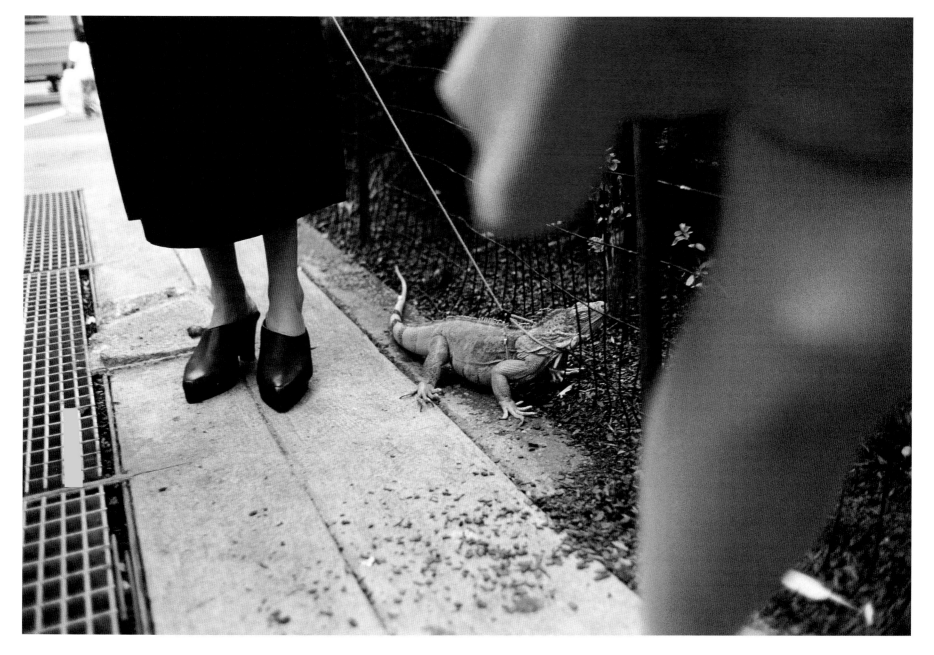

RIGHT:
Run #6, New York City,
2003-4

BELOW:
Run #4, New York City,
2003-4

BOTTOM:
Run #9, New York City,
1999–2000

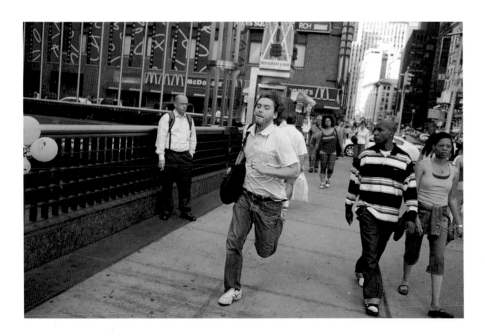

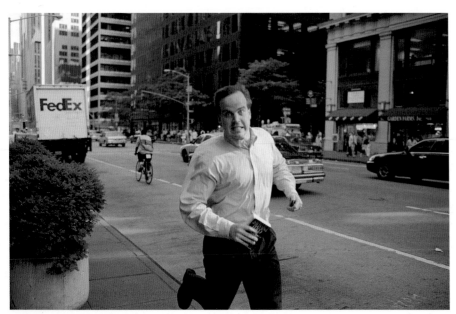

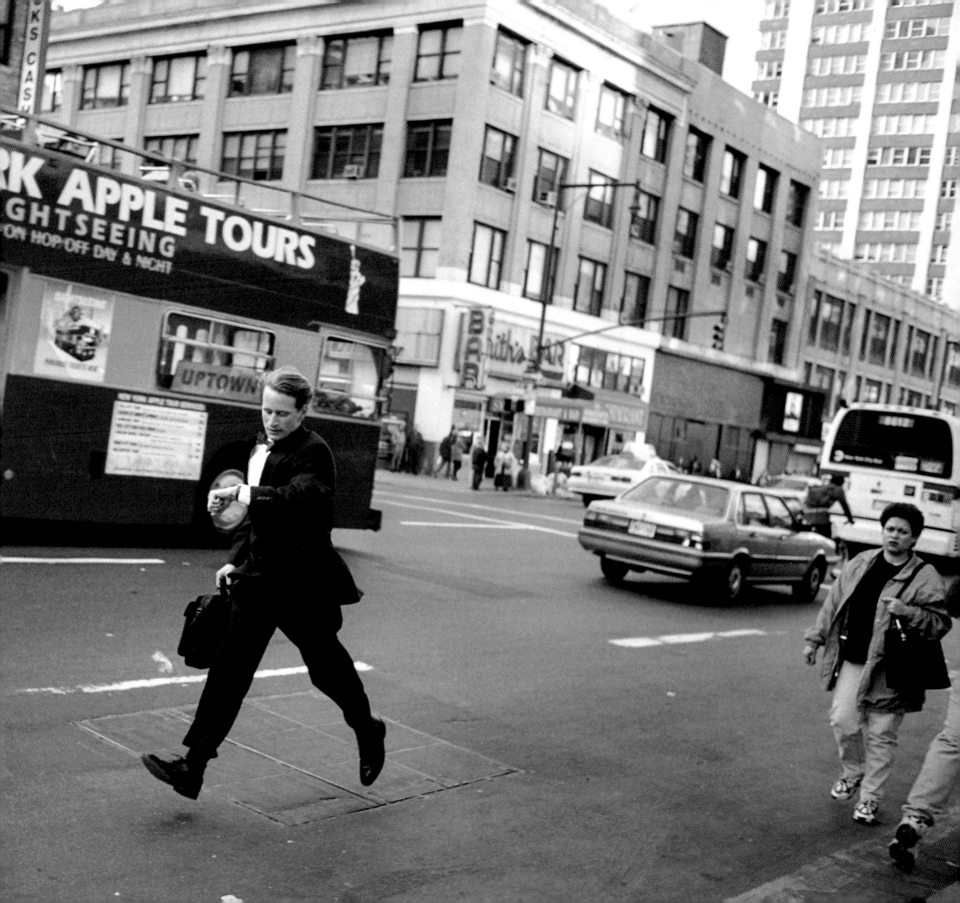

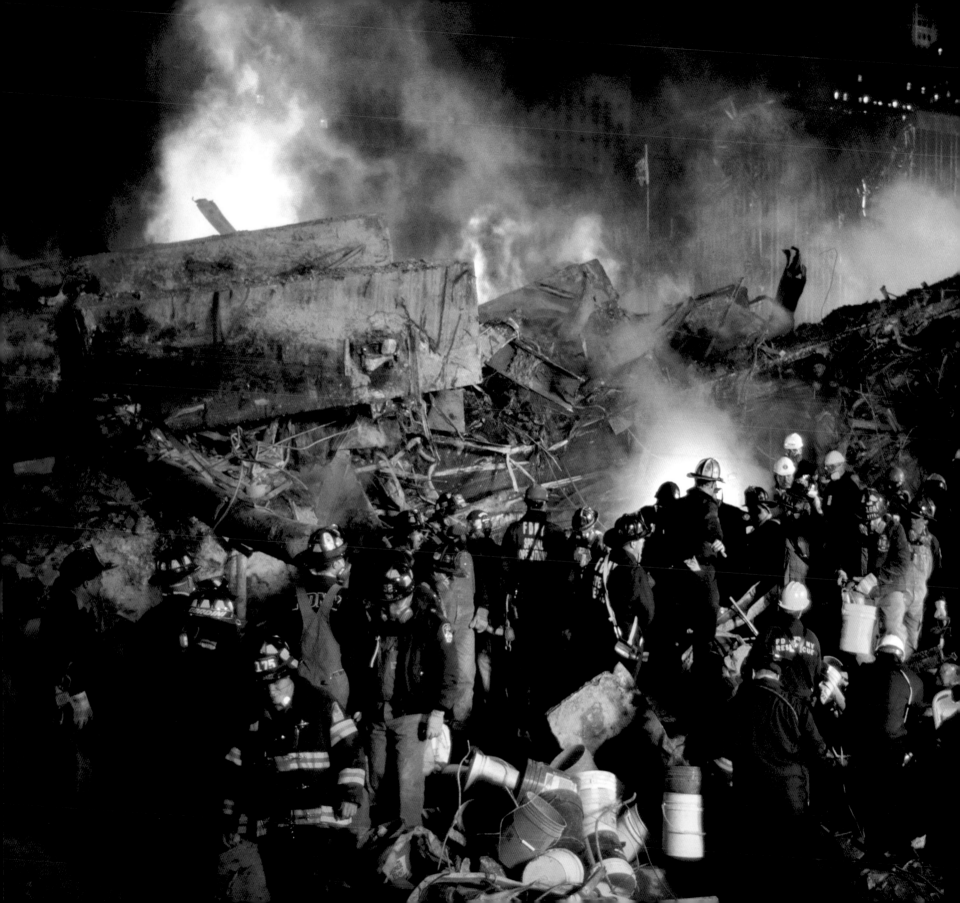

'I brought my old
street habits to bear
on something that
was much more than
ordinary street life
and yet not quite
documentary in any
conventional sense.'

A towering figure in the world of street photography,
Joel Meyerowitz has been documenting public life
in his home city of New York for nearly fifty years.
In the 1960s and 70s he pounded up and down
Fifth Avenue with the likes of Garry Winogrand and
Tony Ray Jones, chasing moments of unexpected
drama and curious incident. Always quick-witted
and lithe, Meyerowitz displayed an extraordinary
energy in his early work. He famously commented
that he wanted to make 'tough' photographs:
'Tough to like, tough to see, tough to make, tough
to understand. The tougher they were the more
beautiful they became.'

In recent years, Meyerowitz has worked on
a number of studied documentary projects. After
9/11, he was given exclusive access to Ground
Zero, where he produced a vast body of
photographs that simultaneously managed to
be epic and intimate, devastating and exquisite.
Recently he was commissioned by New York City
Department of Parks & Recreation to document
life in the city's numerous parks and along its
waterfronts. Commenting on the relationship
between his early street work and his more recent
documentary projects, Meyerowitz explains that
'human behaviour means something different
when you have seen the repetitions year after year.
The photographer I am today has a different energy
and attitude and understanding of what street life,
or life in general, means.'

In addition to being a photographer himself,
Meyerowitz co-authored *Bystander: A History of
Street Photography* (1994) with Colin Westerbeck;
the book was the first to document the history of the
genre extensively. Meyerowitz also mentored many
among the younger generation of New York street
photographers, including Melanie Einzig and Gus
Powell, and generously continues to encourage
others around the world who share his burning
passion for street photography. 'Every photographer
needs to do it for themselves,' he enthuses. 'It's a
way of discovering what the world looks like –
no one can do that for you.'

LEFT:
Five More Found, New York
City, 10 October 2001

131

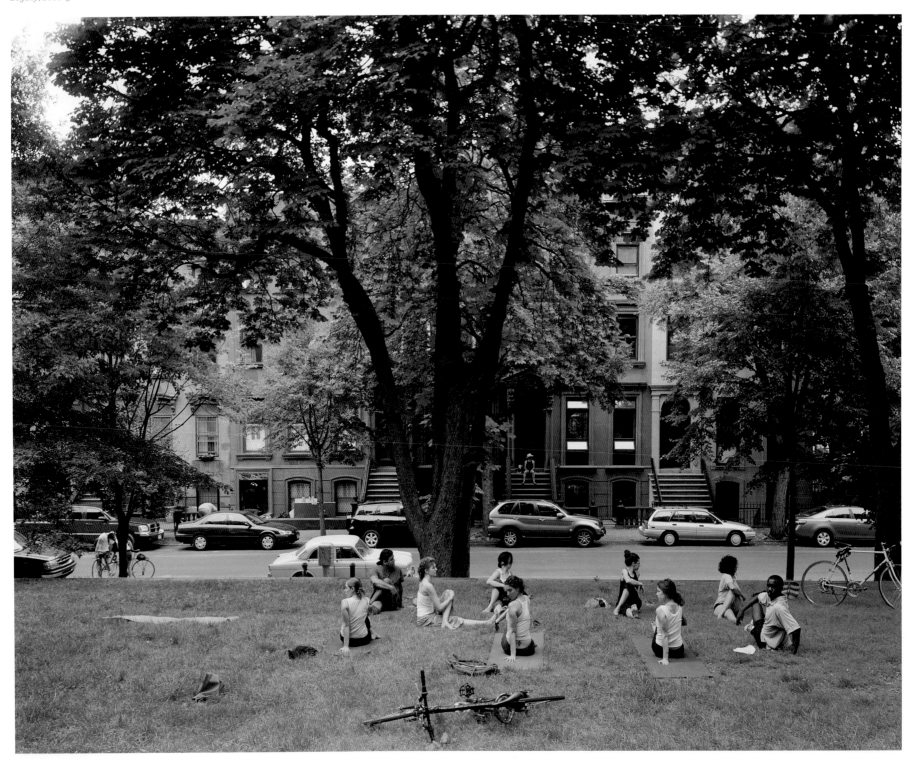

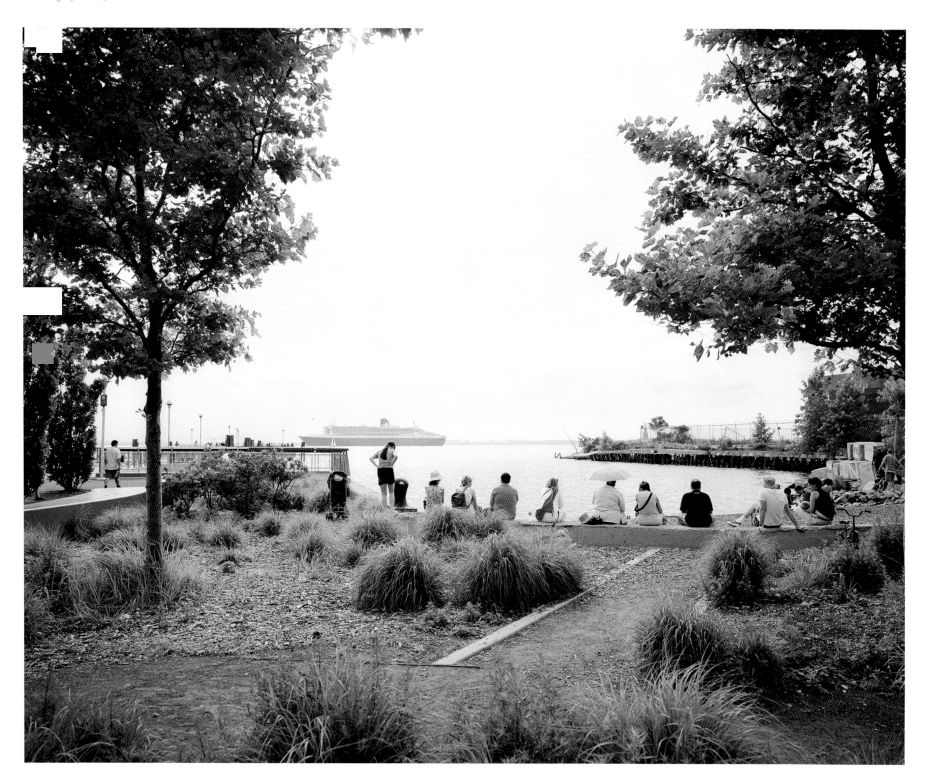

Louis Valentino, Jr. Park,
near the pier, summer,
New York City, from the
series *Legacy*. 2006–9

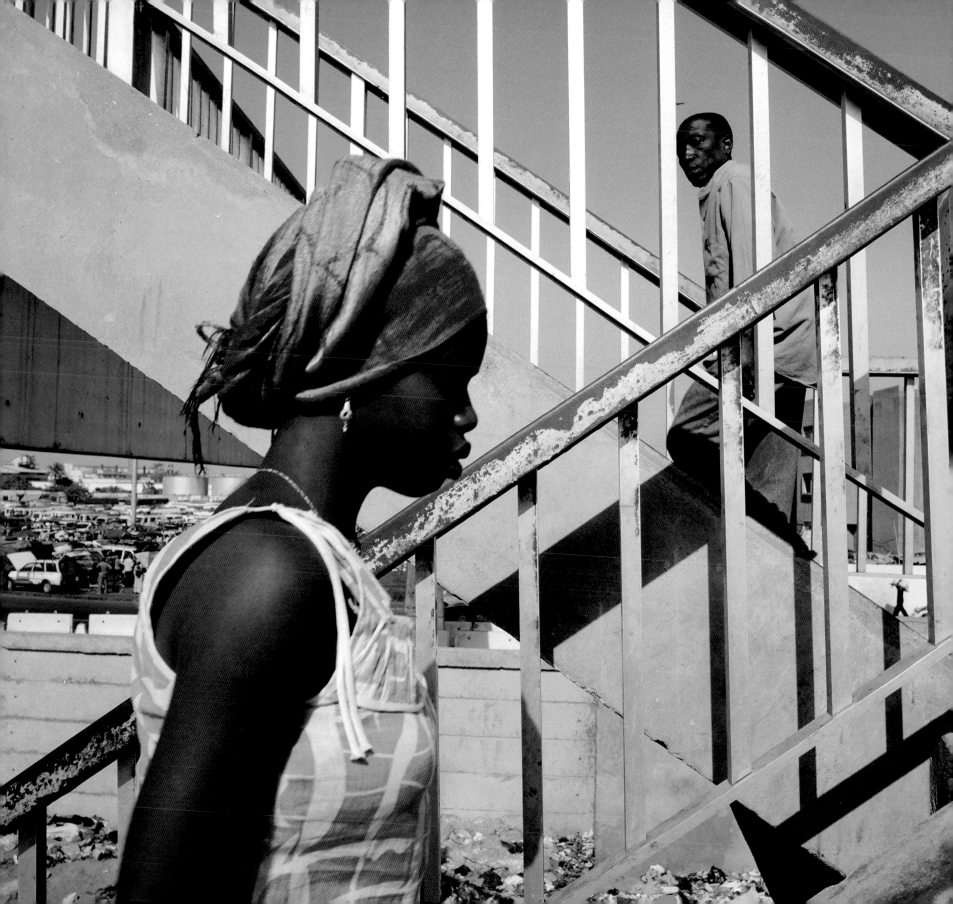

MIMI MOLLICA

b. Palermo, Sicily, 1975, lives in London

Mimi Mollica is an Italian photographer with a passionate interest in human rights and issues surrounding development and poverty. His work for magazines and non-governmental organizations has taken him to Northern Ireland, Brazil, Romania and India. In 2008 he travelled three times to Dakar in Senegal to document the building of its first major modern highway. 'I was attracted at first by a surreal landscape in the middle of a drastic transformation. Bridges were being built and new roads laid down, but what caught my attention was seeing people crossing this road, the Autoroute, to travel from one side of Dakar to the other, or to sell stuff, from goats to phone cards, engaging in some kind of activity or just more simply taking a stroll.'

The photographs, unusually recorded with a square-format camera, are full of humanity and intrigue, people traversing, trading on and inhabiting this arrow-straight strip of tarmac. Even in its unfinished state the highway attracts sharp-eyed entrepreneurs and ambitious migrants. 'Talking to the people I photographed, every single one of them wanted to emigrate to Europe,' Mollica explains. 'So the Autoroute became for me not only a physical place, a symbol of change and engineering progress, but also as a metaphor for a way out of something, for escape.'

Although the strong diagonal lines of Mollica's dynamic compositions seem to promise escape, the images also vividly convey the stench of new tarmac being laid in oppressive heat, the stink of fetid water and the diesel fumes billowing down this black ribbon of road. The months that Mollica spent here testify to his commitment in bringing back new vistas and stories from a continent that only seems to draw photographers when the four horsemen of the apocalypse are in town.

RIGHT AND OPPOSITE:
Dakar, Senegal, 2008

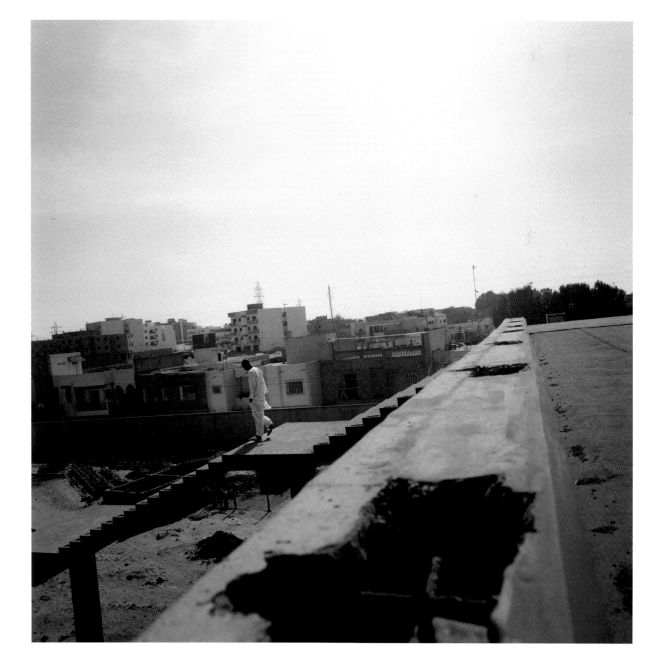

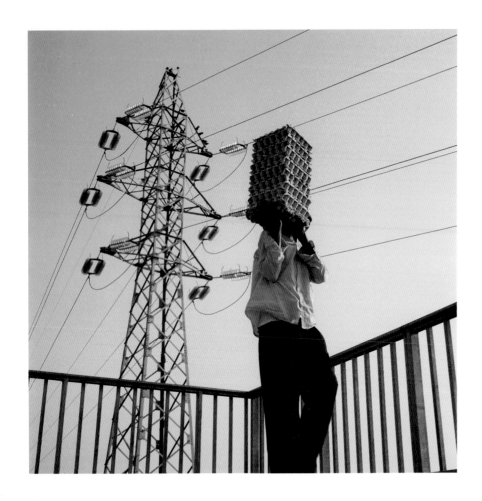 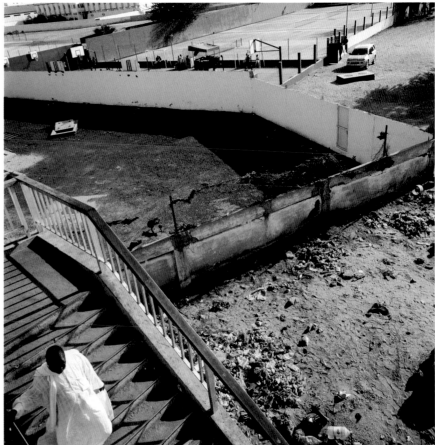

'The Autoroute became for me not only a physical place, a symbol of change and engineering progress, but also as a metaphor for a way out from something, for escape.'

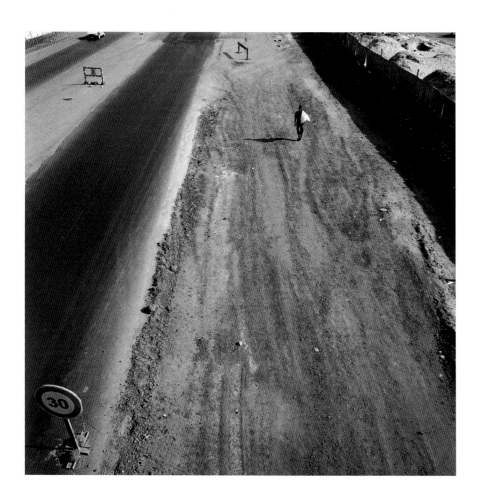

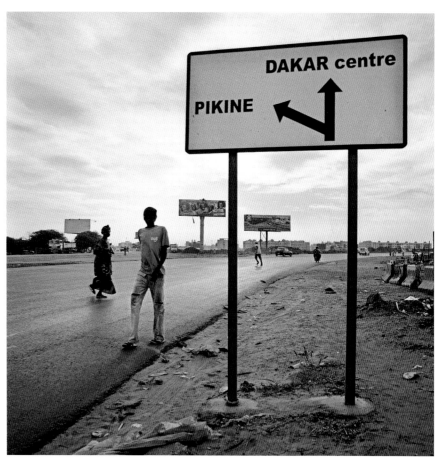

'My photographs are more questions than answers.
 I use photography as a way to help me understand why I am here. The camera helps me to see.'

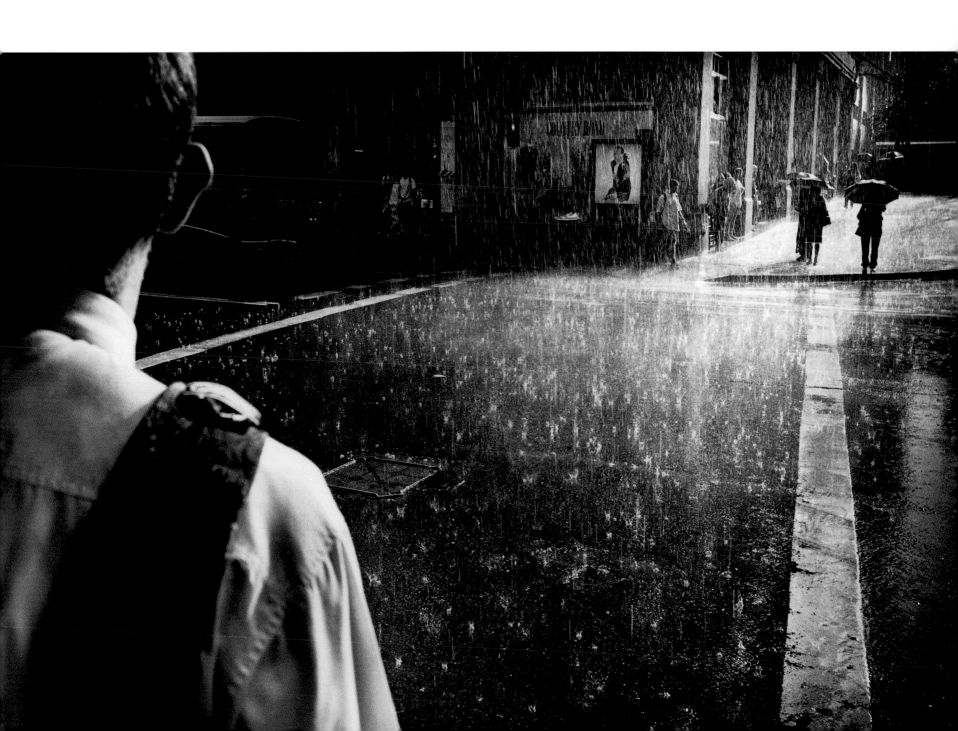

TRENT PARKE

b. Newcastle, Australia, 1971, lives in Adelaide, Australia

Among contemporary street photographers, Trent Parke stands apart because of his restless urge to experiment with the technical limits of the medium, defying conventional limits for shutter-speeds and exposure times. Parke's technical brilliance stems partly from the ten years he spent as a sports photographer. In his street photography he seems to anticipate people's movements through space and bring an instinctive sense of timing to fast-moving situations.

Although now employed as a photojournalist working for Magnum Photos, Parke's photographic practice remains firmly rooted in intensely personal encounters with his homeland. 'I had a vision of Australia as quite a dark and mysterious place. As a very visual person I had to go out there and understand it for myself.' His two landmark Australian projects, *Dream/Life* and *Minutes to Midnight*, veer between apocalyptic and ecstatic in tone. The radically expressive images in *Minutes to Midnight* were made during a two-year road trip with his partner, Narelle, hanging his negatives on trees overnight and working with a high-contrast black-and-white film stock. This continental survey produced an influential book and exhibition, whose images offer an elemental and introspective take on the Australian landscape and its people, containing 'fragments of dreams as well as nightmares.'

The birth of his son and his return to Sydney in 2004 coincided with Parke's decision to switch to colour film and a medium-format camera. In his new work, which examines how light moves through a modern glass-filled city, Sydney's downtown streetscapes are bombarded by harsh sunlight, while passers-by are bathed in pools of reflected light that make their clothes shimmer. The effect is at once otherworldly and emblematic of urban Australia in the twenty-first century.

OPPOSITE:
Sydney, 1998

RIGHT:
Sydney, 1999

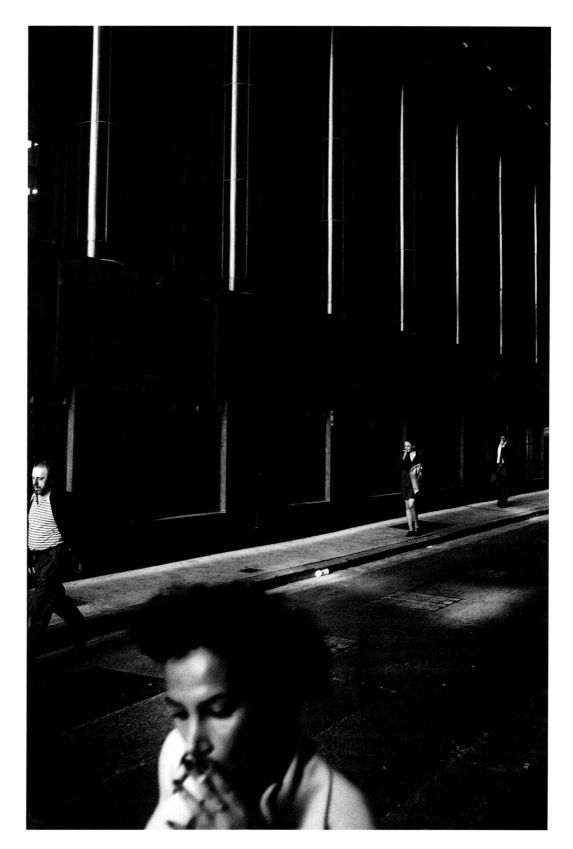

TRENT PARKE: PUTTING YOU IN THE PICTURE

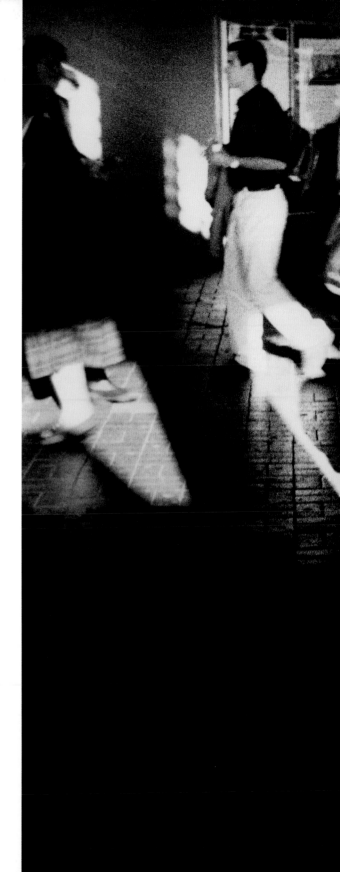

'COMPARED TO A LOT OF OTHER CITIES worldwide, Sydney is relatively small. Repeatedly circling the same streets provoked me to come up with new ways of showing the place. This in turn led to constant experimentation, especially with light, and a concern with how photographic technique relates to the conceptual and emotional content of a picture.

I can't remember the exact moment, but one day I thought I should try to shoot a person dressed entirely in white walking directly into the harsh sunlight. I achieved this photograph on the same day the idea came to me. For the next few days I took hundreds more similar shots but none worked as well as this one.'

Sydney, 2001

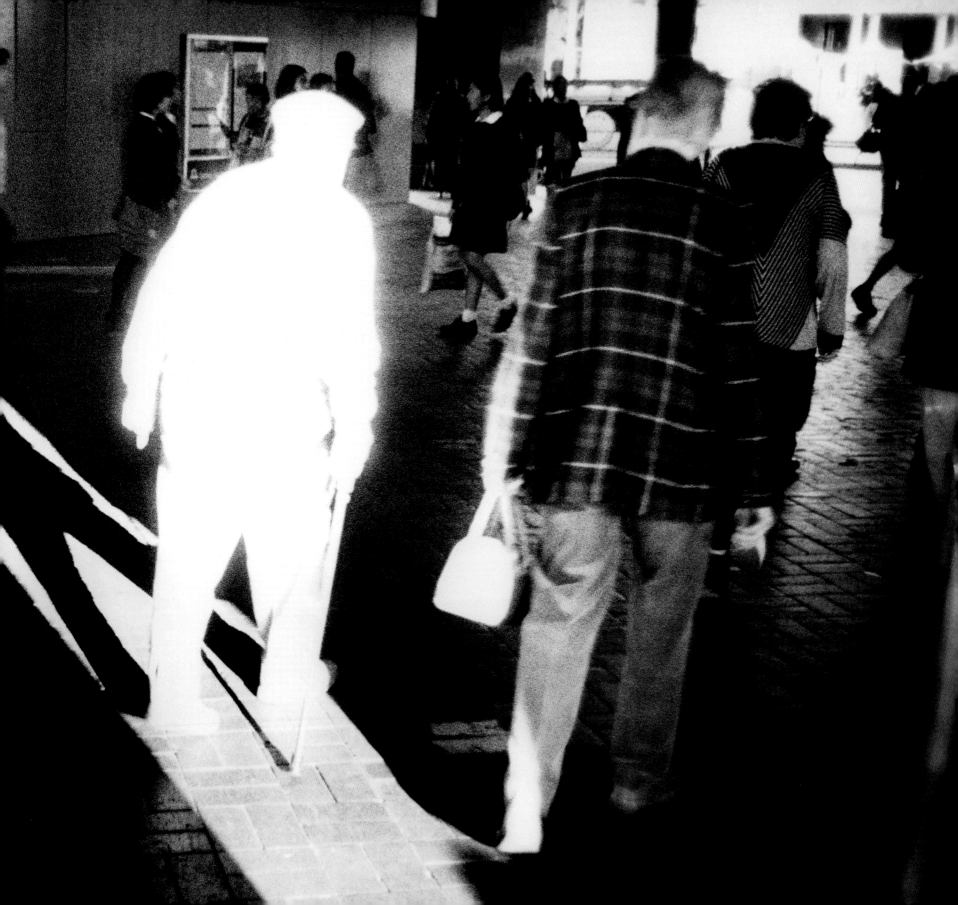

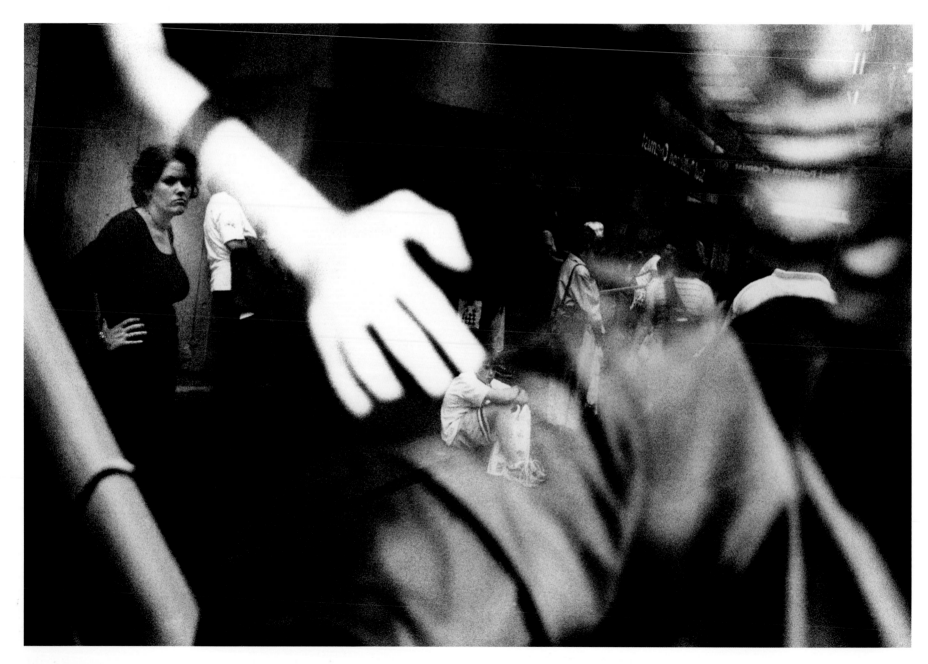

'I am forever chasing light. Light turns the ordinary into the magical.'

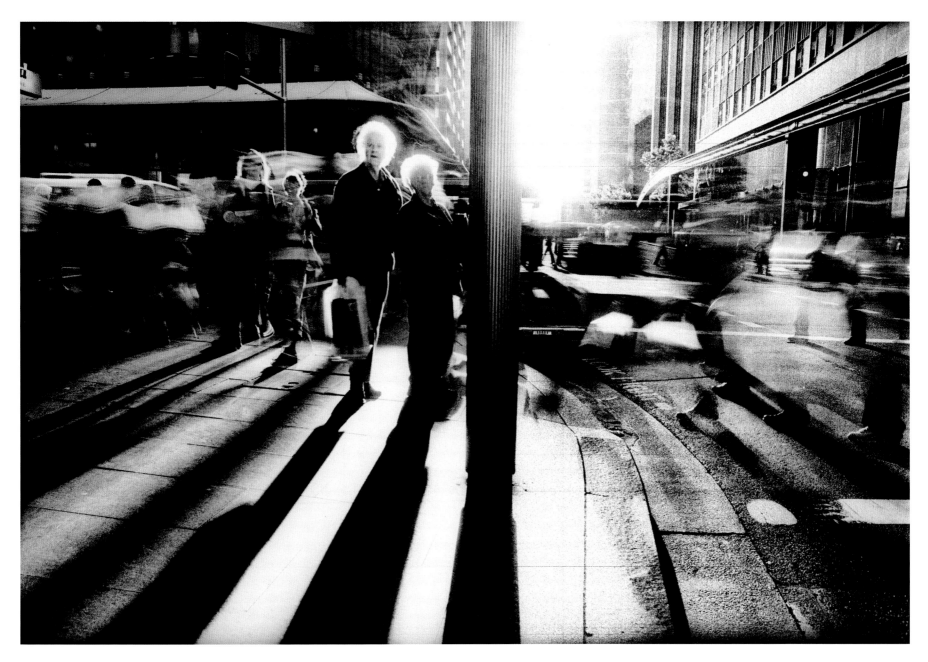

MARTIN PARR

b. Epsom, England, 1952, lives in Bristol, England

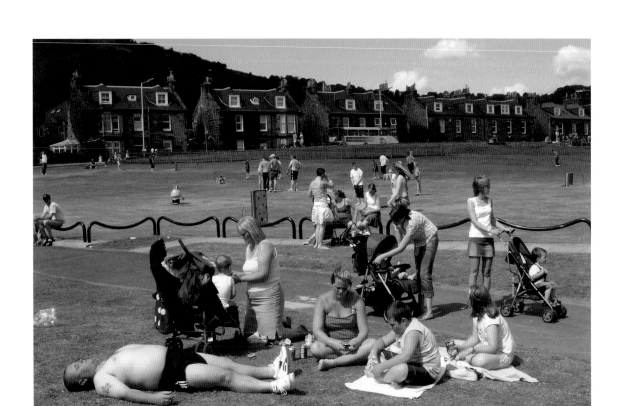

British photographer Martin Parr shines a raking light on how we live, how we present ourselves to others and what we value. His unflinching documentary style is a strange mix of the critical, the seductive and the entertaining. 'I do the things I do because I am interested in people,' he explains. 'I do accept that photography is to a degree exploitative. But I quite like controversy. It doesn't do you any harm. In any case, what is so controversial about walking into a supermarket and taking photographs, as opposed to photographing a war in Afghanistan or Gaza?'

During a career that began in the early 1970s, Parr has revelled in highlighting the foibles and tribal alliances of different social classes, most recently those of the international super-rich. Britain remains his home and continues to be the setting for much of his work, but he travels extensively and is as likely to be found taking pictures on the beaches of South America or at an arms fair in the Middle East as in a charity shop on Britain's south coast. At a time when many street photographers complain of a lack of editorial work, Parr, who has been a member of Magnum Photos since 1994, consistently finds ways to get his projects featured in magazines. 'I shoot interesting subject matter but disguise it as entertainment.'

Parr has always had an eye for detail and the colour-saturated close-up has become a hallmark of his style. He is fascinated by cultures of consumption and leisure: while walking the streets of a town he zooms in on foodstuffs and shop displays as often as human gestures. Parr's most recent project, *Luxury*, profiles members of the international jet-set as they snatch at canapés and quaff champagne from Ascot to Dubai. Extravagance, Parr argues, is just as problematic as poverty, but humanist photographers have generally turned away from it. In Parr's portraits, the pleasures that money can buy – art, cars, jewels, horses and manners – are shown to be more or less identical the world over, and the sphere of the wealthy increasingly bereft of authentic self-expression.

ABOVE:
Burntisland,
Scotland, 2006

OPPOSITE:
The Portree Games,
Isle of Skye, Scotland,
2009

'I like to create fiction out of reality. I try and do this by taking society's natural prejudice and giving it a twist.'

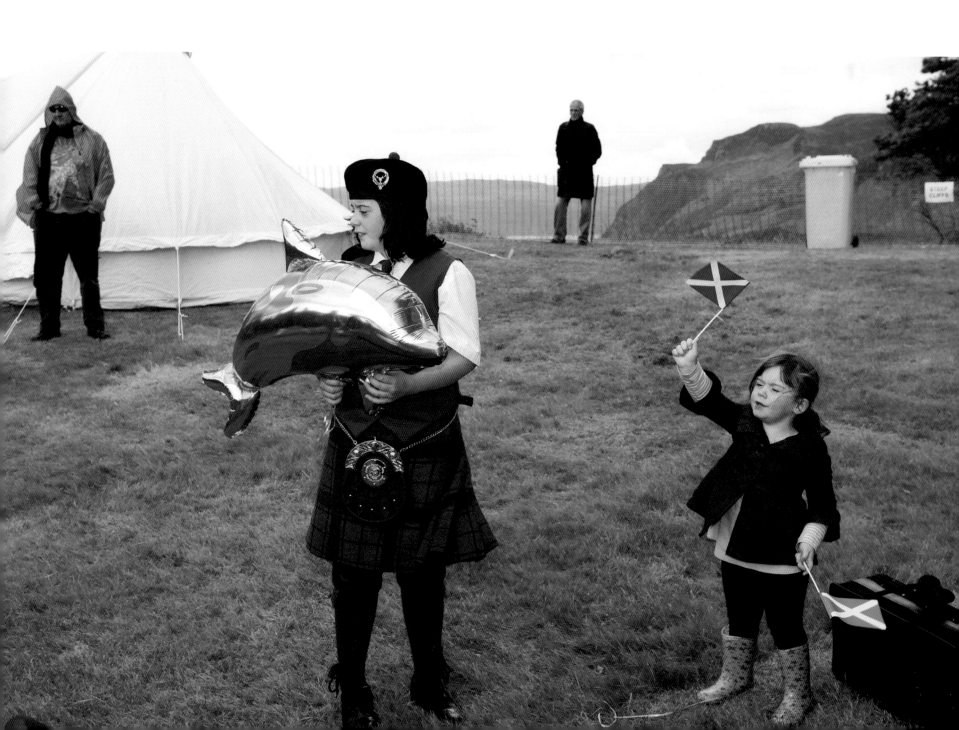

LEFT:
July Races, Durban,
South Africa, 2005

OPPOSITE:
Fashion Week, Moscow,
Russia, 2004

'Traditionally a
photographer
would do a story
about poverty.
I am approaching
wealth with the
same spirit.'

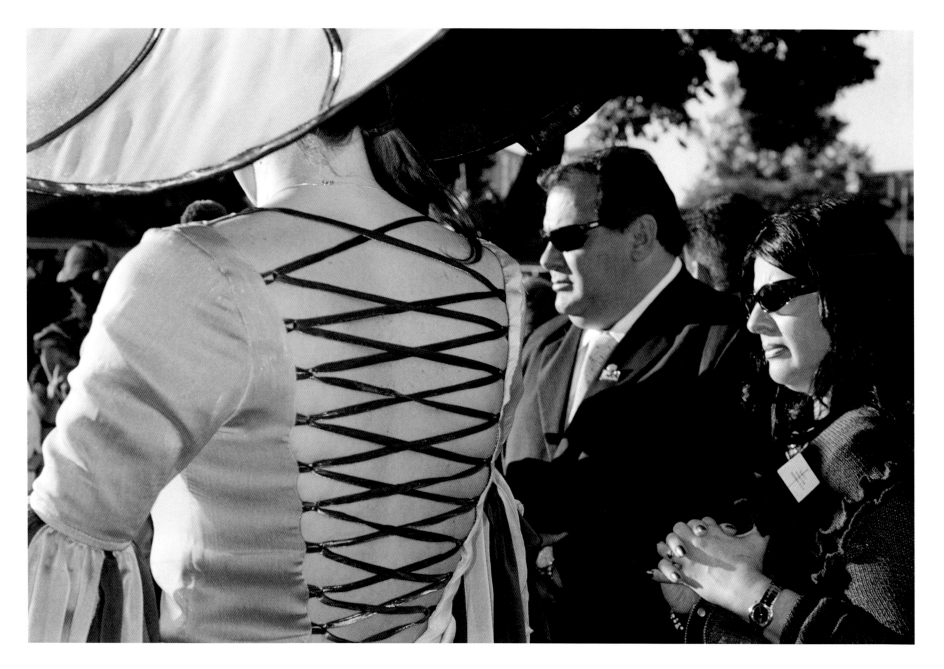

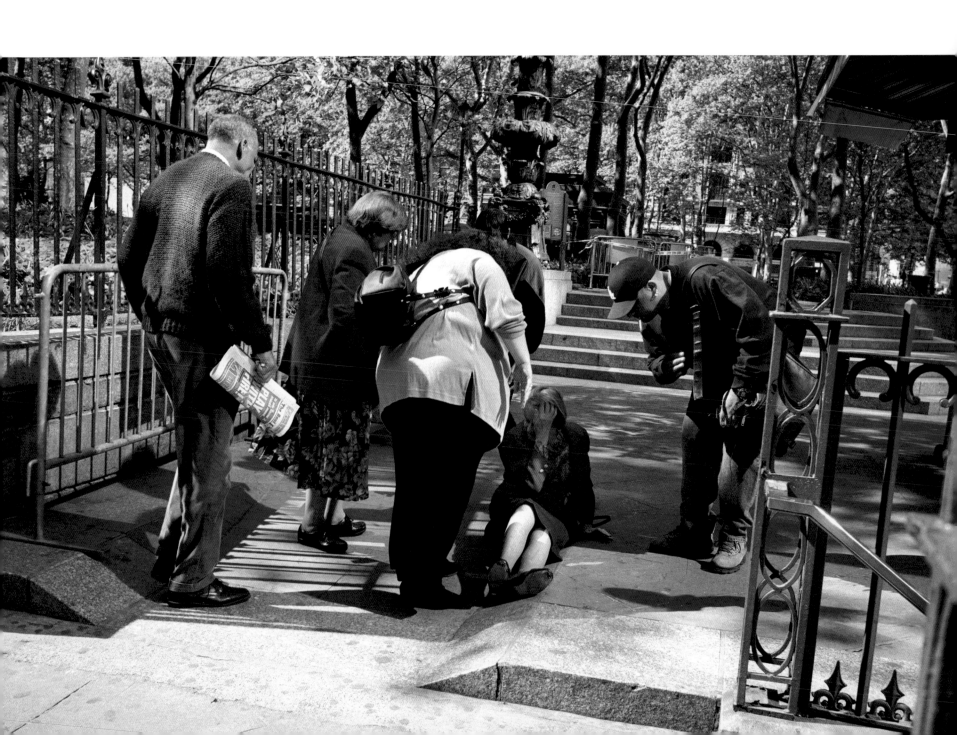

GUS POWELL

b. New York City, 1974, lives in Brooklyn, New York

Critics of cities often describe them as dog-eat-dog environments, but in Gus Powell's pictures the phrase that more often comes to mind is 'You scratch my back, I'll scratch yours'.

A native New Yorker, Powell seems acutely attuned to the way that private moments often burst out into the public sphere in crowded urban spaces, and fascinated by the social grooming and mutual comforting that city-dwellers often indulge in. 'I try to be ready for those moments that have a subtle comedy or tragedy to them; moments when strangers come together for a split second and are rendered inseparable through a photograph.'

In manic Manhattan many of these little dramas unfold during lunch hour when people leave the office and retake some control of their lives. Powell's forays out around the midday break brought many opportunities to get close-up to his fellow city-dwellers.' If the photographer is a fly-fisherman then I definitely believe that the streets of New York are some of the best streams to work in. There are so many kinds of creatures sliding past one another and so many ways to approach the little moments that happen. For me it's when one sort of moment rubs up against another that is the most moving and satisfying.'

Appropriately enough, Powell's recent book and exhibition was called *The Company of Strangers*. His approach to his work and his fellow New Yorkers is less confrontational and more empathetic than some of his contemporaries. 'I am not an aggressive person so I am not really up for jumping four feet in front of a person with a 28mm lens and flash…I just enjoy taking pleasure in responding to a situation with an open heart and some wit.' Although New York is often portrayed as misanthropic Babylon, Powell's photography shows that even in the biggest and baddest of cities there remains a generous beating heart.

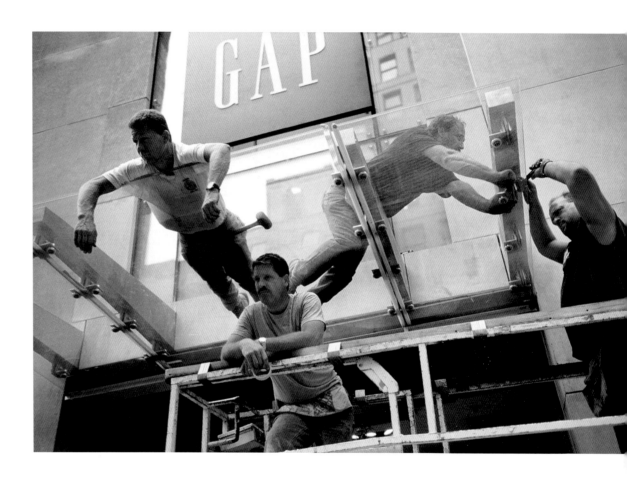

ABOVE:
Putti, from the series
Lunch Pictures, New
York City, 1999–2007

OPPOSITE:
The Fall, from the series
Lunch Pictures, New
York City, 1999–2007

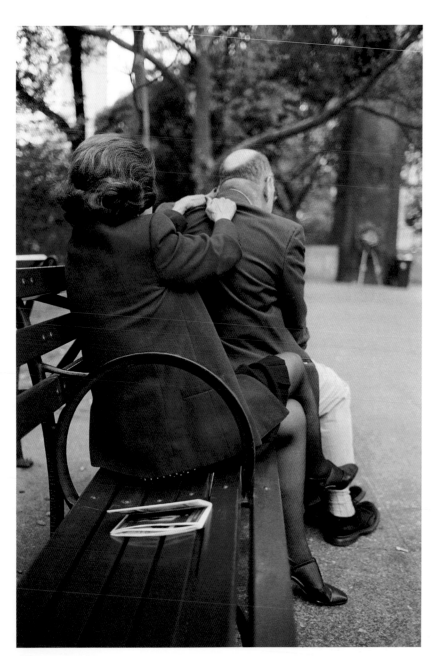

'In the absence of a restful European *siesta*, New Yorkers take the lunch hour by storm. We get our shoes shined while our hair is being cut, run three errands while eating a sandwich, smoke four cigarettes while we dance past tourists. We jaywalk. We move on. Yet amidst all this independent action, there exists an unspoken fraternity.'

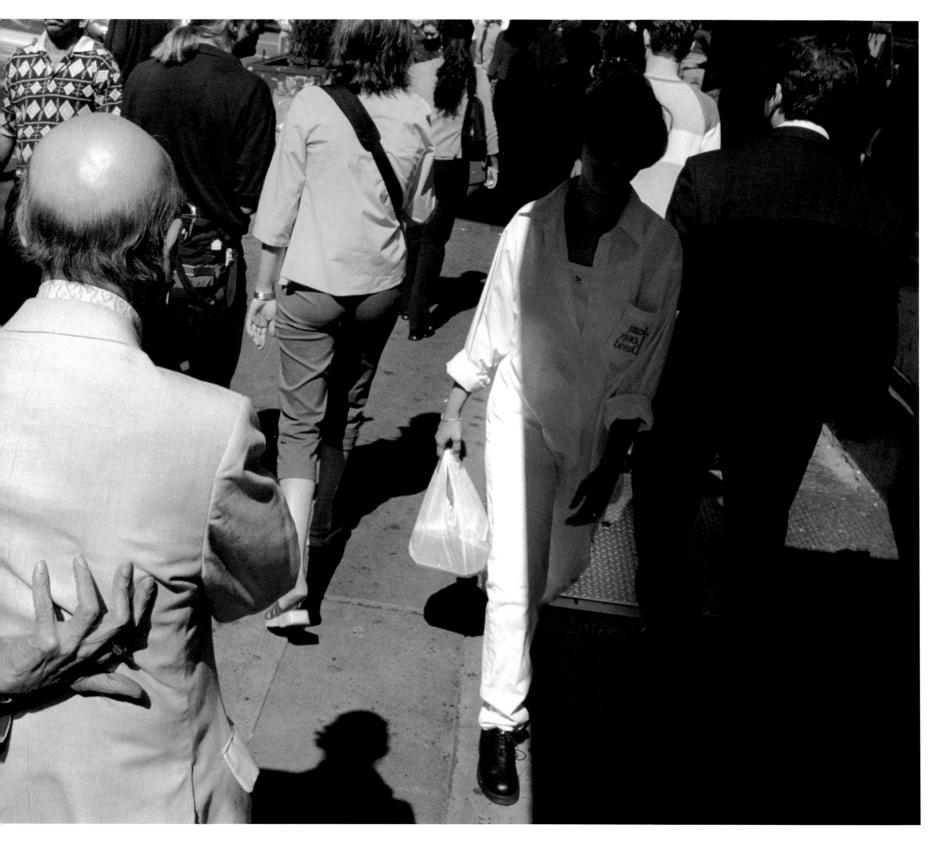

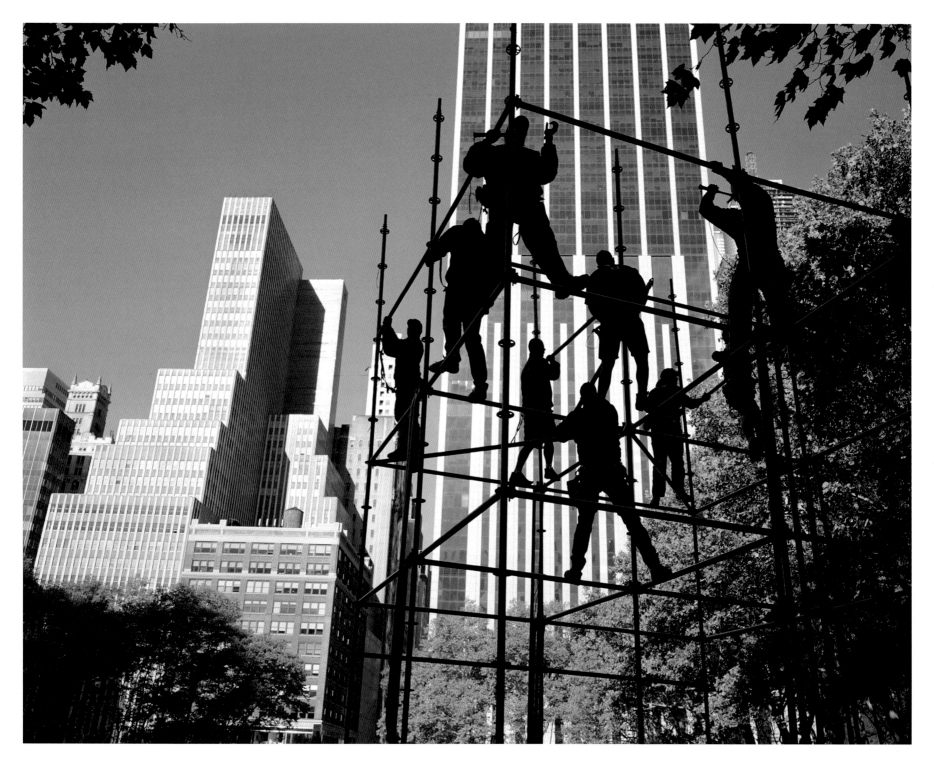

MARK ALOR POWELL
b. Decatur, Illinois, USA, 1968, lives in Mexico City

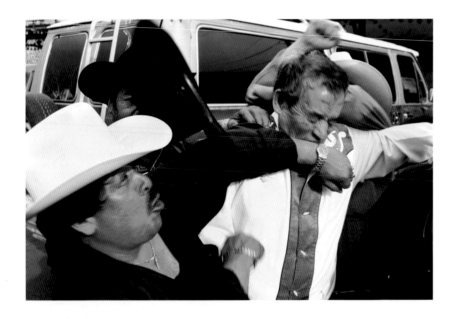

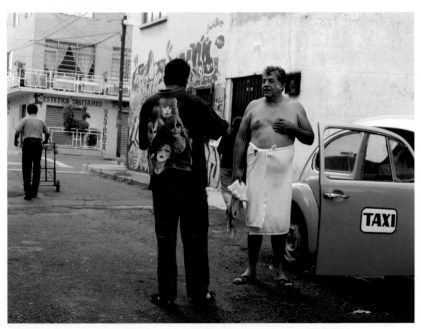

Mark Alor Powell began his career in Detroit but now lives and works in Mexico City. The size and complexity of his new home offers Powell an endless source of inspiration: 'Mexico City can match any thought and offer it up anytime for examination and contemplation photographically'.

An inveterate walker, he strolls the city streets, alert for incidental drama, however small and apparently insignificant. Unlike many street photographers he is more than happy to ask people if he can take their picture, and his delight in making new acquaintances is palpable in the warmth and conviviality of his work.

'I like to approach strangers directly and ask for a photograph. This often leads to whole new chain of events that allows me to make more photographs. There seems to be law of attraction and people respond in an immediate, spontaneous and real way when I take an interest in them. I still feel shy about approaching people and it takes guts every time, but that's what allows my pictures to feel fresh, new and exciting. In a sense the photographs feel like a series of first dates or tiny visual love affairs.'

Powell is very conscious of being an outsider in the city but uses this to his advantage. 'I think most people regard me as a little strange and definitely out of place, I may be a reporter, nosy intruder and/or a potential friend, depending how close I get, how much time I spend photographing or how long I stay and talk. If I stay longer my intentions are usually known and hopefully everyone has a nice time together. If my intentions are not known I leave fast, but at least I got a picture.'

OPPOSITE:
Mexico City, 2007

ABOVE LEFT:
Mexico City, 2006

LEFT:
Mexico City, 2005

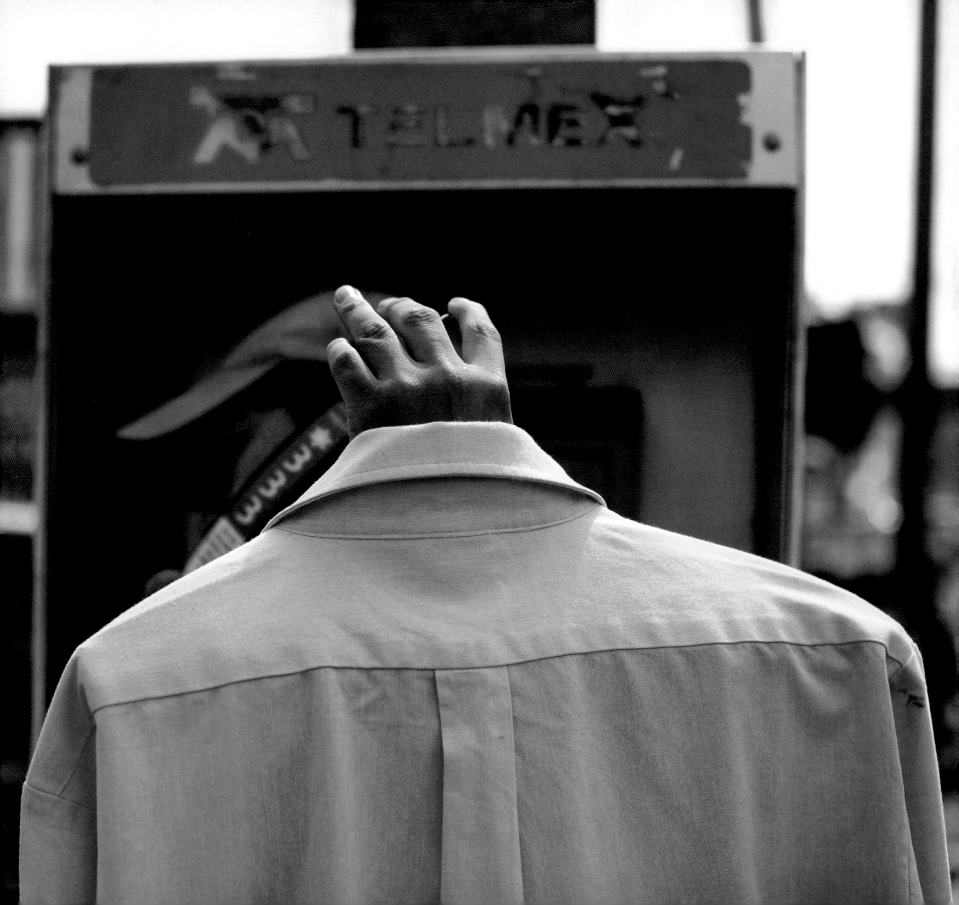

MARK ALOR POWELL:
PUTTING YOU IN THE PICTURE

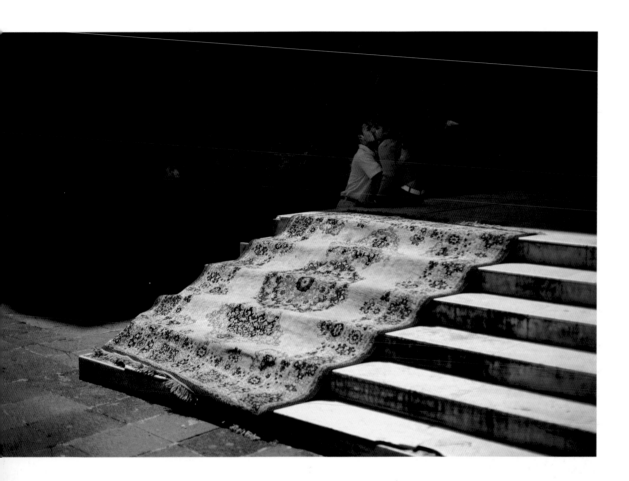

'I THINK IT IS IMPORTANT to be in the
right mood to receive a photograph.
Sometimes I feel absolutely nothing and
the world is numb. Then suddenly the world
throws something at me. I don't quite
understand why this happens – it's a
receptive emotional synopsis that luckily
clicks into place.

 Carpet Kiss (*left*) resulted from a
stumbling act: a lot of walking and looking,
and then there it is. I first saw the carpet
on the steps, probably being left out to dry.
The couple was there, but not kissing until
the third or fourth shot when the boy
suddenly reached for her and gave her a
strong passionate kiss – they were not
aware of me at all. *The Man in Box* came
from a more confrontational approach.
I was working on a commission for an
anthropologist about the Sonidero (Mexican
street DJ) movement. It was in the morning
and the sonideros had been working all
night installing these huge sound systems,
some as tall as small buildings. A group of
workers were milling around and relaxing.
One of their exhausted workmates was
dozing off in the most comfortable spot he
could find: the box of a speaker component.
I came up to the group and asked them to
move away, like I was playing a joke on their
friend by photographing him sleeping. They
moved away, giggling. In a way I become
more of a protagonist since the scene
changed because of my presence.'

BRUNO QUINQUET

b. Chambéry, France, 1964, lives in Tokyo

French photographer Bruno Quinquet has made an award-winning body of work out of what is usually regarded as the street photographer's most frustrating problem: the right to privacy.

The *Salaryman Project* consists of diptychs of anonymous Japanese office workers as they walk through the streets of Tokyo, ride the subway, make business calls, eat their lunch or board planes. The project, which Quinquet presents in the format of a weekly business scheduler, is an insightful commentary on the way in which office work erodes personality and an exploration of the legal issues around candid street photography.

In Japan, as in Quinquet's native France, there are no restrictions on taking photos in public places but if the image is published and you have infringed someone's right to privacy, the person can sue you and stands a good chance of winning. Quinquet avoids potential litigation as none of his subjects are recognizable. Their identities are hidden behind street furniture or blurred by smoke or mist. Sometimes the protagonist only appears as a shadow. He is always alone.

Street photographers typically search out unique characters, turning their cameras on faces that stand out from the crowd. But Quinquet's salarymen are elusive figures, notable for their lack of distinguishing features. They are modern-day wage-slaves who wake up each morning, don the same uniform (black suit, white shirt, inoffensive tie, trench coat and briefcase) and then disappear into the throng. Quinquet uses formal devices ingeniously – the stripe of a tie echoed in a painted pedestrian crossing, or the blandness of a black suit contrasted with the beauty of Tokyo's famous cherry blossoms – to suggest how these men merge with the infrastructure of the city that has produced them.

ALL IMAGES:
Salaryman Project,
Tokyo, 2008–9

'I never show recognizable faces. *Salaryman* is a reflection on the problem of candid street photography and portrait rights.'

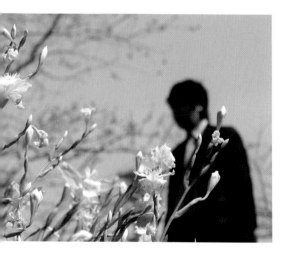

'I believe that the photographer's job is to cut a frame-sized slice out of the world around him, so faithfully and honestly that if he were to put it back, life and the world would begin to move again without a stumble.'

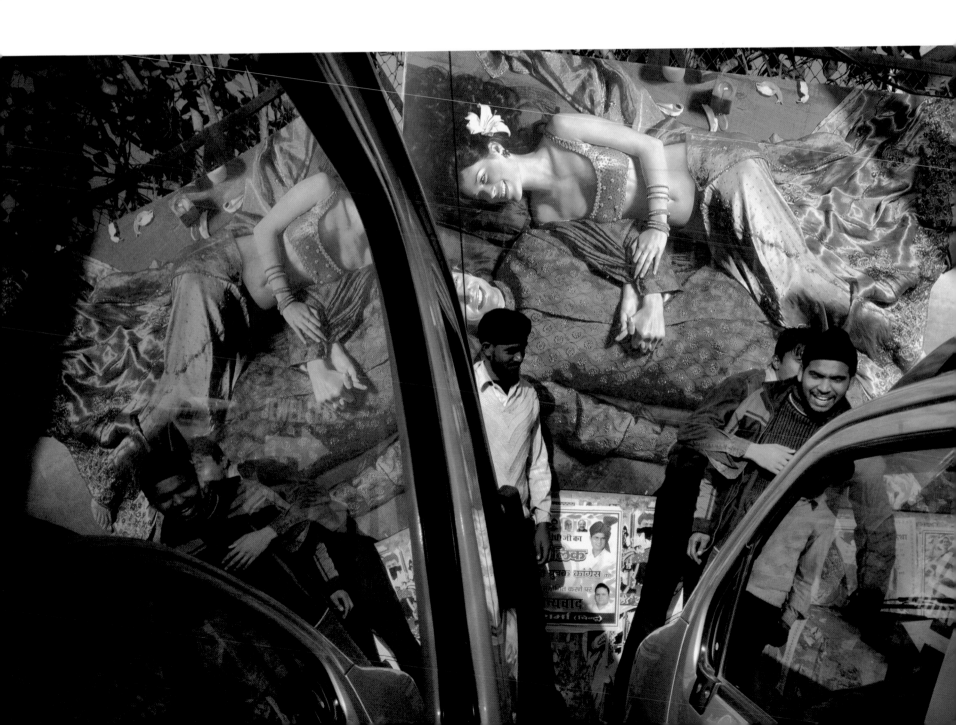

RAGHU RAI

b. Jhhang, India (now Pakistan), 1942, lives in Delhi

The tumultous streets of India's vast and chaotic cities are an endless source of delight for Raghu Rai, who has devoted his life to photographing his native country. Rai spent the early part of his career as chief photographer for *The Statesman*, a New Delhi publication, and from 1982 to 1992 was the director of photography for *India Today*, India's leading news magazine. His photo-essays on subjects ranging from political celebrities to wildlife have appeared in many of the world's prominent magazines and newspapers. Impressed by an exhibition of his work in Paris in 1971, Henri Cartier-Bresson nominated Rai to join Magnum Photos in 1977.

Rai still works as a photojournalist on occasional big stories but increasingly feels that what is most important lies in the small things. Unlike the many foreign photographers drawn to India's teeming streets, Rai interprets the public life of his country from an insider's perspective. The years he has spent on newspapers have left him alert to ways in which social issues – including economic inequality, inadequate healthcare, the status of women, ecological crises, war, caste, housing and religious difference – play out in the street. Rai no longer tries to take photographs that illustrate a simple message. Intricate and often irresolvable visual constructions are his way of portraying a country where pizza parlours and mobile phones butt up against beggars and religious rituals. 'Over the centuries so much has melded into India that it's not really one country; it's not one culture. It is crowded with cross-currents of many religions, beliefs, cultures and practices that may appear incongruous.'

Although he enjoys an almost-celebrity status in India, and has exhibited in major museums and galleries around the world, Rai remains humble. He sees himself as a pilgrim, travelling his country, putting his faith in the camera that is for him not only a device to record but also a means to keep learning. 'I need ten lives to do something about my country; unfortunately I have only one life. But one thing is certain, I am getting closer to things now.'

OPPOSITE:
Youngsters around the shopping mall, Delhi, 2005

RIGHT:
Shifting polished granite stones, Delhi outskirts, 2006

ABOVE LEFT:
Children of Dharavi (one
of the largest slums in
Asia), behind Sarah
Airport, Mumbai, 1995

LEFT:
Children of Dharavi,
behind Sarah Airport,
Mumbai, 2004

OPPOSITE:
Camel cavalry seen
through a jet fighter,
Republic Day, 1998

'India is, for me, the whole world, an ocean of life, churning day in, day out. I stand amid this human deluge trying to untangle the merging and emerging of various colours, the myriad hues of every emotion, set in motion by each charge and recharge.'

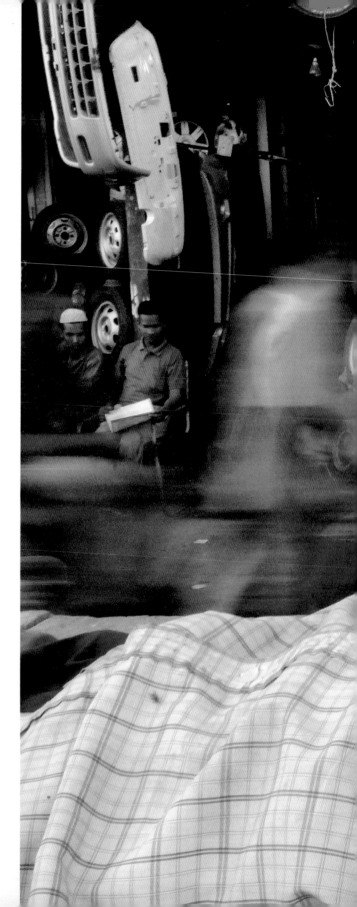

RIGHT:
A rickshawman taking a nap in Jama Masjid Market, Delhi, 2005

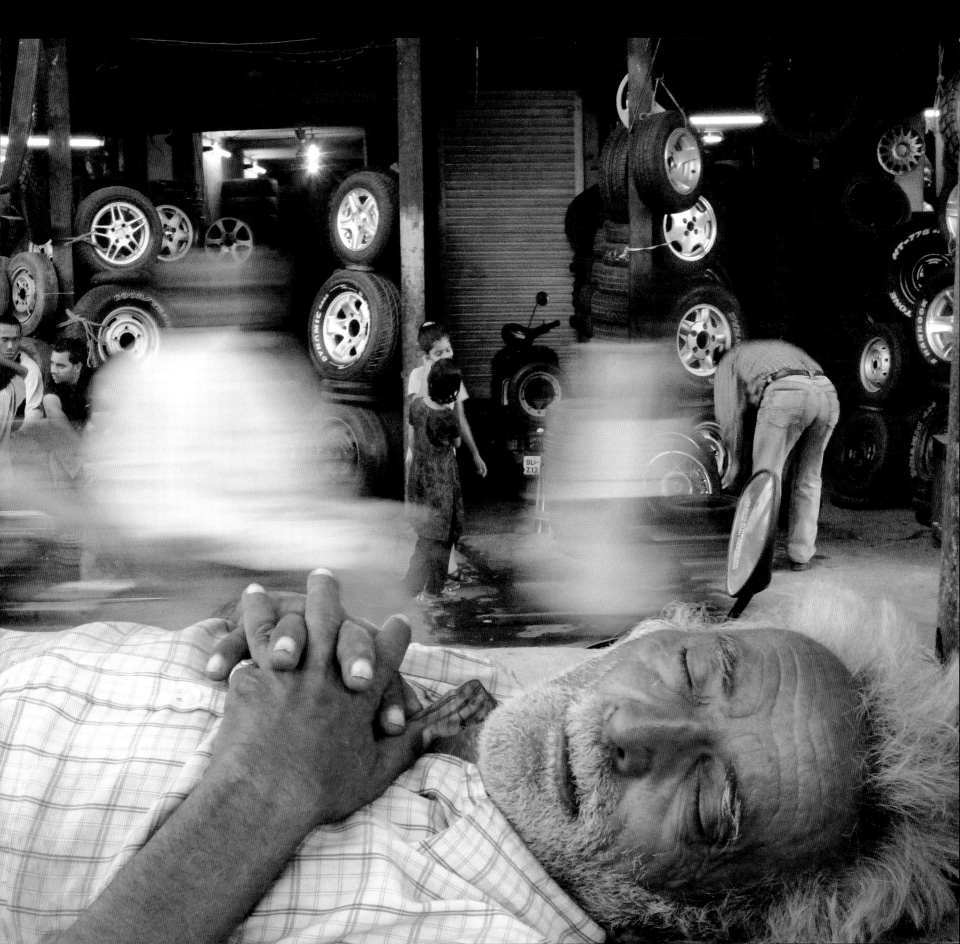

OPPOSITE:
West Bay, Dorset,
England, 2006

BELOW:
Bournemouth,
England, 2007

PAUL RUSSELL

b. London, 1966, lives in Weymouth, England

Candid beach photography has a long and lively history. Paul Martin risked arrest in the 1890s for surreptitiously turning his camera on the resorts of eastern England. His delightful scenes of genteel, black-clad ladies relaxing with their paramours would have caused such scandal that they were rarely published. In the 1940s New York's Weegee (Arthur Fellig) stalked Coney Island on boiling summer days and captured the manic crowds on the boardwalk. British photographer Tony Ray-Jones's trips to the seaside during the 1960s produced surreal images of holidaymakers relaxing and performing as they would never have dared at home.

Dorset-based Paul Russell carries on this tradition, treating the English seaside as a quixotic stage-set where the normal rules of everyday living seem suspended. Like Ray-Jones, who talked about the 'gentle madness that prevails in people', Russell is drawn to characters who exist serenelyin their own eccentricity, and in his images the capriciousness of everyday life seems enhanced by the proximity to the sea, whose restlessness affects daytrippers and natives alike.

Although the British have a love–hate relationship with their coastal resorts, Russell, who grew up in one seaside town and now lives in another, views such places with affection.'I'm not sure my seaside pictures are nostalgic, but they do present a slightly rose-tinted-spectacle view. The seaside…has typically been portrayed as either quite gaudy – with the colour ramped up to 11 to emphasize the tackiness – or as spectacularly run-down and desolate.'

Even though Russell's images find humour amid the out-of-season desolation, there is always a deep sense of melancholia lurking in the background. Tourists tramp home, the Punch & Judy man closes for the season, a young girl stares into a bucket on the promenade and an absurdly dressed charity volunteer pauses alongside a sorrowful-looking young man on a public bench.

Russell's approach to people-watching has been informed by the observation of 'non-human animals'. He portrays the British as a peculiar species. 'Birdwatchers will often spend hours waiting for a small, nondescript brown bird to leave its nest,' he observes, 'but we rarely stop to examine our everyday behaviour in such detail.'

'What I am looking for is a chance event, an element of physical change, or a blip in normality. If that sounds pretentious, often when I take a photo I'm just thinking *that looks nice*...'

RIGHT:
Bristol, England,
2007

BELOW:
*Bees Invade Mark
Poulton's Punch & Judy
Booth*, Weymouth,
England, 2008

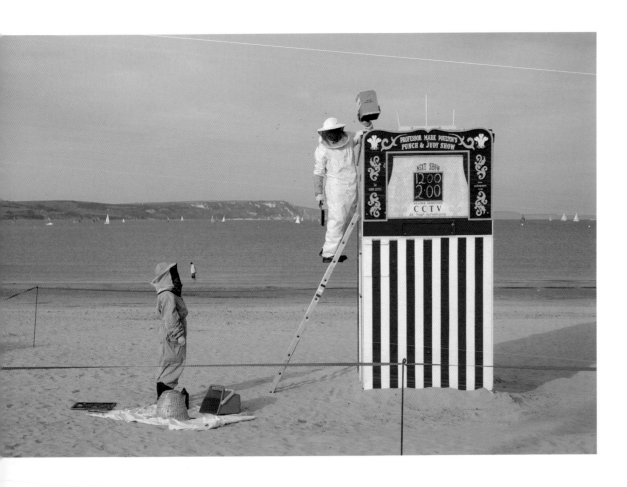

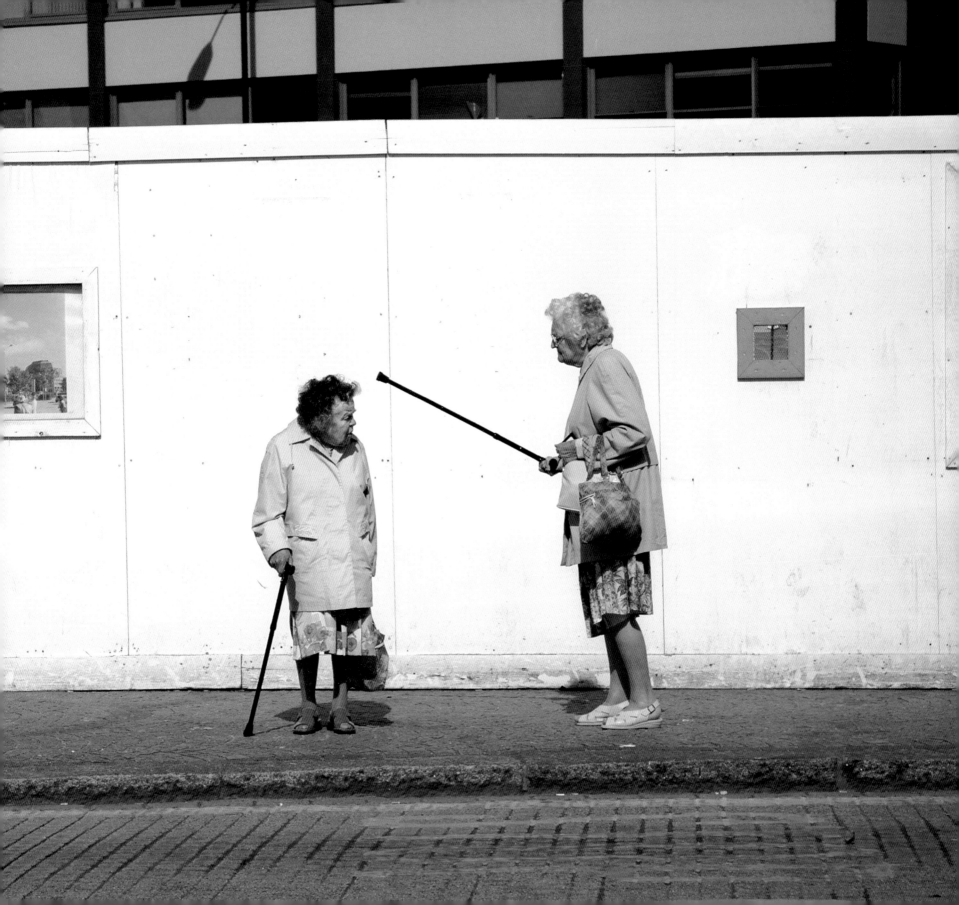

OPPOSITE:
Weymouth, England,
2007

BELOW:
Charity, Bournemouth,
England, 2006

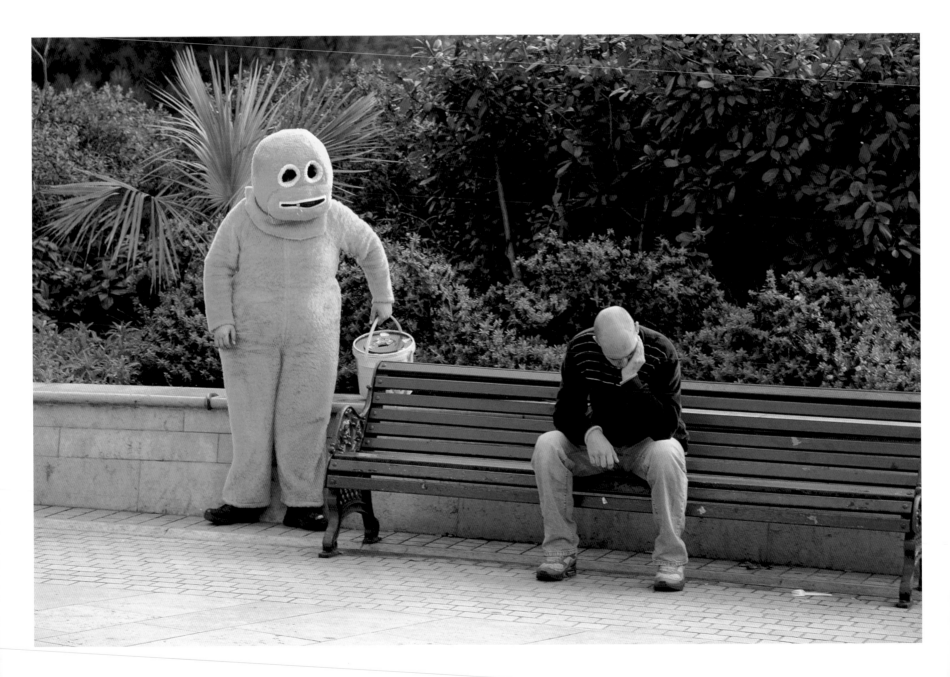

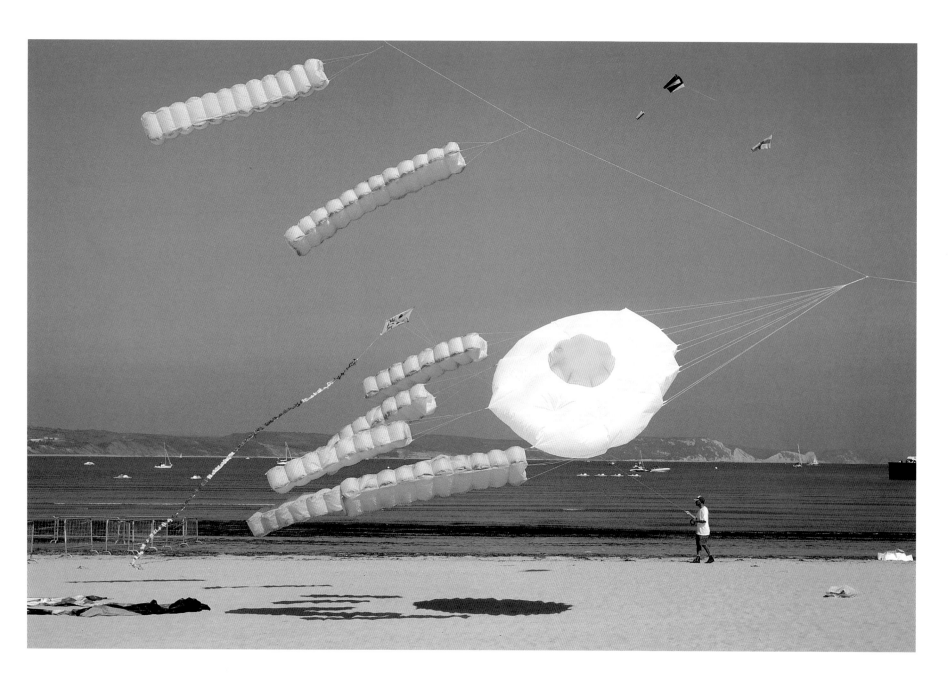

BORIS SAVELEV

b. Chernotsy, Ukraine, 1948, lives in Moscow

Boris Savelev has always been a pioneer. In 1988 he was the first Soviet-era photographer to have a book published in the West. He began using colour and digital cameras before many of his contemporaries and developed his own printing techniques, combining nineteenth-century pigment-based processes with state-of-the-art multi-layered digital printing. Whether shooting in Russia or working on long-term projects in cities such as London, Rome and Dresden, his work has a singular vision and seems immune from current art and photography trends. The only constant theme for Savelev is the illuminating force that shapes all photography: 'light, the great magician, which in a second can transform the trivial into the extraordinary'.

In the 1970s Savelev was an engineer at the Moscow Aviation Institute and was often sent on the road with a camera to record the work of his colleagues thoughout the Soviet Union. In 1977 he formed an informal group that later become known as the 70s Photographic Group, whose members included other Soviet-era photographic mavericks such as Boris Mikhailov and Sacha Sliusarev. In 1978 his first one-man exhibition took place at the Soviet Photo Gallery in Moscow. The exhibition closed after three days; Savelev suspects that his photographs were not deemed positive enough in their portrayal of working people. Images of people in industrial and decaying urban environments have remained a central theme in his photographs, but propaganda- or concept-based narratives have never infected his practice.

In its depiction of urban estrangement, Savelev's work often appears melancholic. He restricts the colour palette and overall illumination of his pictures, forcing the viewer to concentrate on the various elements within the frame, linked in a mysterious set of relationships that defy easy reading. Like Savelev himself, many of his subjects are solitary, waiting figures who seem lost in an impersonal urban realm.

ABOVE:
Moscow, 1988

RIGHT:
Moscow, 2008

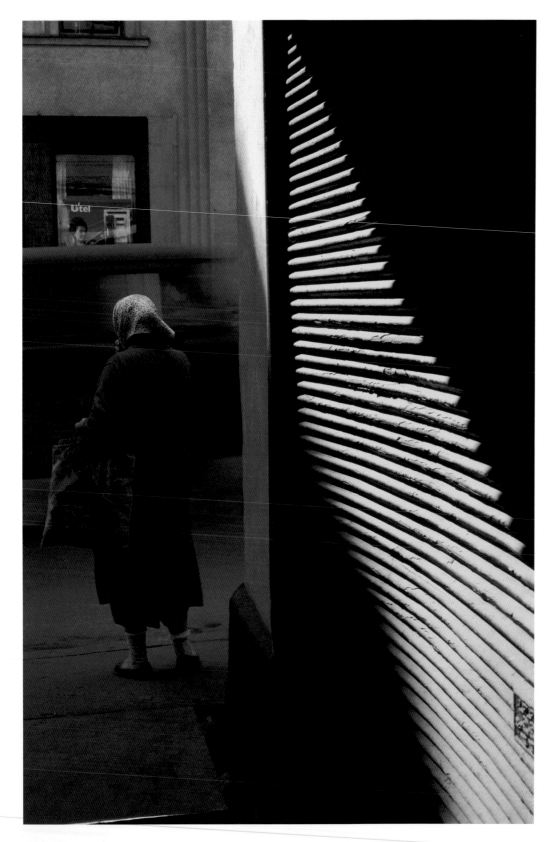

LEFT:
Utel, 1993

OPPOSITE:
Moscow, 2007

'I take a lot of photos when I'm drinking and they usually come out well. Sometimes, if they're not happening, I'll just drink some more.'

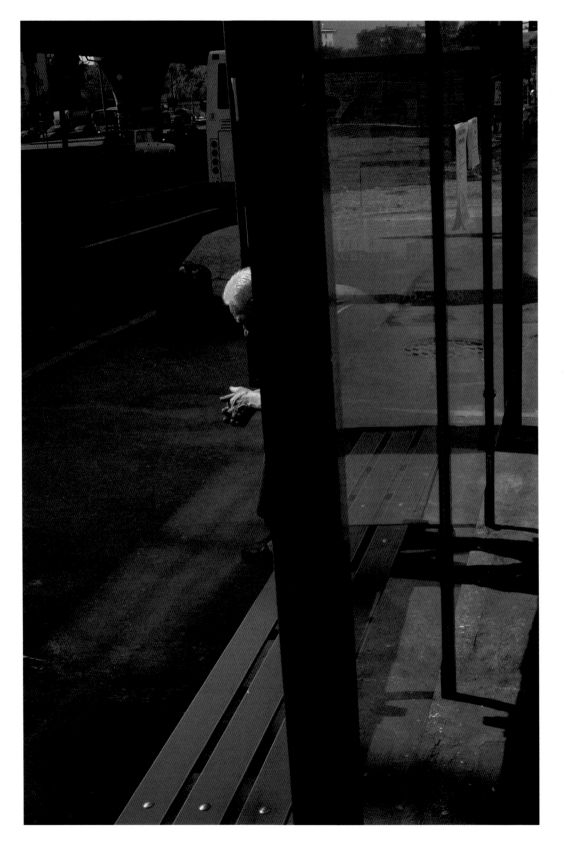

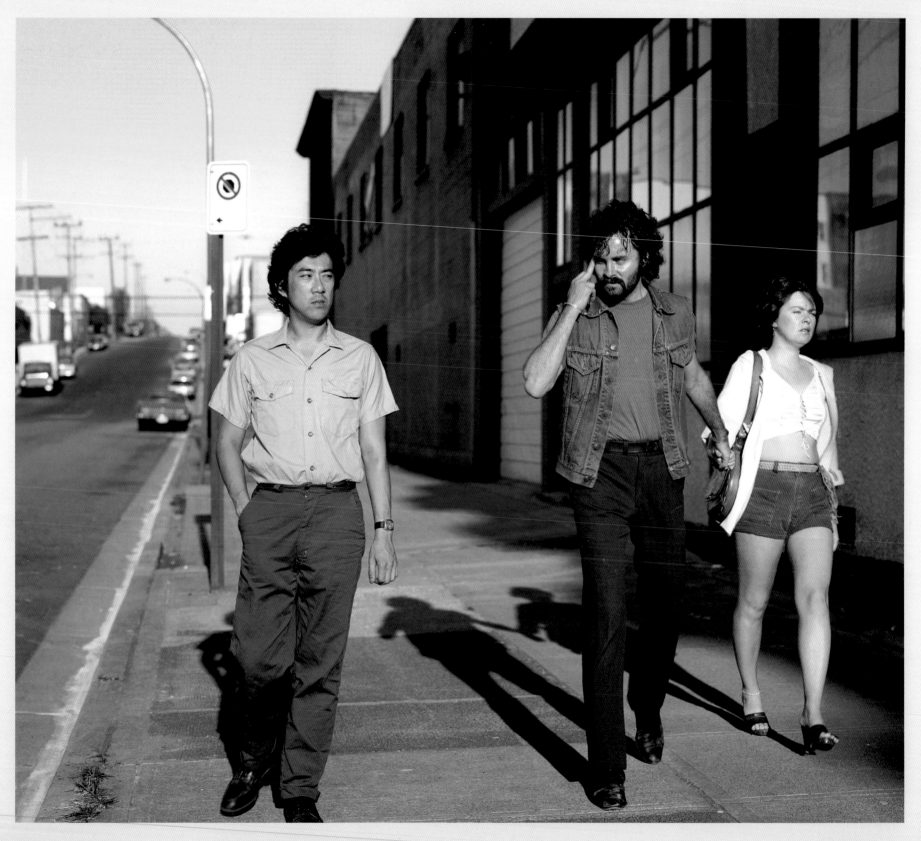

SOME TRUTHS CANNOT BE TOLD EXCEPT AS FICTION

With its fondness for the idiosyncrasies of everyday life, street photography has always played fast and loose with concepts of reality. Mischief-making and a capacity to take subjects out of context and juxtapose unrelated objects is in its blood. American photographer Richard Kalvar expresses this tension succinctly: 'I capture reality, never pose it. But once captured, is it still reality?'

Show a hundred people a dazzling street photograph brimming with uncanny incident and intrigue, and the vast majority will ask how the photographer set it up. Viewers are now so used to seeing images that have been tweaked or smoothed with a little Photoshop voodoo, or carefully planned with story-boards, models and props that they are disinclined to trust the candid moments captured by bona fide street photographers.

The relationship between truth and fiction in street photography has become even more complex in recent years. A new breed of artist–photographers, such as Philip-Lorca diCorcia, Gregory Crewdson and Matthew Baum, have enjoyed considerable success in adapting the look of candid street photography to playful ends. Whether they stage images on the street or digitally manipulate several street photographs to create fictional syntheses, their work throws up a multitude of questions. What is the documentary status of a composite image made up of candid shots? Where, exactly, does street photography sit in relation to the conventions of photojournalism and the liberties of art photography?

The ease with which photographs can be digitally manipulated, and the enthusiastic reception of staged photographs by the art establishment, has led to a crisis of confidence for some of those working in the documentary tradition. As photographer Tod Papageorge explains in an interview with Richard B. Woodward for *Bombsite* magazine: 'Now ideas are paramount, and the computer and Photoshop are seen as the engines to stage and digitally coax these ideas into a physical form – typically a very large form. This process is synthetic, and the results, for me, are often emotionally synthetic too.'

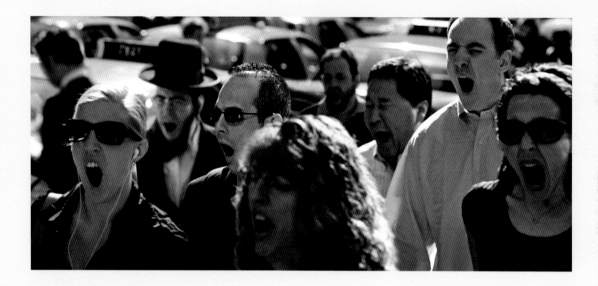

ABOVE:
Peter Funch, *Screaming Dreamers*, from the series *Babel Tales*, New York City, 2007

OPPOSITE:
Jeff Wall, *Mimic*, Vancouver, 1982

In another sense it is peculiar that the issue of authenticity should cause so much controversy among street photographers. One does not have to delve very deep into the history of the genre to discover just how many famous street pictures were staged, including most of Brassaï's *Paris by Night* and Bill Brandt's *A Night in London*, to give two well-known examples. Purists are often distraught when they discover that Robert Doisneau's iconic image *Kiss by the Hôtel de Ville* was a set-up. Doisneau himself was unapologetic: 'I would have never dared to photograph people like that. Lovers kissing in the street, those couples are rarely legitimate.'

Nevertheless, the disappointment we experience if we discover a street photograph has been staged is understandable. We look to these pictures not for the representation of a truth, but for a little bit of truth itself, a slice of real life that may or may not make sense but that we accept because we know it really happened. As one street photographer, commenting on Blake Andrews's website, explains his dislike of 'constructed' images, 'it somehow seems like a rejection of one of the innate

characteristics of the medium – its ability to freeze a real moment from a continuum and by doing so to fictionalize it.' But the candid camera has never been entirely truthful. A split-second exposure is often used to 'represent' anything from a minute to a decade. Certain things are included in the frame, but just as many are excluded. Some compositional elements are centred while others are left peripheral or out of focus. As early as 1938, American critic Lincoln Kirstein wrote that ' The candid camera is the greatest liar in the photographic family, shaming the patient hand-retoucher as an innocent fibber. The candid-camera with its great pretensions to accuracy, its promise of sensational truth, its visions of clipped disaster, presents an inversion of truth, a kind of accidental revelation which does far more to hide the real fact of what is going on than to explode it...It drugs the eye into believing it has witnessed a significant fact when it has only caught a flicker.'

One of the earliest street photographs to be presented as 'fine art' was Jeff Wall's *Mimic* (p. 178). Presented in a large, back-lit lightbox, the picture shows a white man walking down an ordinary Vancouver street with his girlfriend in tow, pushing back his eyelid in a casual but distinctly racist gesture that alludes to the Asian man who walks just in front of them. The photograph is a re-enactment of a real-life scene Wall had observed. It is anything but candid, but this does not mean it is not a documentary image.

Mimic makes a persuasive case for the argument that some truths are best told as fiction. Rather than resign himself to the problem of 'near-misses' that plague all street photographers, Wall imprinted the scene on his memory and later re-created it for his camera. In an interview with David Shapiro for *Museo* magazine, he considers how his work fits into a documentary tradition: 'I think in 1945 or 1955, it was clear that if you wanted to come into relation with reportage, you had to go out in the field and function like a photojournalist or documentary

photographer in some way...I think that's what people in the 70s and 80s really worked on: not to deny the validity of documentary photography, but to investigate potentials that were blocked before, blocked by a kind of orthodoxy about what photography really was.'

American-based British photographer Paul Graham is another who has resisted the orthodoxies of street photography. The images in his 2007 *A Shimmer of Possibility*, a series of twelve artist's books, are all candid, but sequenced in a way that aligns them more with fiction. Each volume in the series is structured as a narrative, with photographs of simple everyday activities such as cutting the grass or waiting for the bus, smoking cigarettes or travelling to and from the supermarket, montaged, repeated, interwoven or contrasted. In an interview with Richard B. Woodward, Graham explains his dissatisfaction with classic documentary photography. 'It was wonderful when it was invented. But it has to be alive, to grow, develop, just like the spoken word. We don't speak the same way we spoke in 1938 or 1956, so why should we make pictures the same way?' He resists all temptation to make daily life seem any more eventful than it really is. The truth is that most of us spend much of our time doing unremarkable things and his achievement is to make a memorable social document out of such banality. Inspired by Chekhov's short stories, the overall theme is of lost potential or failure of significance in everyday life. There may be a shimmer of possibility in each one of these people, but we never see it realized.

Bruno Quinquet's *Salaryman Project* (pp. 160–61) is another carefully manipulated study of ordinary lives and unrealized potential. Candid pictures of several different Japanese businessmen going about their daily commuting and work routines in Tokyo are collated into a fictional portrait of a twenty-first-century wage-slave rendered anonymous by bureaucracy. The project is ingeniously presented in the format of a weekly business scheduler, which underscores the salaryman's conformity. Even though the series is made up of portraits of

'I'm not interested in being objective. I like playing with tools and playing with minds.' Peter Funch

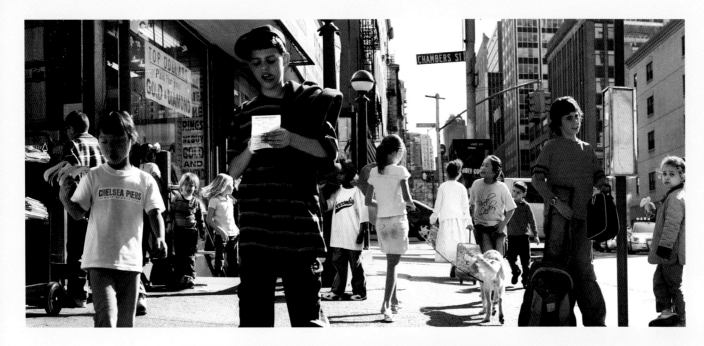

Peter Funch, *Juvenile Bliss*, from the series *Babel Tales*, New York City, 2007

many different workers, once they adopt their business uniforms, ride the subway and walk through the glassy doors of their office buildings, they become indistinguishable from one another, forming the portrait of a modern-day Everyman.

Dutch photographer Peter Funch explores patterns of public behaviour through digitally composed panoramas made up of dozens of individual street photographs. *Babel Tales* is a series of elaborately composed photographic friezes showing an appropriately cosmopolitan cast of characters assembled on the street corners of Manhattan. The images owe a clear debt to the 1960s street photography of Joel Meyerowitz and Garry Winogrand that celebrate the sidewalk as a locus of urban energy. But Funch is also excited by the possibilities that new technology offers the street photographer to enjoy the compositional freedom of a painter or filmmaker. 'I'm not interested in being objective' he explains, 'I like playing

with tools and playing with minds.' *Screaming Dreamers* shows eight passers-by yawning as if struck by a collective epidemic of fatigue. *Juvenile Bliss* offers a fantastical vision of Manhattan populated only by kids. *Following Followers* gathers a crew of hipster dog-walkers to the same place at apparently the same moment, and for a split-second the city's four-legged inhabitants seem to outnumber its two-legged ones.

German photographer Mirko Martin has taken the American film industry as the inspiration for his *L.A. Crash* project, which documents the making of Hollywood crime movies, mixing straight photographs of scenes being staged for the film cameras with real street scenes in nearby neighbourhoods. 'I started out taking pictures on film sets in downtown L.A., trying to capture the scenes in such a way that their fictional character would not be revealed to the viewer. While working on the project, it seemed remarkable to me that the sites where the dramas

'I want to address our habitual ways of seeing, our trained eye, our knowledge of culture, film and photography.' **Mirko Martin**

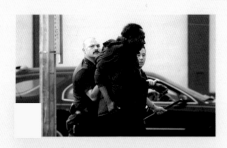

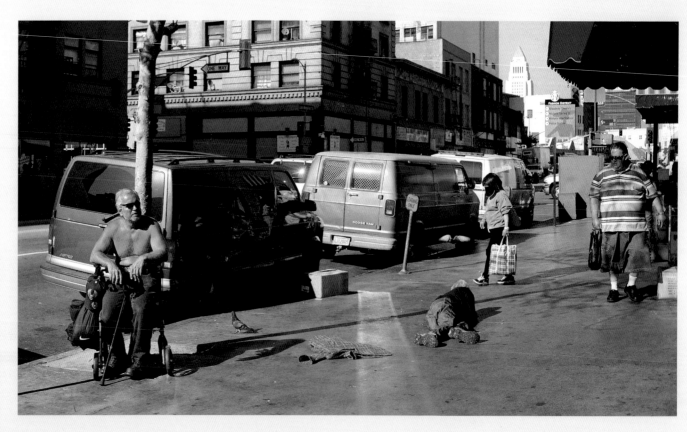

were staged were often located in extremely run-down places with a high rate of homelessness and a strong police presence, so that tension-filled scenes could be observed even beyond the movie sets.' Martin deliberately blurs the boundaries between reality and fiction by obscuring the backstage lighting and rigging in his film-set images. Because we do not know which of his images are real and which are staged, the project becomes a powerful commentary on the slippage between cinematic and real-world violence, and more broadly on the pervasive influence of the film industry on our attitudes to race and violence.

The intersection between real and culturally mediated lives also intrigues Slovakian photographer Martin Kollar. While documenting the aftermath of Hurricane Katrina, Kollar started photographing the attendant TV news circus with its halogen-lit anchormen hooked up by satellite to twenty-four-hour news feeds. Heavily made-up reporters stand with peculiar composure in their own little stage sets, surrounded by the devastation of the hurricane. Kollar has continued the series, documenting the making of other news stories on location, exposing the smoke-and-mirrors artifice of the modern news-media machine.

As the fretful debate about what counts as 'proper' street photography continues among the keepers of the flame, the advertising industry has enthusiastically embraced both real and staged street photographs. The 'street photography look' – with its connotations of quirkiness, fun and good luck – is increasingly used to give products a sense of urban authenticity in campaigns advertising everything from sportswear to mobile phones. Sometimes a photographer may be paid to walk the streets for days on end with the hope of getting the right shot to suit a campaign, but in a world where time is money and model-release issues are hotter than ever, street photographers are much more likely to be paid handsomely to 'fake it'. Telling the difference isn't always easy: Matt Stuart's 2007 campaign for the Grand Tour exhibition at the National Gallery in London was candid, but Nick Turpin's 2008 campaign for IBM was staged.

Asked if his pictures were posed, the great American street photographer Garry Winogrand answered: 'I'll say this, I'm pretty fast with a camera when I have to be. However, I think it's irrelevant. I mean, what if I said that every photograph I made was set-up? From the photograph, you can't prove otherwise. You don't know anything from the photograph about how it was made, really. But every photograph could be set up. If one could imagine it, one could set it up.'

If one could imagine it one could set it up: that's the crux of the matter. Although it remains an open contention where truth and fiction elide in street photography, for many contemporary practitioners the best proof of authenticity is in the improbability of what they have captured. New York photographer Melanie Einzig puts it succinctly: 'At a time when staged narratives and rendered images are popular, I am excited by the fact that life itself offers situations far more strange and beautiful than anything I could set up.'

OTTO SNOEK

b. Rotterdam, the Netherlands, 1966,
lives in Rotterdam

Otto Snoek is a cheeky and inquisitive Dutch
photographer who revels in the visual dissonance
and culture clashes in his hometown of Rotterdam,
the Netherlands' second city. 'Floods of new
immigrant faces arrived, creating big changes in
a town that was already in a process of endless
reconstruction. The city became increasingly
obsessed by leisure and spectacle and now claims
to be the town of festivals,' explains Snoek. 'This
new Rotterdam demanded a new photographic
approach.'

For the past ten years Snoek has been trying
to document 'the ambivalent relationship between
the promise and the letdown' in the modern urban
Netherlands. His photographic method is as brash
as his subject-matter. Snoek and his bulky medium-
format camera and flash gun are usually found in
the front row during any incident in Rotterdam,
gawking at the crowd as his unflinching eye
vacuums up all the contradictions that multicultural
Holland has to offer. Women in hijab jostle in his
frames with rave-generation hedonists, grumpy
senior citizens and the finest Eurotrash suntans
and fake breasts.

In Snoek's agitated, boistrous pictures
aggression is never far from the surface. 'People
can react unpredictably,' he admits. 'Occasionally
I face verbal aggression, though it seldom results
in physical violence. I don't make any particular
efforts to release tension. I used to describe my
sphere of work as a chicken run and my enterprise
as a city safari.'

ABOVE LEFT:
Rotterdam, Binnenrotte,
2007

LEFT:
Rotterdam,
Schouwburgplein, 1999

OPPOSITE:
Rotterdam, Hoogstraat,
2007

'I used to describe my sphere of work as a chicken run
and my enterprise as a city safari.'

OPPOSITE:
Rotterdam, Vasteland,
1999

BELOW:
Rotterdam, Karel
Doormanstraat, 2007

'Buy a good pair of comfortable shoes, have a camera around your neck at all times, keep your elbows in, be patient, optimistic and don't forget to smile.'

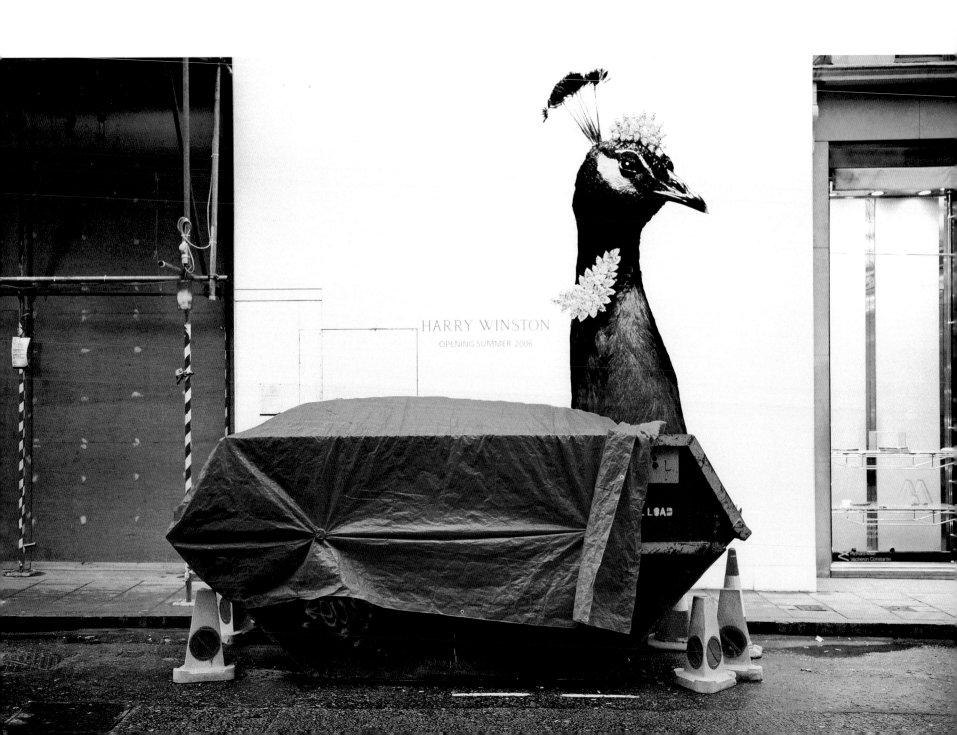

MATT STUART

b. London, 1974, lives in London

If there is a photographer working today who seems to have eyes in the back of the head, it is Matt Stuart. Stuart is a hyper-alert, ever-watchful presence on London's streets, a man with an uncanny ability to be wherever something unexpected or peculiar is happening.

'I am not sure which came first, being nosey or an interest in street photography,' he explains, 'but a fascination with people and the way they live their lives is why I enjoy the business so much. I can't hide behind lights and technology, I rely on a small Leica camera, patience and lots of optimism. But what I get in return is the chance to make an honest picture, which people know immediately is a genuine moment and which hopefully burrows deep into their memories.'

On his website, Stuart professes to 'Shoot People' and 'Snap Legs', and much of his work has a comedic turn. His best shots remind us that photography does not just excel in the darkest moments, but also when it celebrates the absurdity of life. He uses his upbeat and charming demeanour to slip inside the comfort zones of notoriously private Londoners, his apparent lightness of touch masking a steely resolve to extract moments of truth from the city he stalks remorselessly. Often these truths bring a smile of recognition from viewers, at other times a wince of self-consciousness.

Stuart is a generous supporter of other street photographers and one of the guiding forces behind the website www.in-public.com. His advice for aspiring street photographers is practical and down-to-earth: 'Buy a good pair of comfortable shoes, have a camera around your neck at all times, keep your elbows in, be patient, optimistic and don't forget to smile.'

ABOVE RIGHT:
Hyde Park,
London, 2004

BELOW RIGHT:
Trafalgar Square,
London, 2006

OPPOSITE:
Bond Street,
London, 2006

OPPOSITE:
Oxford Street,
London, 2006

BELOW:
Oxford Street,
London, 2004

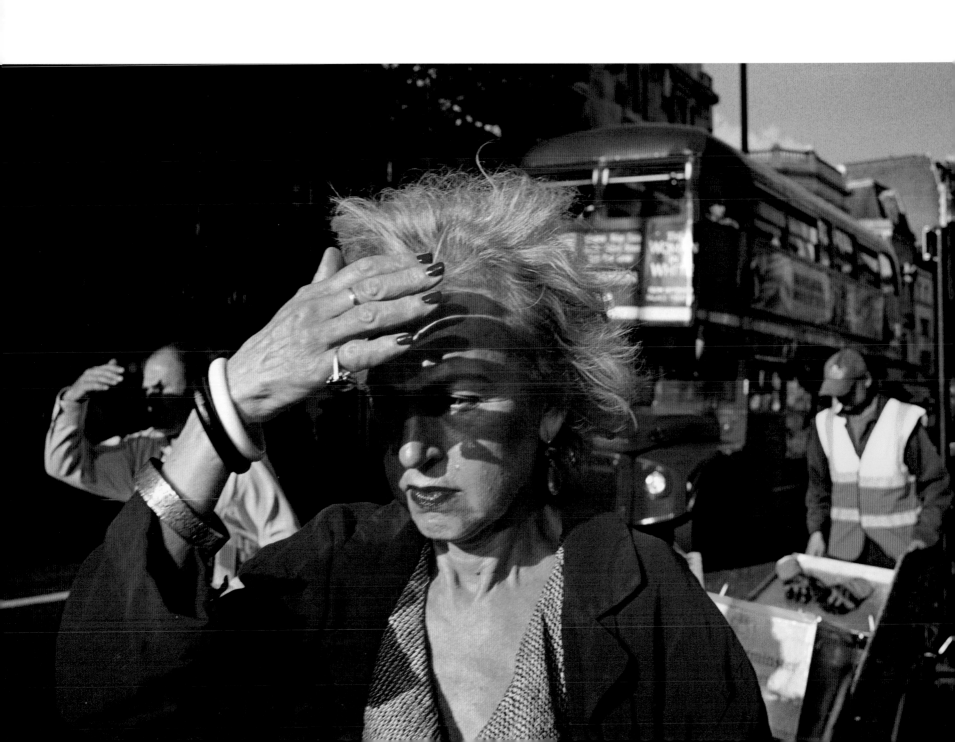

MATT STUART: PUTTING YOU IN THE PICTURE

'It was two flashes of red – a woman's turban and a discarded box of chips – that got my radar twitching as I walked down a very busy Oxford Street. I noticed that the woman was furtively eating fast food and decided to take some shots as it seemed like a grimy place to be eating lunch. I took a few frames from behind, which weren't that interesting, but just as I got close, she sensed my presence and turned round and I got this picture. Although she gave me a killer look, she went straight back to her snack, which I thought was quite strange.

People looking at this shot often notice the discarded chips on the pavement and assume that I frightened her into dropping them. In fact they were on the floor already but I don't mind people thinking that I was responsible. Part of the fun of this kind of photography is that people can make their own assumptions about what went on. All I know is that I took one shot and left without either of us saying a word.

I am really interested in the way that people nowadays create their own little personal spaces in amongst the city's chaos where they can gulp a meal down. If you remember, Garry Winogrand used to talk about people as animals and when you see situations like this you know that there is a bit of the feral animal in all of us.'

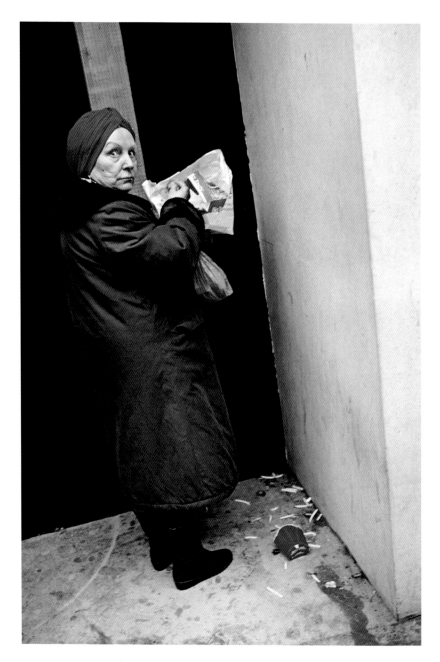

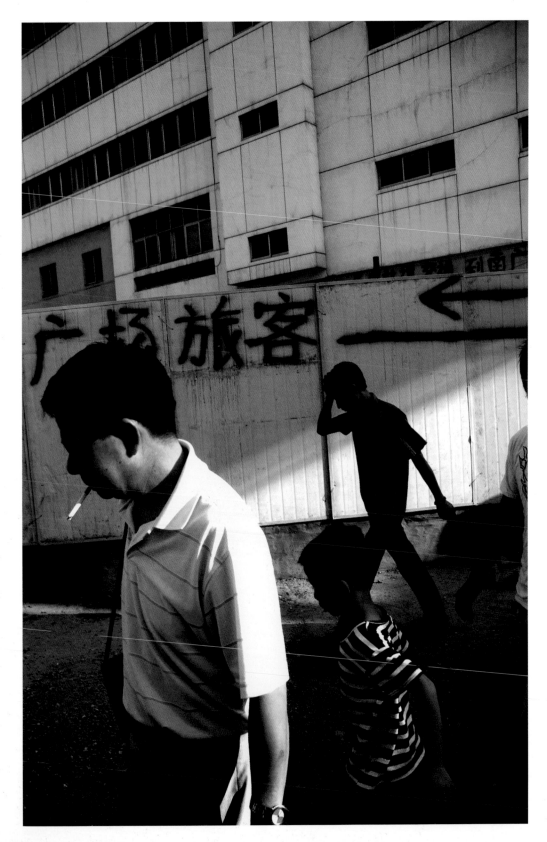

YING TANG
b. Shanghai, 1976, lives in Shanghai

'I am a very shy person,' Ying Tang explains. 'The camera gives me confidence to communicate with the world around me.' In spite of her shyness, Tang has developed a massive following on Flickr, inspiring photographers around the world with her gentle empathy and technical rigour. Her photographs are unsentimental but full of feeling, offering an affirmative outlook on an often harsh reality.

Tang spent most of her twenties studying and working in the USA. Her first book was a street-portrait of San Francisco. In 2007 she moved back to her native Shanghai, and since then she has immersed herself in documenting a city in the throes of massive change.

Whether it be the rise of pets as fashion accessories among Shanghai's nouveau riche, the city's increasing crisis in garbage management, or its inhabitants' mass consumption of poultry, Tang identifies photographic projects that allow her to communicate her personal philosophy. 'I don't see my work as either photojournalism or documentary. What is important is to catch moments that mean something for me, to show my own point of view through the people I shoot on the street.'

Working primarily in black-and-white, Tang has complete fluency with shadow, shape and line. From a jumble of dogs, umbrellas, pigeons, bicycles, newspapers, shoes and other urban detritus, she is able to pick out decisive moments. There is humour in her work – a woman cropped just above the knee walks past a pile of mannequin legs, a man coos at his chihuahua, who returns the gesture – and pathos: two men and a boy walk swiftly past her lens, heads bowed as if swept involuntarily in the direction of a graffiti arrow behind them. Many images show people making do and getting by: three men play cards on a cardboard box while a fourth rests on an abandoned mattress. Above all, her work conveys the sense of a city in flux, nowhere captured more succinctly than in a close-up of four young boys playing games, one using a traditional yo-yo, one a portable electronic game and one a toy gun. Or is it real?

'For me it is a personal journey to be out there on the street.
I'm trying to catch a moment that means something to me.'

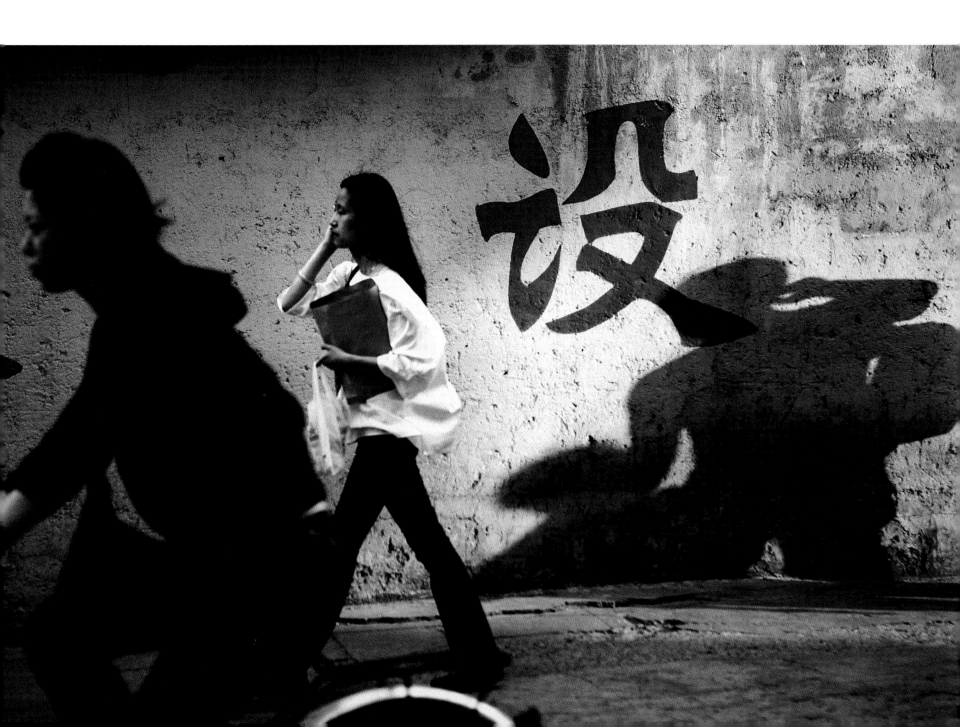

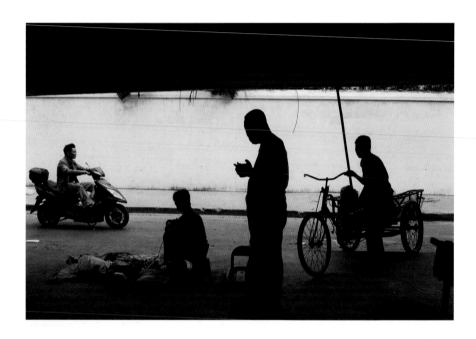

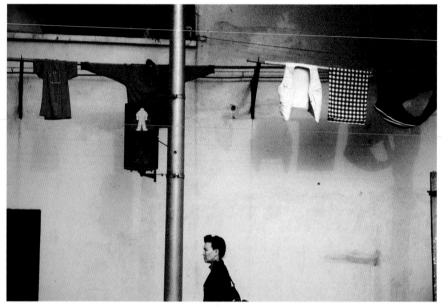

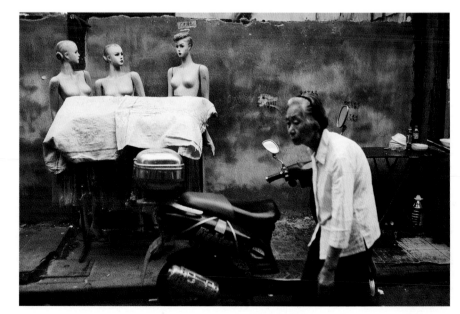

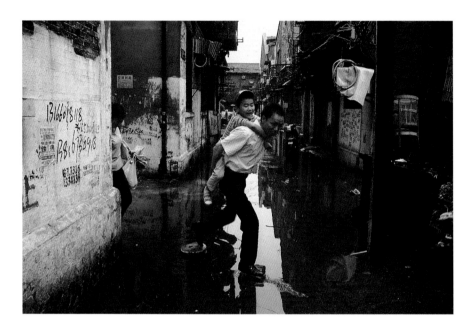

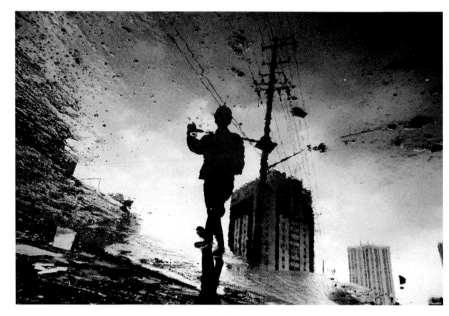

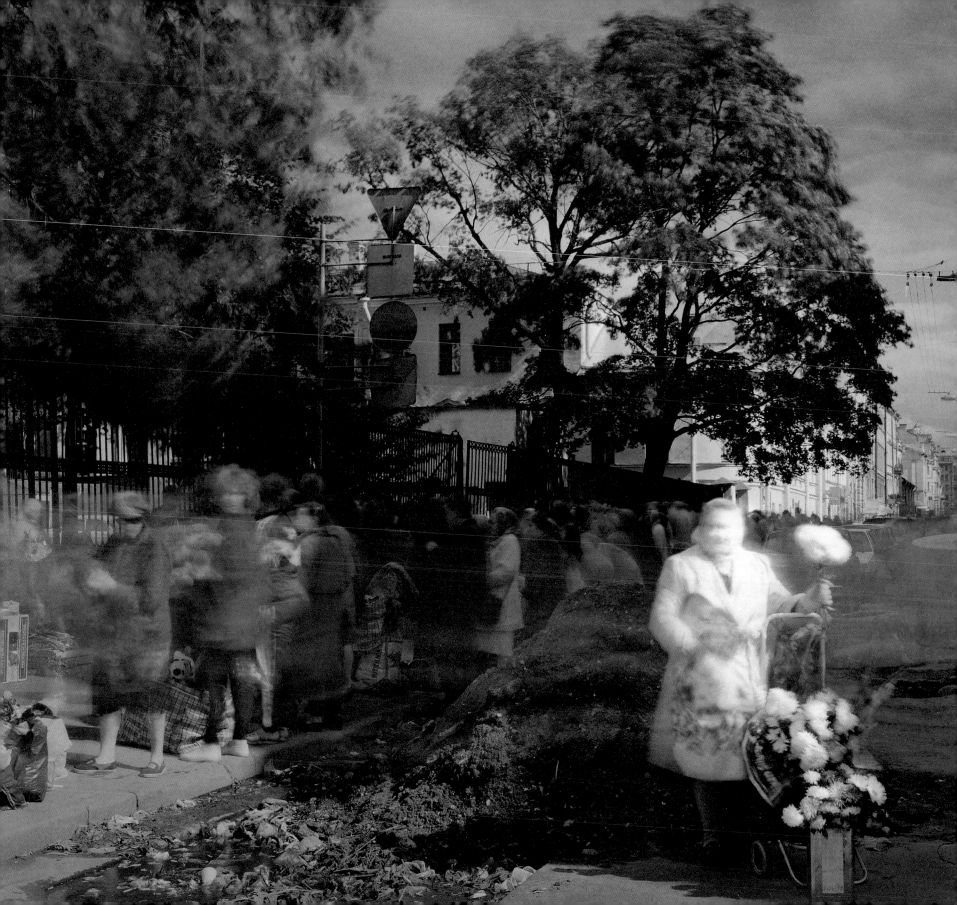

ALEXEY TITARENKO

b. Leningrad (now St Petersburg), 1962,
lives in New York City

Alexey Titarenko's street photography conveys a
moody and otherworldly artistic vision, using long
exposures that make his human subjects appear
fragile and ghostly. His distinctive style was inspired
by the technical constraints of nineteenth-century
French photography. Although his native St
Petersburg dominates his oeuvre, he has also made
work in Havana and Venice, cities whose historic
atmospheres intensify the sense of timelessness in
his images.

Like many photographers working in the Soviet
Union before its collapse, Titarenko joined a
photographic club – The Mirror – to evade censorship
as he developed his creative skills with the camera.
'You were free to show whatever you wanted. [The
club] was outside of state control, which was
extremely unusual. Most of the members were not
photographers; they were engineers, scientists,
writers, free thinkers, and they discussed all sorts
of ideas', he recalls. 'For me it was the foundation of
my artistic personality.' Later, as Russia lurched from
state socialism to free-for-all capitalism, Titarenko
tried to capture the intense uncertainties felt by so
many, 'the range of emotions forming the deep inner
character of the people who lived in this country
and endured all these disasters, people who were
usually only represented from outside.' His dramatic
long-exposure images from St Petersburg during
this time vividly convey the power and unbridled
movement of an urban crowd and, indeed, an entire
society in flux.

OPPOSITE:
Untitled, from the series
Time Standing Still, St
Petersburg, 1998

RIGHT:
Untitled, from the series
*Black and White Magic
of St Petersburg*, 1995

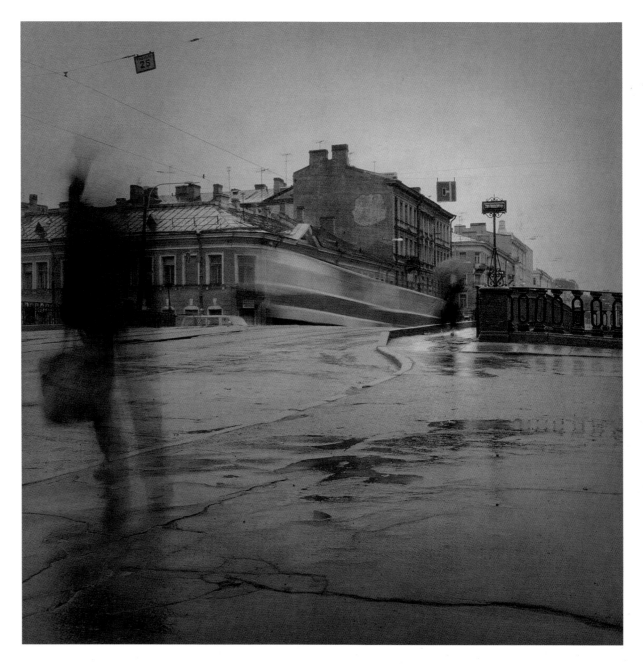

OPPOSITE LEFT:
Untitled, Havana, 2006

OPPOSITE RIGHT:
Untitled, Havana, 2003

BELOW LEFT:
Untitled, from the series
City of Shadows, St
Petersburg, 1992

BELOW RIGHT:
Untitled, from the series
City of Shadows, St
Petersburg, 1993

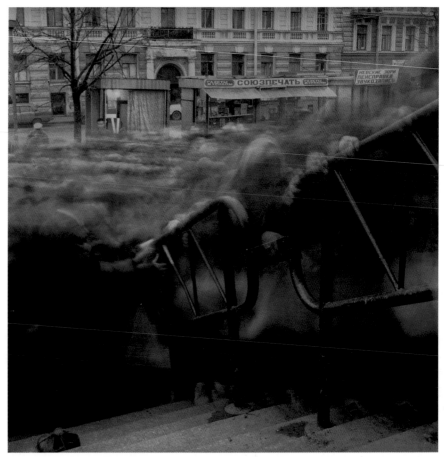

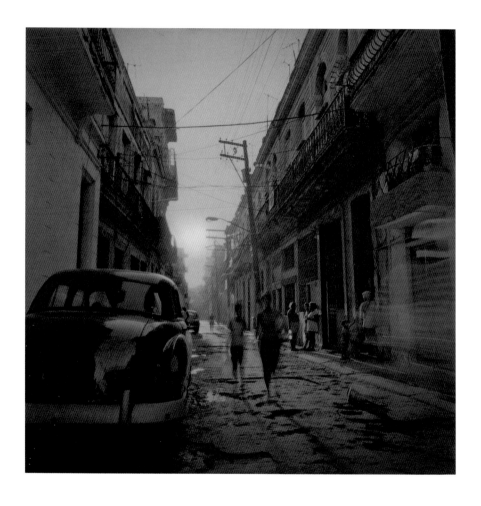

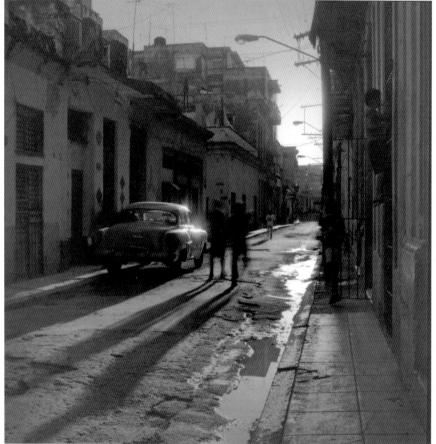

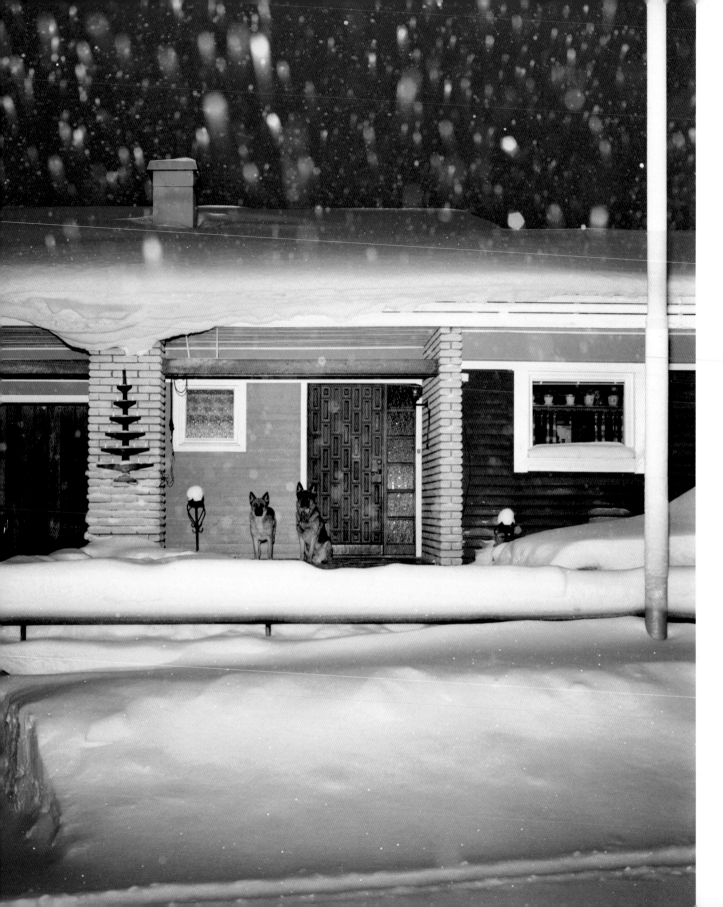

LARS TUNBJÖRK

b. Börås, Sweden, 1956, lives in Stockholm

Lars Tunbjörk is a curly-haired, bespectacled figure whose unthreatening demeanour masks a mischievous and playful personality. He works for the respected photojournalism agency VU, shooting events ranging from camel racing in Dubai to Paris Fashion Week in his own inimitable style, his camera and flashgun poking around wherever there is opportunity for telling comment and satire.

Tunbjörk's personal work focuses on the trials and tribulations of the place he knows best, Sweden. After spending many winters chasing sunlight abroad, he decided that to get a true representation of his countrymen's character he had to spend time exploring Sweden during the darker, colder months, eventually producing his 2007 book *Vinter*. 'A major aspect of Swedish culture, its literature and its films, is this strong melancholia, and I really tried to work with that....I really think the climate is a major reason: the hard winters and the bittersweet feeling in summer, which is wonderful, but you know it has to end. If you go to school's end before the long summer break, all over Sweden you will see parents crying when we sing the special summer psalm with its very beautiful bittersweet melody. Your time is counted.'

Unlike many other street photographers, whose work is centred on brief, random encounters and assumes no prior contact with their subjects, Tunbjörk develops a more intimate and sustained relationship with the people he photographs, relishing how the camera serves as an entry pass into the everyday lives of others. 'The camera is a protection, a tool to contact people. It gets me into different situations, which I wouldn't have managed without it.' Like Martin Parr, another photographer with a benign demeanour and a large flashgun, Tunbjörk is a modern-day photographic trickster who seems bemused and thrilled in equal measure by the crazy cavalcade to which his work allows him access.

LEFT:
Kiruna, Sweden, 2004

OPPOSITE:
Avesta, Sweden, 2007

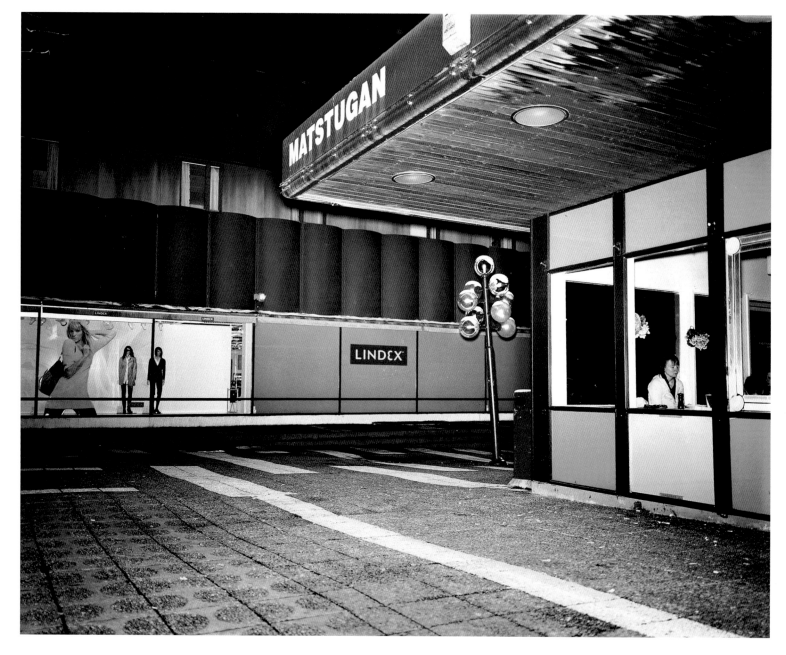

BELOW LEFT:
Timrå, Sweden,
2007

BELOW RIGHT:
Sala, Sweden, 2004

OPPOSITE:
Mölndal, Sweden,
2006

NICK TURPIN

b. Welwyn Garden City, England, 1969, lives in London

Witty, elegant and deceptively simple, Nick Turpin's street photographs wear their virtuosity lightly. They offer incisive social commentary without the heavy-handedness we so often associate with documentary. 'For me, pictures made in a shopping street or business district of a city reveal as much about our world as pictures made in places of international conflict or famine or environmental disaster', he says. 'If we have become workers and shoppers, our lives about earning and spending; if our families are separated and our neighbours are strangers; if our media are focused on celebrity, sex and sport, where can we look to be shown the state we are in? It is in images made right on the streets that we are best able to see the mixed blessings of life in a democratic free-market economy.'

Turpin makes his living from shooting fashion and advertising campaigns. The freedom of street photography brings him another kind of reward. 'It makes me feel special to be there but not to be chatting, not to be shopping or not even to be heading for somewhere else. I feel like I am invisible to the passing crowds. This in turn leads to a loss of my sense of self, which is the finest feeling of all.'

Turpin's dedication to the genre has seen him not only pursue his own work, but also act as a champion of contemporary street photography from around the world. In 2000 he founded the collective In-Public, in 2008 he set up the blog sevensevennine.com, and in 2009 he started a dedicated street photography magazine called *Publication*. He is, by his own admission, a street photography evangelist, and one of its most eloquent commentators.

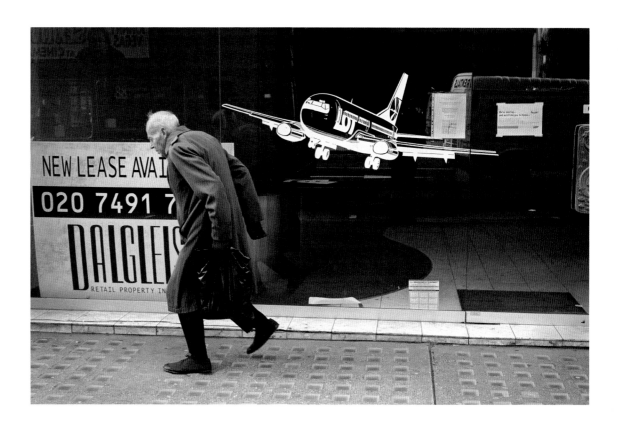

'My personal pictures don't have to "do" anything. They don't have to sell in a gallery or sit well beside the ads in a magazine. I don't have to make pictures that are easily categorized. They are not reportage. They are just pictures about life.'

RIGHT:
Piccadilly, London, from
Un-civil Aircraft, 2005

OPPOSITE:
Regent Street, London,
from *Un-civil Aircraft*,
2005

NICK TURPIN: PUTTING YOU IN THE PICTURE

'I HAD CHOSEN TO SHOOT a project called *Trading Life* about the men in suits who inhabit the financial district of London. I didn't research it like a photojournalist, I just turned up daily on the streets around the banks and the city wine bars where the bankers go for lunch.

First I noticed two guys who looked like characters from *The Matrix* in their matching dark suits and completely shaved heads. I followed them for several streets, hoping for another element to present itself and complete the picture. Looking ahead, I got into position as the two guys passed a shop with black bowler hats displayed on poles, and I took a frame that reminded me of a Magritte painting. It was nice, but still not enough. Eventually my patience was rewarded when two workmen in hard hats appeared in the opposite direction. I hit the shutter release at just the right moment as the four men were momentarily lined up.

The picture works on several levels. Initially it's just an amusing contrast; then you notice the subtler symmetry of heights and hands in the two halves of the picture. Finally, it's a record of the city at that time when land values were high, a building boom was on and bankers shared the streets with construction workers.

I guess sometimes when you cast out your line you get a good catch.'

Broadgate, London, from
Trading Life, 2004

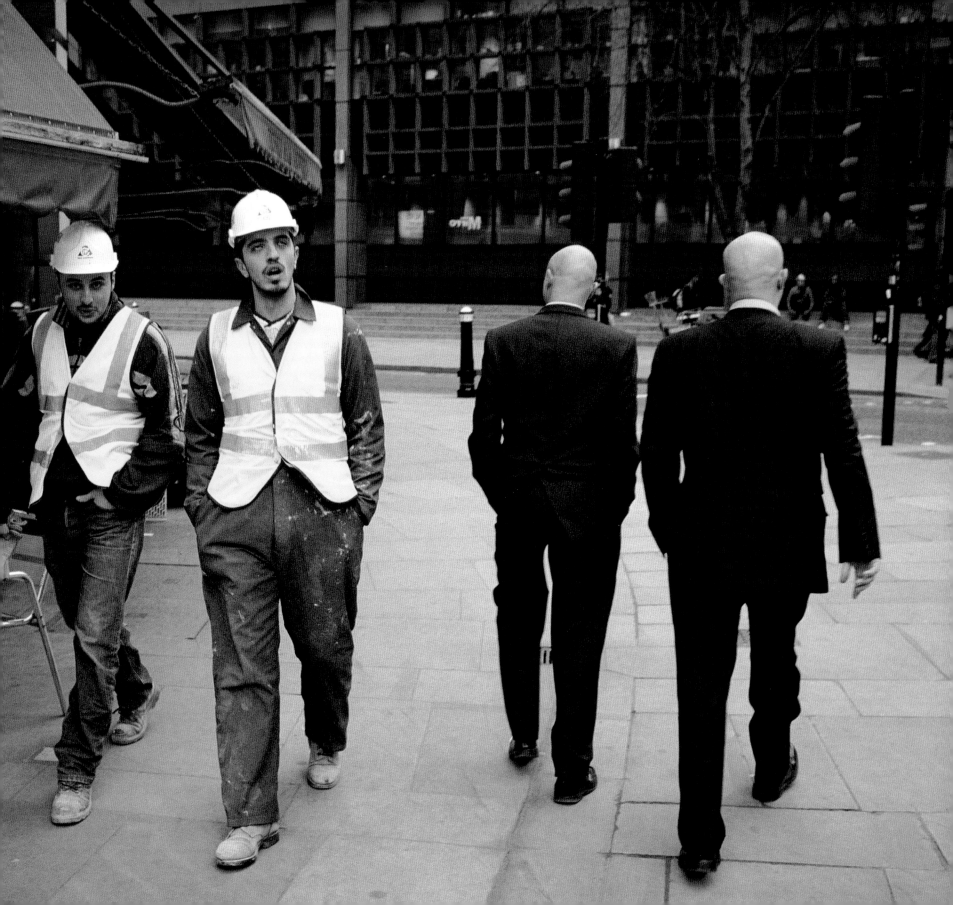

OPPOSITE:
Bishopsgate, London,
2004

BELOW:
The Strand, London,
2002

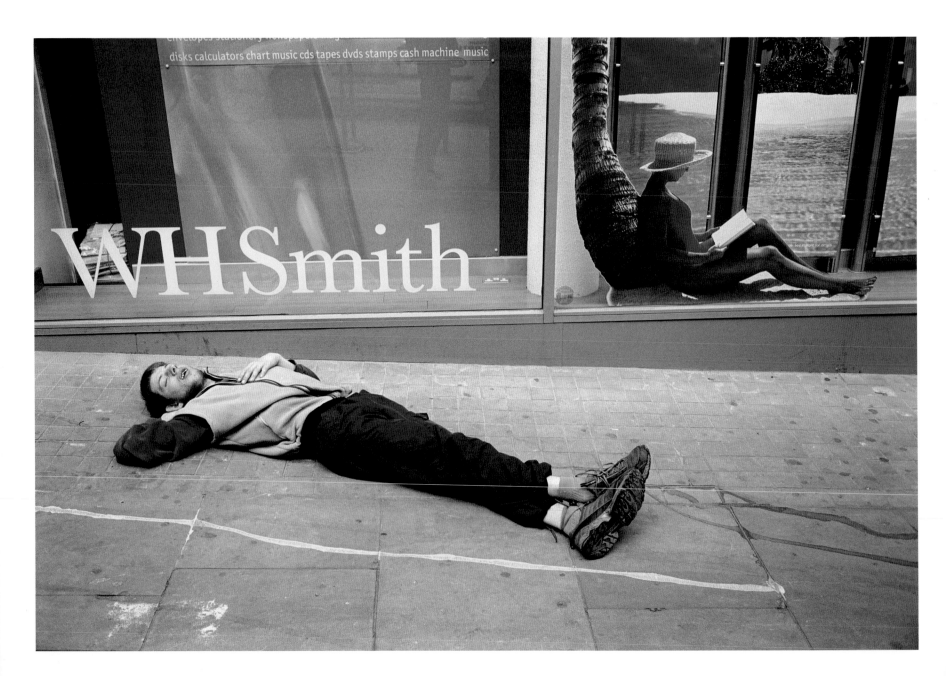

'I used to go fishing as a child, and now I see the street as a river, you just don't know what it's going to serve up, if anything.'

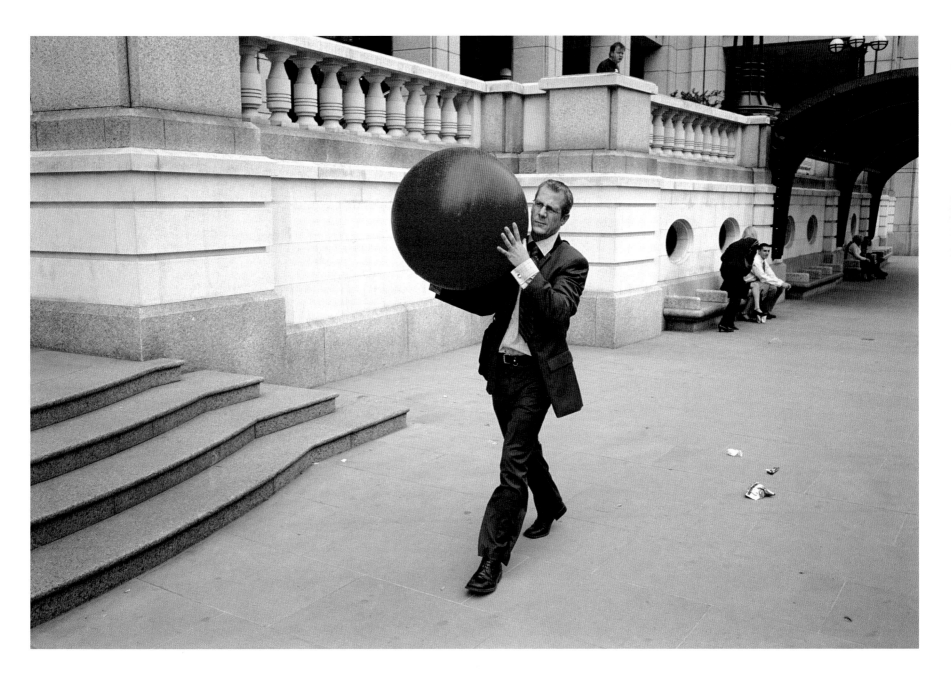

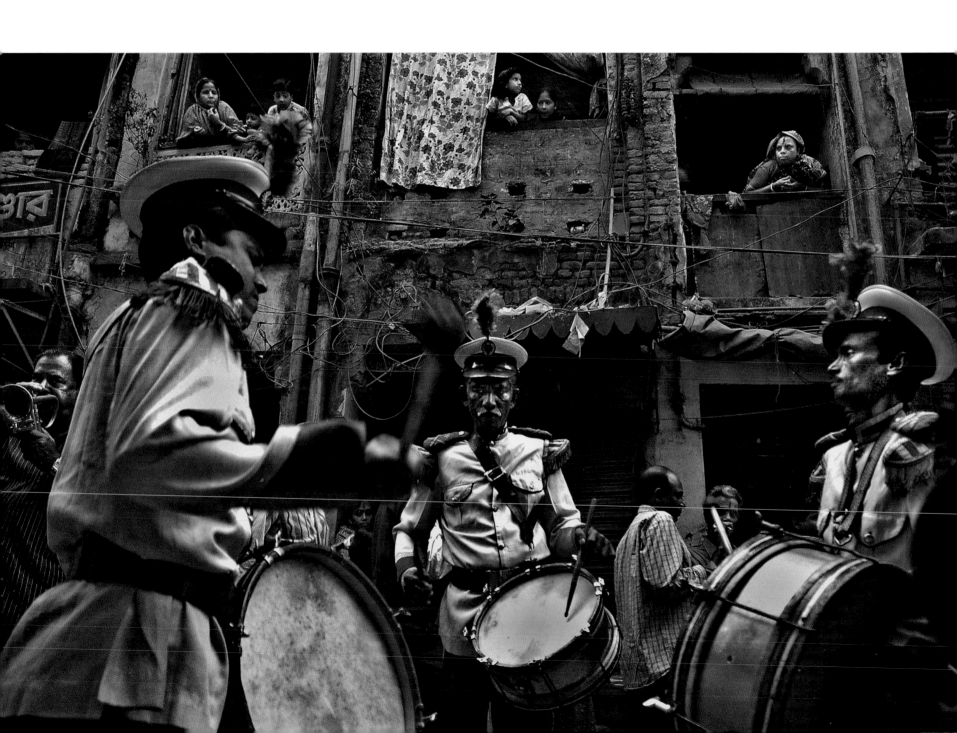

MUNEM WASIF

b. Comilla, Bangladesh, 1983, lives in Dhaka

Although Munem Wasif is one of the younger photographers in this survey, his achievements as a photojournalist belie his age. His work has been shown at Visa pour l'Image, the prestigious documentary photography festival in Perpignan, and he has found representation with Agence Vu in France who distribute his politically conscious work made in Bangladesh.

Bangladesh may not seem like a fertile location for street photography, but the Drik photo agency and the Chobi Mela photography festival, both based in the capital, Dhaka, champion a candid photojournalist approach. Much of Wasif's work has been made on his own doorstep.

'I have worked in Old Dhaka for years....I can smell this part of town and it is not easy to put into photographs. I was looking for something special in everyday life; I know it exists all around me, I just had to look differently.'

Wasif shoots in black-and-white, portraying Old Dhaka as a timeless and atmospheric city-within-a-city. 'I think I have fallen in love with photography because of some black-and-white images that haunted me all the time when I was learning photography. In the last eight years I have tried to see life in black-and-white, even when I am doing it in digital. This way I feel that my content takes priority.'

An intense sense of belonging, both for the photographer and for the inhabitants of Old Dhaka, brings authenticity to his work. While many street photographers avoid interacting with their subjects, Wasif, as a local, is as much a part of the community drama as those he photographs. 'They ask me, "Where have you been for so long?" "Why didn't you come for last Puja?" "Would you have a cup of tea?" "Oh! don't forget to give me those pictures."'

ALL IMAGES:
Dhaka, 2006

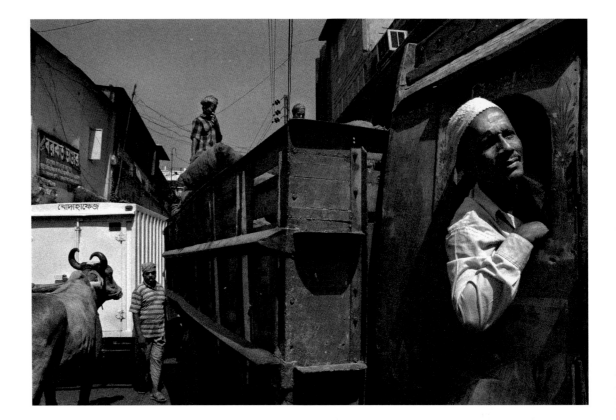

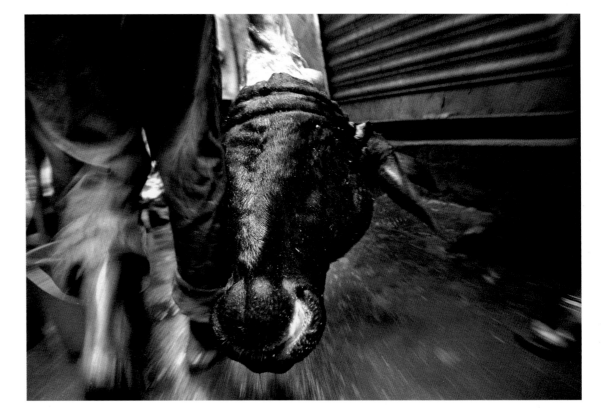

'Puran Dhaka, or Old Dhaka, was a rather unlikely subject. For it exists all around me. I live here. It was almost trying to find the unseen within the everyday.'

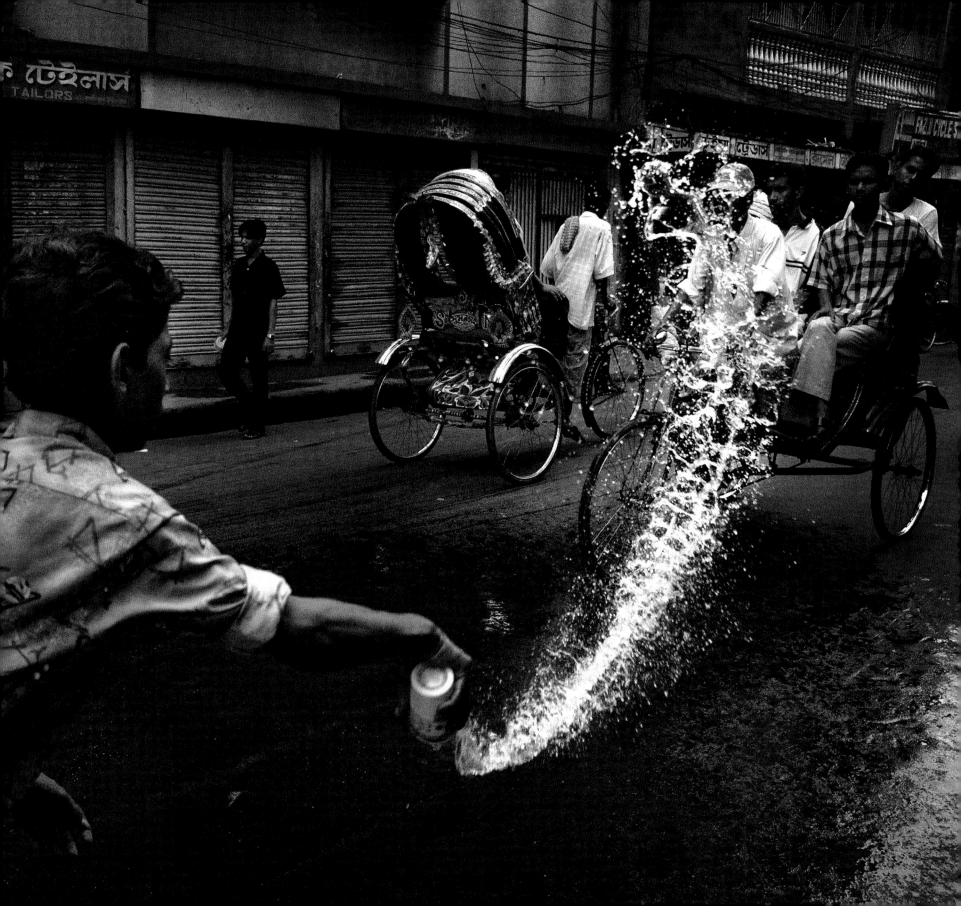

ALEX WEBB

b. San Francisco, 1952, lives in New York State, USA

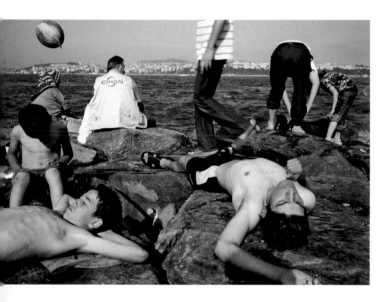

'I only know how to approach a place by walking. For what does a street photographer do but walk and watch and wait and talk, and then watch and wait some more, trying to remain confident that the unexpected, the unknown, or the secret heart of the known awaits just around the corner.'

'There are different kinds of photographers: some feel the need to photograph where they live, others leave home behind and explore,' explains American photographer Alex Webb. Raised in New England where 'things often happen behind closed doors', Webb became attracted to places 'where there is a certain level of political and/or cultural tension', which he documents being played out in daily life. Since the mid-1970s he has worked primarily in Haiti, Cuba, Mexico, other parts of Latin America and the Caribbean, as well as in Istanbul. Inspired by the intense colours and dramatic qualities of light in these countries, he abandoned black-and-white photography and has worked exclusively in colour since 1978. He has been with Magnum Photos since 1974.

Webb's way of working is almost ritualistic. He gets up early to wander the streets. Then, as the light becomes brighter, he often stops to eat or rest. In late afternoon, as the sun retreats, he is out again, people-watching and shooting quickly as deepening shadows and glorious hues animate his multi-layered compositions. The many hours spent walking through a city, observing the small incidents of daily life and tuning in to the peculiar rhythms of a social space, are critical to his success.

Literature – specifically fiction – has often inspired Webb's global explorations. He cites Graham Greene and Joseph Conrad among his early influences. It's important to him that his work in foreign countries is not overly influenced by non-fiction writing. 'I do not read too much journalistic, political, or historical writing before I go....I do not want my intellectual knowledge to hinder the immediacy of my visual response. What I am looking for is intuitive and non-rational: an insight into the unexpected or the secret heart of the known.'

ABOVE:
Istanbul, 2005

OPPOSITE:
Tenosique, Mexico,
2007

216

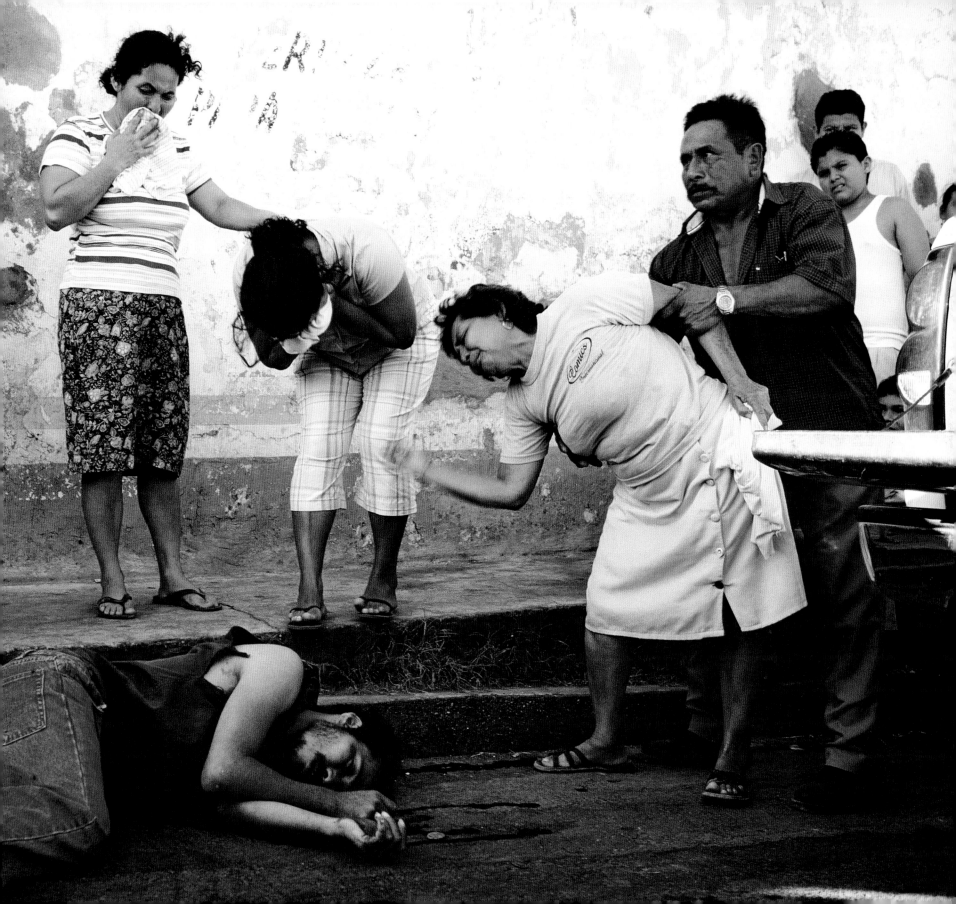

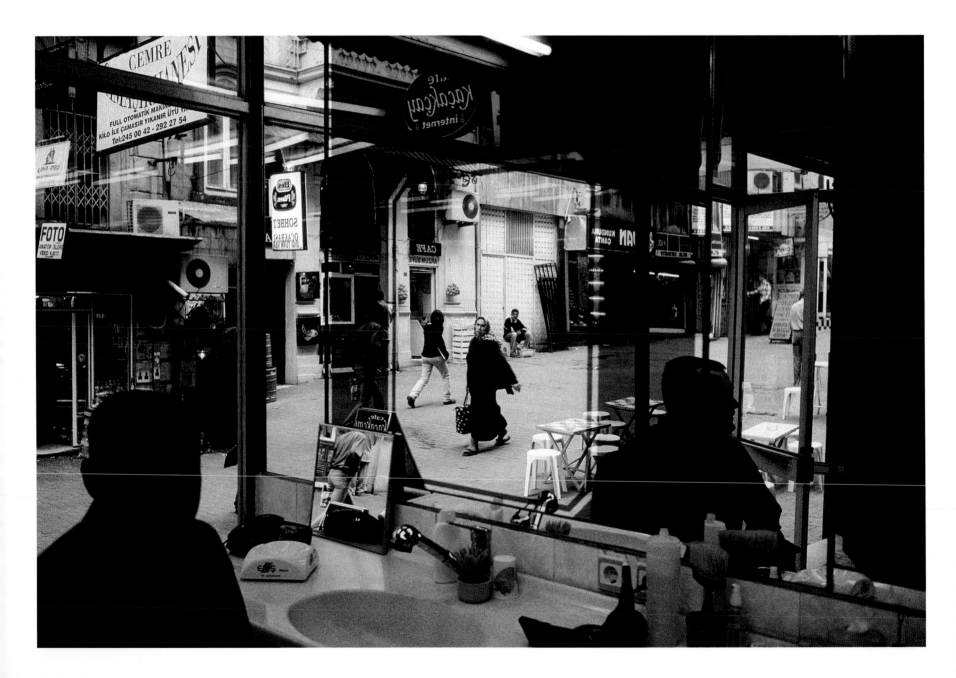

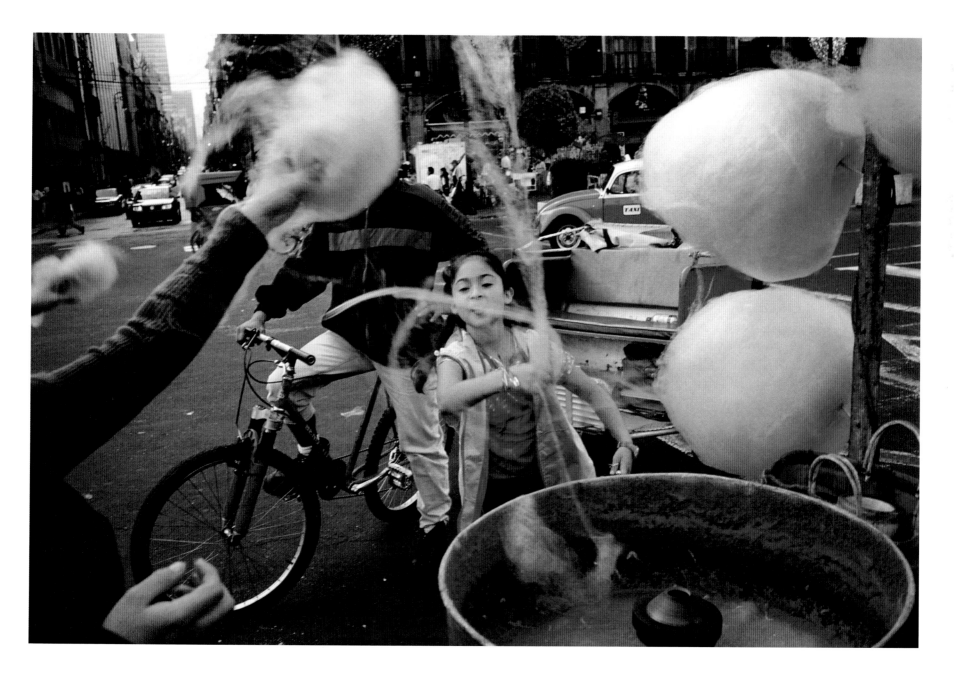

OPPOSITE ABOVE:
Gonaives, Haiti, 1994

OPPOSITE BELOW:
Nuevo Laredo,
Tamaulipas, Mexico,
1996

BELOW:
Havana, 2000

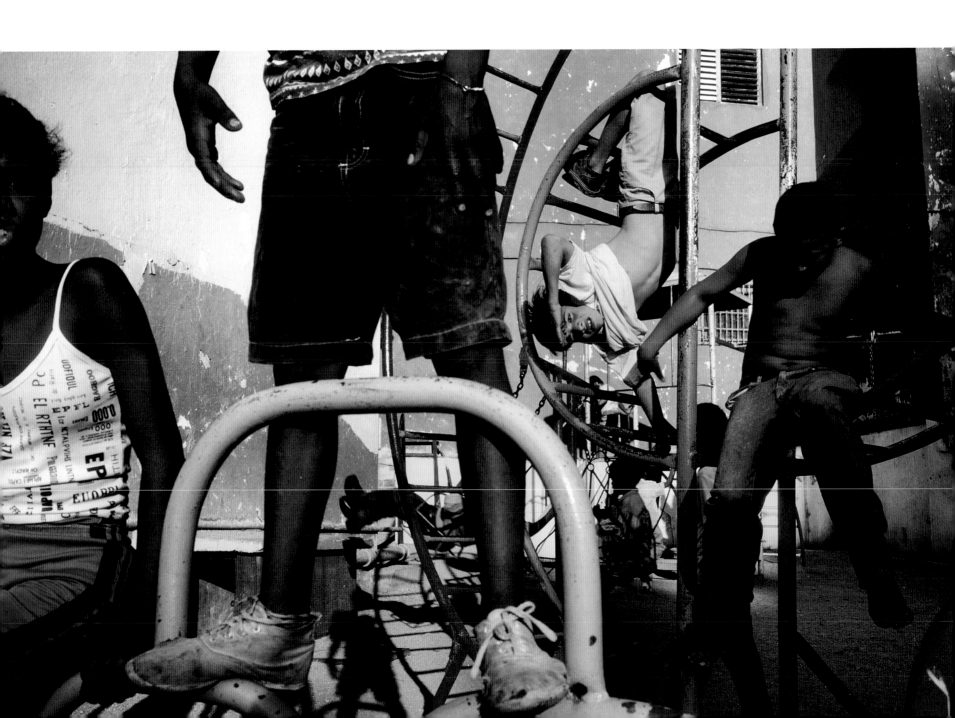

'In Haiti and along the US–Mexico border I began to sense something, a sense of energy on the street, a sense of life as lived on the stoop and in the street.'

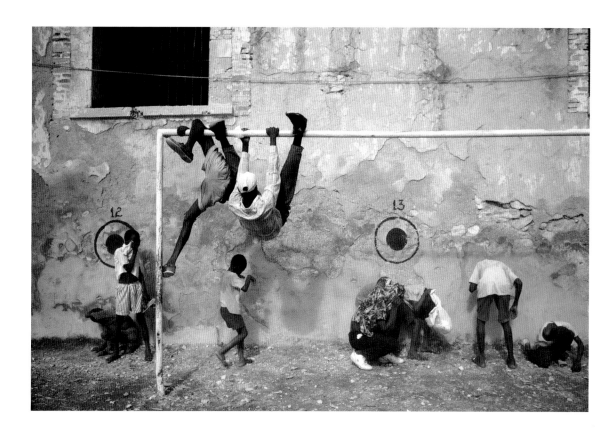

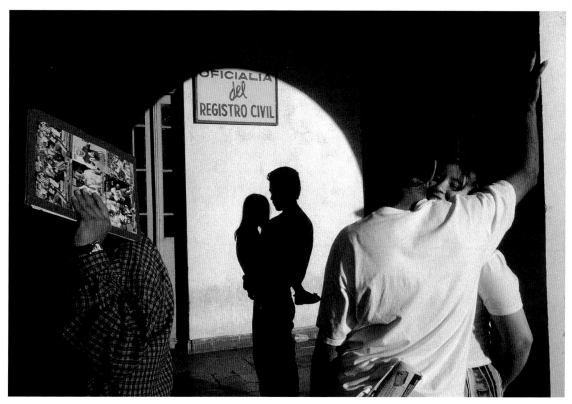

AMANI WILLETT

b. Dar es Salaam, 1975, lives in New York City

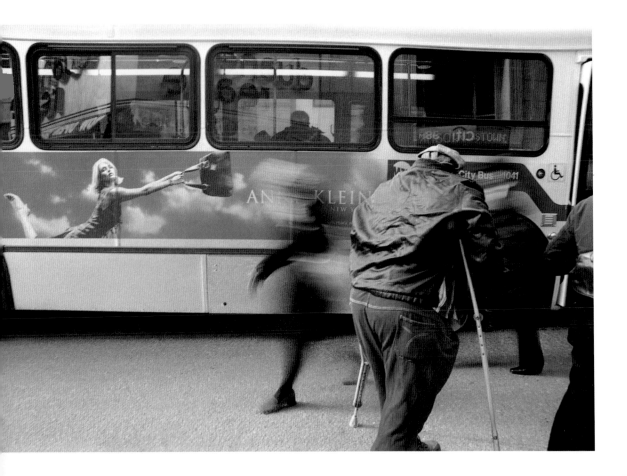

'One of the wonderful things about street photography is that most of the best images are ones that can never be re-created,' says Amani Willett. 'People often perceive identical situations in astonishingly different ways. I firmly believe that if you put five photographers on the same street corner, you will get five very different bodies of work.'

Willett, who was born in Dar es Salaam, has worked across the globe, undertaking extensive work with NGOs, including the Soros Foundation and the United Nations project on Children's Rights. Yet he is equally at home making fashion and advertising photographs in New York. 'I am always seeking new challenges,' he says of his strikingly diverse portfolio.

For Willett, looking through the eye of the camera is a way of delighting in vitality and nuance of life in a big metropolis. 'The best images ask more questions than they answer. I am attracted to images that you can look at over and over again and each time get something new, something fresh.' Willett's energetic photographs revel in the juxtapositions and curiosities that have long been a hallmark of New York street photography. Quick-witted and playful, they throb with the pulse of city life.

ABOVE:
86th Street, New York
City, 2004

OPPOSITE:
Canal Street, New York
City, 2005

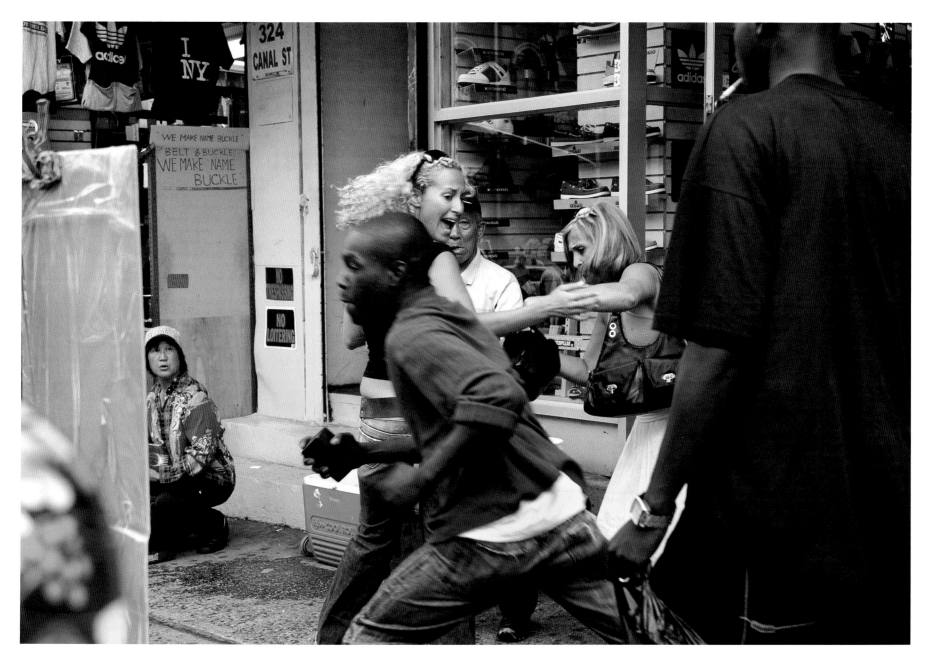

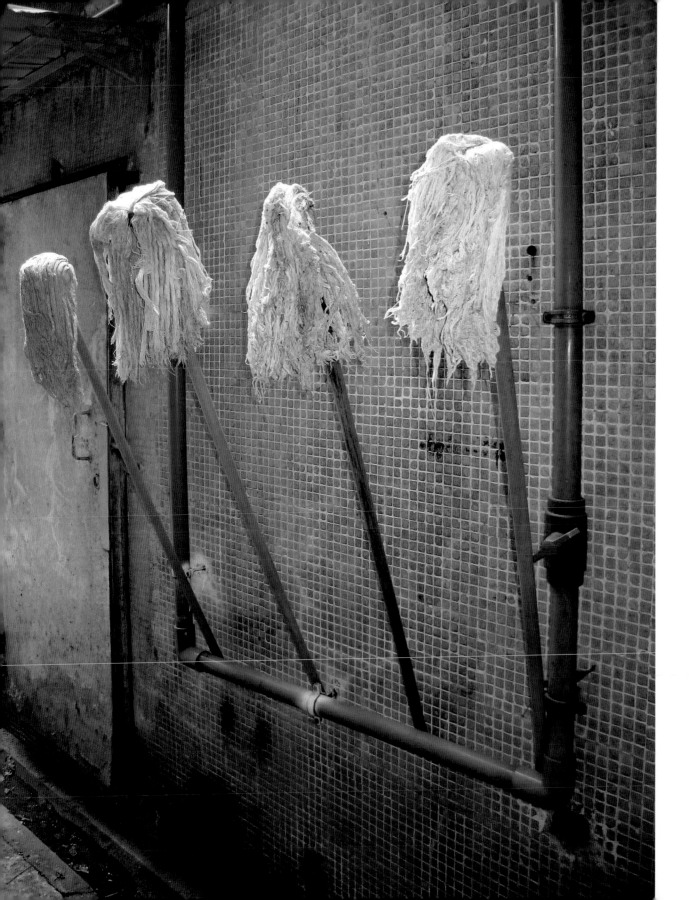

MICHAEL WOLF

b. Munich, 1954, lives in Hong Kong and Paris

Stimulated by the complex urban dynamics of his adopted home city of Hong Kong, German photographer Michael Wolf's photographs comprise a quirky and unique anthropological study. His vision of one of the most densely populated areas of the world is one surprisingly devoid of people: city-dwellers are present in his images only through the objects they use and sometimes abuse. Under the scrutiny of Wolf's photographic gaze, their random detritus morphs into a series of installations, made up of ordinary objects that are as fascinating for their form as for their function.

Wolf's witty photo-sculptures are testaments to human ingenuity. As he explains: 'Hong Kong is one of the most densely populated areas in the world. Most people do not have enough private space for their needs; therefore public space becomes private space. Private acts happen in public places: laundry and even vegetables are dried on fences surrounding the housing estates, houseplants are raised in back alleys, shoes are jammed under outside water pipes because there is no space inside for them, washed gloves are hug to dry on barbed wire. If there is no more space inside, something must go out: mops, shovels, pots and pans are hung on hooks on the walls outside of apartments. In order to survive in this dense environment, one must be able to adapt. In comparison to the ordered and well-planned European cities, Hong Kong is almost like a plant – it grows organically, making space for itself wherever possible.'

LEFT:
Hong Kong, 2007

OPPOSITE LEFT:
Hong Kong, 2003

OPPOSITE RIGHT:
Hong Kong, 2003

'When people don't have enough space, they improvise and adapt.'

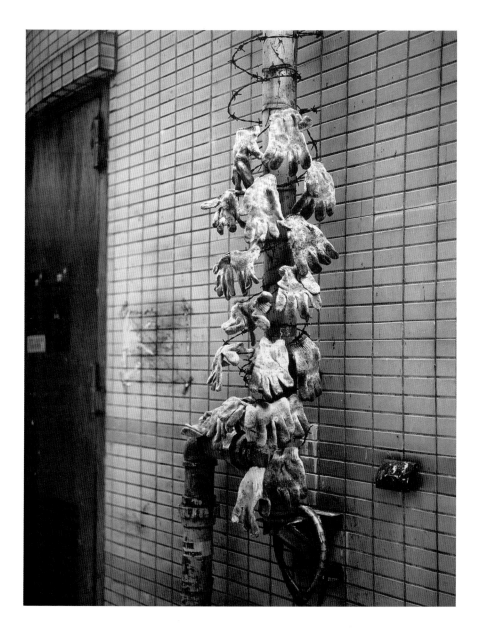

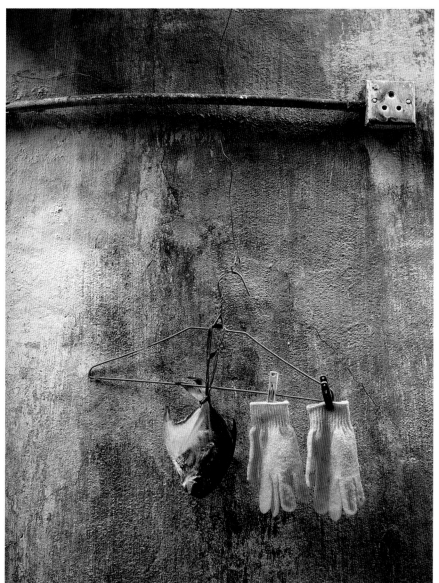

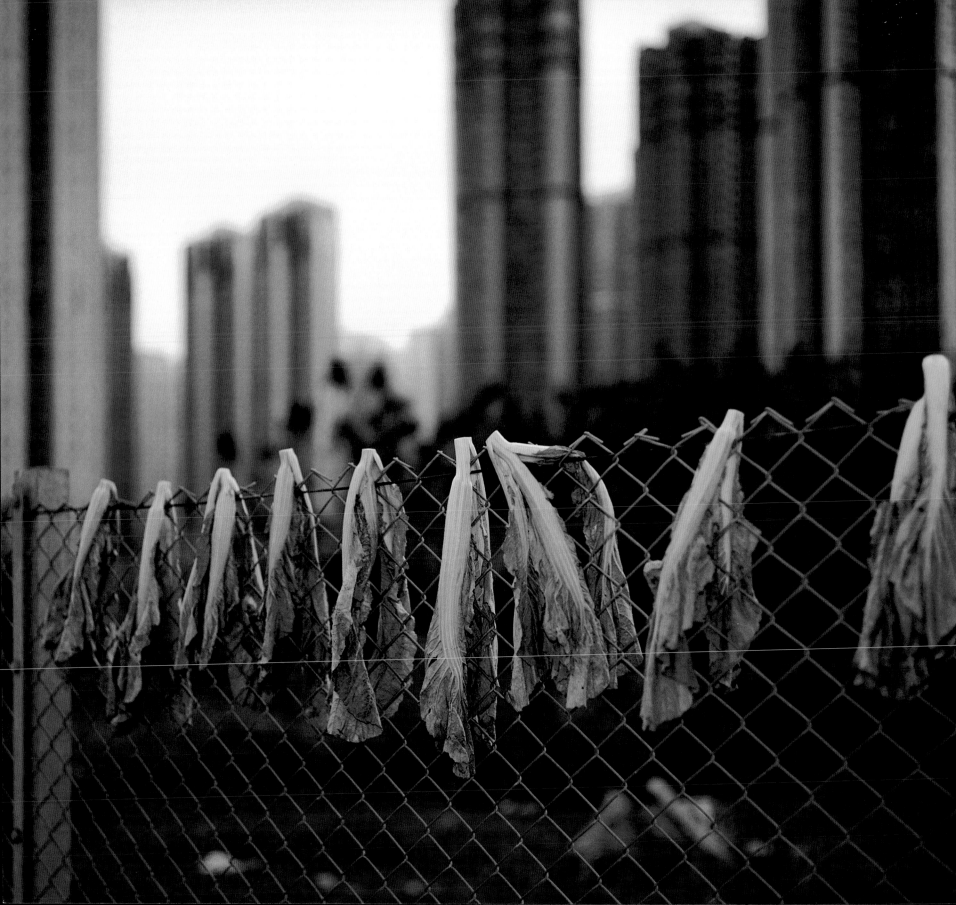

OPPOSITE TOP:
Moscow, 2008

OPPOSITE BOTOM:
Moscow, 2009

BELOW:
Moscow, 2007

ARTEM ZHITENEV

b. Moscow, 1968, lives in Moscow

Wide-eyed and gregarious, Artem Zhitenev spends his day working as staff photographer for Moscow's daily newspaper *Gazeta*. When not chasing news, he remains on the city streets looking for the tragi-comic scenes that have become his trademark, relishing his freedom of expression. 'When I'm making street photographs, I feel free from any editor's policy, I'm doing it just for myself.'

The raucous sense of humour in many of Zhitenev's pictures offers light relief as Moscow recovers from decades of social repression and economic hardship. He often makes visual puns from the city's proliferation of advertising hoardings, the mixed blessings of capitalism proving ideal raw material for his witty commentary.

Zhitenev loves to get right into the action as he snatches slices of life from the city streets. 'It is not necessary for me to remain invisible. Sometimes I like to communicate with people on the street, talk to them, even charm them. At other times I'm like a hunter quietly sneaking towards his victim before taking a single unique shot.'

WOLFGANG ZURBORN

b. Ludwigshafen am Rhein, Germany, 1956, lives in Cologne

German photographer Wolfgang Zurborn has developed a unique documentary style to depict his subjective experiences of contemporary city life. Much of his work tends towards abstraction, with signs, materials, surfaces, colours and lines densely and often enigmatically layered. 'I use photography as a way of reacting to complexity', he explains, 'extracting stills out of the mass of sensations that surround us'. He is drawn to large public events such as carnivals and festivals, as well as to visually complex urban spaces – traffic terminals, shopping malls or entertainment parks – where found imagery is abundant and distinctions between fiction and reality are often blurred.

Zurborn exaggerates the labyrinthine nature of his images by using a daytime flash and a wide-angle lens unusually close up. The effect is to dissolve any depth of field into a series of surface patterns. 'My aim is to express the loss of orientation in the impenetrable thicket of our consumption- and media-fixated society,' he says. Preserving the sense of ambiguity in his chaotic scenes is important to Zurborn; unlike many street photographers he tries to avoid 'the decisive moment when all the elements of a picture work together for a definite message'.

A trip to China in 2006 offered Zurborn the chance to immerse himself in a culture he found entirely indecipherable. 'Life in the streets of Beijing and Shanghai appears like a dense collage of signs, people and structures, a kind of semiotic overkill', he recalls. With his aesthetic appreciation for complex and disorienting public spaces, Zurborn's first encounter with China's hectic megacities deepened his creative challenge 'to describe the ambivalence and the great vividness of urban life'.

LEFT:
Untitled, Beijing, 2006

OPPOSITE:
Untitled, Shanghai, 2006

'Life in the streets of Beijing and Shanghai appears like a dense collage of signs, people and structures, a kind of semiotic overkill, which – at first sight – I am unable to decipher.'

STREET PHOTOGRAPHY NOW: A GLOBAL CONVERSATION

FREDERIC LEZMI GERMANY

JESSE MARLOW AUSTRALIA

MARK ALOR POWELL MEXICO

GUS POWELL USA

PAUL RUSSELL UK

YING TANG CHINA

NICK TURPIN UK

NICK: I think shooting really good candid shots in public is the greatest challenge in photography. I have shot huge advertising campaigns for IBM in New York and front-page pictures of riots for national newspapers, but those challenges are dwarfed by the difficulty of making special pictures with a single small camera on an ordinary city pavement. With no filters, no fancy lenses, no lights or models, street photographers have nothing to hide behind.

GUS: The question of what makes an outstanding street photograph always seems to be very hard to pin down. Joel Meyerowitz made a lot of sense to me when, in *Bystander*, he described good street photos as 'tough to like, tough to see, tough to make, tough to understand'. Stephen McLaren also has a nice definition. 'A good street photograph should tease, puzzle, reveal, stun, provoke and thrill in equal measure. They should be light in mood but dense in emotion, hard to read but easy to enjoy. Above all they should have the WTF factor. Life isn't easily interpreted and neither should photographs which are derived from it.'

PAUL: There are so many ways to make a good picture, and even more ways to make bad ones. I made a quick collection of eleven photos I liked a few weeks ago, and one's a complex urban jigsaw; the next one's bawdy, in-your-face funny with a sort of visual joke; the next is a classical composition with really nice light; the next couple of photos are unusual occurrences frozen in time, one involving pigs; the next is someone doing nothing but deep in thought, and so on and so on; and the last is a portrait. If I was trying to find a link it would be an unusual moment frozen in time, or a mundane moment where everything lines up into an aesthetically pleasing way.

NICK: One of our fellow In-Public photographers, Richard Bram, likes to say that good street photography is like good pornography: you can't really describe it but you know it when you see it! The definition of street photography has only been firmly teased out in the last decade or so. The new generation (who were, ironically, inspired by many of those who objected to the term so vehemently) have separated it from the rest of the documentary tradition and are proud to be called street photographers.

YING: I call myself a street photographer because I document the lifestyle of people on the street. The difference between street photography and photojournalism is that street photographers don't necessarily have a theme to start with, or an agenda for taking pictures. When I work for the press, they give me an idea about the story – say it's about problems with pollution for example – and I have to shoot for the story they want to tell. When I'm shooting my own work it's much more random.

GUS: I am never happy calling myself a street photographer. I find that it still means little in the photography and art world and it falls completely flat outside of those worlds. When I have to describe the sort of pictures I make, I often end up stealing a line from Jeff Ladd: 'I take pictures of people walking towards and away from me.' For me the heart of the difference between what a photojournalist does and what I do, has to do with what information each of us wants to collect and communicate to our respective audiences. While the photojournalist is working on answering questions of Who, What, When, Where and Why, I am interested in creating more questions.

FREDERIC: When I go photographing I am more or less a *flâneur*. I do not have appointments with people I want to photograph and I do not have a plan on where to end up at the end of my walk. I am just walking and looking and trying to understand the things I see.

PAUL: I understand what you are saying about not having appointments or a plan when out photographing. I like to have complete freedom for that day or afternoon – if I have just one thing I have to do at a certain time, it hangs over me and puts a dampener on the whole day!

YING: For me street photography is almost a lifestyle choice, a daily routine. It's a way of reconnecting to the city (Shanghai) where I was born after being away for fifteen years. It enables me to see the city close up, to see the strangeness in a familiar place. All the walking is also great exercise!

MARK: Yes, the walking is a key part of it! I remember before I began photographing I would go on long walking adventures. I look back on these experiences and swear it felt like I must have had a camera with me, but I didn't. I would love to get in all these unexpected entanglements with strangers, and go inside places and drink beers on porches and inside garages and see personal lives and hear their stories. People seemed obliging when I took an interest. The camera just added to the formula.

GUS: The walking is also at the heart of it for me. The wandering and the waiting. Before I was a street photographer, or even a photographer, I was a walker – most native New Yorkers are. I would (and still do) choose to walk the long way home. At some point the camera became a part of the walking.

PAUL: I wonder how much the bizarre urge to do street photography is related to being a natural wanderer and an outdoors sort of person. I remember that as a child, as soon as I was allowed to leave the house by myself I would go for huge, long walks every day. I knew at the time that this was unusual because I rarely bumped into anyone else! The thing that was exciting for me about the outdoors is that it is an uncontrolled environment with wild variables, where anything can happen.

NICK: I suppose it's really about exploration. Some of us focus our explorations on our native cities, wandering the same streets again and again, whereas others need to be in foreign places to feel they are exploring. Thinking about it, there have always been two types of street photographer – those like Robert Doisneau and Willy Ronis who spent their whole careers shooting one city, and others like Henri Cartier-Bresson who travelled the world in search of new subjects. Personally, I have always enjoyed the fact that I can find pictures on London's shopping streets or in its business district – the everyday nature of life in my city is itself the draw and the challenge. I love that if you stand on one street corner long enough something amazing will always happen, it's just a matter of time. Last year, however, Samsung paid me to travel the world taking street pictures and I found that a great challenge, to arrive in Tokyo or LA or Athens, dump my bags at the hotel and head out on to the streets to see what caught my eye.

JESSE: I've never been a subscriber to the theory that you have to be anywhere special to take strong street photos. I love travelling with my camera but it's never once been the catalyst for a new body of work I've produced.

YING: For me it takes a long time to really develop a good portfolio, and that means I need to stay in one city for a long time and really become familiar with it.

FREDERIC: I am more the abroad type of photographer. My work deals with interfaces between the Western and Arab worlds. While travelling the only thing I do is make photographs. Nothing else, no emails, no editing and definitely no looking at what I have shot already. I find this important, because it keeps me hungry. When I come home I like to leave the pictures to rest for a couple of months, for the subjective memories to fade away and allow space for an objective judgment of each image.

GUS: I like shooting everywhere but I find that some limitations help me. When I was working on my *Lunch Pictures* in New York I found that being forced to work in the limited time and space that was available to me while having a full-time job encouraged me to see the merit and surprise in less and less of an event. When I travel I create a self-enforced set of rules to navigate a new city, and I often end up working the same paths again and again rather than trying to see the entire place.

MARK: I love it when I return home from a trip and everything seems odd and wonderful again! That is the time to pick up the camera and hit it while it is hot and in new light. So, yes I think it is pretty important to travel but the best part is coming home and seeing your native city appear a little like a foreign land.

NICK: I'm changing the subject a bit but I wanted to discuss what I see as an increasing threat to street photography. I was stopped recently by police in my home city of London who told me that a member of the public had reported 'a man taking photographs'. It's absurd, I know, but this kind of over-reaction happens more and more and I am genuinely beginning to fear that we are in danger of losing the freedom to practice street photography.

PAUL: Ironically, I think one reason the 'general public' in the UK is so suspicious of photographers is that everyone now has a mobile-phone camera that they use to take a lot of cruel, allegedly funny photos, and are worried that you are doing the same to them! As someone who has taken a lot of photos of strangers, and probably thought more than most about the ethical issues, I'm often amazed at what other people will casually photograph. I have seen commuters grab a quick shot of a person hanging off a bridge threatening to commit suicide. I once witnessed quite a few people getting out their camera-phones to snap a disabled man who had become confused and was wandering around with his trousers at his ankles. I find that sort of mockery depressing.

JESSE: In the short time that I've been taking street photos, I've noticed an extreme increase in places I can't shoot. The two big train stations in Melbourne were my favourite spots. The amazing light and range of people who came through these stations daily made shooting so fun and easy. I remember one day wanting to take photos from the roof looking down on the mass of people flowing through the foyer at peak hour. I asked the station master for access. No problem. He gave me the key to the internal staircase and told me to go for it. Then came the S11 protests and the whole public liability insurance situation went beserk. Access disappeared, replaced by suspicion and fear among the public about anyone with a camera. Long-term shooting in these kinds of places now seems impossible. Unless it's a passing grab-shot on my travels it's generally not worth the hassle of trying to explain myself. I'm sick of the confrontation.

PAUL: I think the privatization of public space is an important issue, which is creeping up largely unnoticed in the UK. Recently an outdoor area of Bristol city centre, where I sometimes shoot, has been privatized. At first the company came down very hard on people photographing, with numerous security guards telling anyone with a digital SLR camera to stop shooting (as usual, people using camera-phones, etc., got a better deal). People with SLRs were asked to get a permit that they could show to security guards. Imagine if every time you went to a new city, you had to queue up to get a permit for every bit of privatized space you came across. It would be a nightmare! I believe that after a lot of complaining via the internet, the company has softened its approach. However, when I've been down in that part of the city, there are so many security guards in hi-vis jackets, itching for something to do, that it makes you think twice about shooting there. And I'm not going to take photos that include children in case I get lynched. The self-censorship issue is a worry if you consider that street photography has any documentary value.

FREDERIC: I know what you are talking about. In Beirut, for instance, the complete reconstructed downtown area is owned by one company. Photographing is not allowed. A whole army of security personnel is employed to make sure no 'professional pictures' are taken. At first I tried to get permission but it turned out to be so difficult and when I had to specify the exact location and angle of each shot, I quickly gave up. The only way to get the pictures I wanted was to be quick and pretend I was a tourist.

YING: In China there are no laws forbidding you to take pictures on the street, though there are situations in which you are likely to be questioned by authorities. Ordinary people are often suspicious too, thinking you are looking to make money in some way. I've certainly suffered abuse – been shouted at and even pushed. As in every profession in this world, there are certain new difficulties but also many new advantages. There is certainly enough going on on the streets of Shanghai to keep me busy.

MARK: I guess in every country one needs to feel the pulse and improvise within each specific situation. In relation to what Paul was saying about photographing kids, here in Mexico you have to be extremely careful. I always ask permission. With all the kidnappings going on, everyone is a little on edge and you could end up on the wrong side of a lynch mob.

PAUL: In the UK the paranoia about photographing kids has increased very quickly. On the rare occasions that I take a picture with a child in, I usually make sure that it's a situation where there are a load of other things going on in the picture. Shooting digital gives me a bit more confidence as I am very bad about formatting memory

cards and usually have hundreds of pictures on my card, so if I had to show someone what I had been shooting they could see that 99% of my shots were exclusively of adults. Whereas a film camera is a mysterious black box. I have produced a series of seaside photos with virtually no children, even though the British seaside is seen as a very family-oriented place. But what can you do?

YING: In China, parents don't just allow you to take pictures of their children, they even try to stage a shot for you because it is seen as an honour, not a sign of planned kidnapping.

MARK: Some people pose their kids here too, and are generally obliging and friendly, but the paranoia people feel about the camera is always present.

JESSE: I haven't taken a photo of a child on the street in about five years. The last time I did a suspicious father chased me on foot for a couple of city blocks. Now, it's my turn to change the subject, if that's OK. Recently I was showing a gallery curator my work and halfway through looking at my set of prints he stopped and asked how I had set up a particular photo. For the next few minutes I felt like a schoolboy in trouble with the principal as I sat there defending my work and explaining how a particular scene had occurred. My favourite street photos are the ones that invite this sort of questioning. They are absurd in their happenings and couldn't really be set up.

PAUL: Well, I guess there's always been natural scepticism about images that seem 'too good to be true' or feature amazing occurrences, but that extraordinary stuff is often the staple of street and documentary photography. Now that so many people have a camera and access to photo-editing software, there is more scepticism. There have also been quite a few widely publicized cases where news photographs have been tampered with, which has added to doubts about the authority of images in general. I can't keep up with the debate about whether Capa's falling soldier picture is a 'fake' or not! I know when I initially saw Matt Stuart's shot of the Trafalgar Square pigeon with all the human feet I did wonder if that was set up for an advert (well, the people anyway – it would be hard to direct a pigeon), so I was pleased to learn it was a straight candid shot.

FREDERIC: I know what you mean about being pleased to learn that a shot is candid, Paul, but I cannot say I feel disappointed if I find out that it is not. Instead I have to question the picture in another way. I have to question it more as a picture than in terms of the event it refers to. Should every picture be stamped 'FAKE' if it's a digital

composition? Somehow I like this flirtation with reality in these pictures. Sometimes I like to be pushed as a viewer to find out how true a picture really is.

MARK: For me a photo definitely has a longer shelf life for enjoyment and examination if it is extracted from real life. The bizarre component is usually greater, and it allows us to re-examine lost customs, the way people dressed, the mundane details that stand out more as time passes.

NICK: That's the crux of it to my mind. You're out in a public place, lots of everyday stuff is going on, your finger is on the button and something comes out of the crowd, exists for a tiny moment and is gone. You have to recognize that it's special and make your picture. That's what I see in the best street photographs: evidence of the quick-witted mind of the photographer.

FREDERIC: We used to take things for granted and first of all wonder how things could be so and so, but nowadays we have become very suspicious. The first thing we do is to check a photograph for 'mistakes' to gauge its probability. I do not recompose my pictures, adding or taking anything away. I see it as my job to identify a situation in which all the things happening in a particular place are greater and better than everything I could imagine. But at the same time I think that in the end there is just the picture and we should accept any photograph as valid whether it is digitally composed or naturally shot. The more important question is what we do with the pictures. Are we only looking for an affirmation of reality or do we want to use them to raise questions and sometimes even give answers. In this case a digitally manipulated picture may have the same veracity and power as a candid one.

GUS: Like the rest of the choir here, I also do not do any major post-production or set things up to make a picture, but I feel very strongly that the act of putting four corners around something at a specific moment in time is already a manipulation of real life. We link things and create relationships that only exist because of our decisions. It's just that we are choosing to work moment-to-moment and doing our cutting and pasting in camera.

NICK: It's interesting, Paul, Frederic and Jesse, that you all allude to the idea of pictures that are almost too crazy or unimaginable to be set up or created on a computer. Paul, you say 'too good to be true', Frederic mentions 'greater and better than everything I could imagine' and Jesse agrees that the best images 'couldn't really be set up'. No picture that you compose on the computer is ever going to surprise and delight its creator like a crazy grabbed moment of street reality.

RESOURCES

WEBSITES OF FEATURED PHOTOGRAPHERS

CHRISTOPHE AGOU
www.christopheagou.com

ARIF ASCI
www.arifasci.com

NARELLE AUTIO
www.stillsgallery.com.au/
artists/autio

POLLY BRADEN
www.pollybraden.com

BANG BYOUNG-SANG
www.fotoful.net

MACIEJ DAKOWICZ
www.maciejdakowicz.com

CAROLYN DRAKE
www.carolyndrake.com

MELANIE EINZIG
www.witnessx.com

GEORGE GEORGIOU
www.georgegeorgiou.com

DAVID GIBSON
www.gibsonstreet.com

BRUCE GILDEN
www.magnumphotos.com

THIERRY GIRARD
www.thierrygirard.com

ANDREW Z. GLICKMAN
www.andrewglickman.com

SIEGFRIED HANSEN
www.siegfried-hansen.de

MARKUS HARTEL
www.markushartel.com

NILS JORGENSEN
www.nilsjorgensen.com

RICHARD KALVAR
www.magnumphotos.com

OSAMU KANEMURA
www.amadorgallery.com

MARTIN KOLLAR
www.martinkollar.com

JENS-OLAF LASTHEIN
www.lasthein.se

FREDERIC LEZMI
www.lezmi.de

JESSE MARLOW
www.jessemarlow.com

JEFF MERMELSTEIN
www.billcharles.com

JOEL MEYEROWITZ
www.joelmeyerowitz.com

MIMI MOLLICA
www.mimimollica.com

TRENT PARKE
www.magnumphotos.com

MARTIN PARR
www.martinparr.com

GUS POWELL
www.guspowell.com

MARK ALOR POWELL
www.markalor.com

BRUNO QUINQUET
www.brunoquinquet.com

RAGHU RAI
www.magnumphotos.com

PAUL RUSSELL
www.paulrussell.info

BORIS SAVELEV
www.b-savelev.com

OTTO SNOEK
www.ottosnoek.com

MATT STUART
www.mattstuart.com

YING TANG
www.yingphotography.com

ALEXEY TITARENKO
www.alexeytitarenko.com

LARS TUNBJÖRK
www.amadorgallery.com

NICK TURPIN
www.nickturpin.com

MUNEM WASIF
www.munemwasif.com

ALEX WEBB
www.webbnorriswebb.com

AMANI WILLETT
www.amaniwillett.com

MICHAEL WOLF
www.photomichaelwolf.com

ARTEM ZHITENEV
www.artemzhitenev.com

WOLFGANG ZURBORN
www.wolfgangzurborn.de

BLOGS AND PERIODICALS

www.in-publication.com
www.burnmagazine.org
www.sevensevennine.com
http://insig.ht
http://2point8.whileseated.org
www.foto8.com
www.americansuburbx.com
lapuravidagallery.com/blog
www.lensculture.com
http://streetreverbmagazine.com

COLLECTIVES AND AGENCIES

www.in-public.com
www.seconds2real.com
www.public-life.org
www.zonezero.com
http://strange.rs
www.magnumphotos.com
www.panos.co.uk
www.agencevu.com
www.drik.net
www.majorityworld.com
www.flickr.com/groups/
onthestreet

SELECTED BOOKS BY FEATURED PHOTOGRAPHERS

Agou, Christophe, *Life Below: The New York City Subway Photographs*, New York, Quantuck Lane Press, 2004

Asci, Arif, *Istanbul Panorama*, A4 Ofset Publications, 2010

Braden, Polly, *China Between*, with essays by David Campany and Jennifer Higgie, Stockport, Dewi Lewis, 2010

Dakowicz, Maciej, *Sixteen Countries*, Blurb, 2009

Gilden, Bruce, *Facing New York*, Manchester, Cornerhouse Publications, 1992
— *A Beautiful Catastrophe*, New York, PowerHouse, 2005

Girard, Thierry, *Brouage*, Paris, Marval, 1993
— *D'Une mer l'autre*, Paris, Marval, 2002

Hara, Cristóbal, *Vanitas*, Utrera, Seville, Spain, Photovision, 1998
— *Autobiography*, Göttingen, Steidl/Huis Marseille, Amsterdam, 2007

Kalvar, Richard, *Earthlings*, Paris, Flammarion, 2007

Kanemura, Osamu, *My Name is Shockhammer*, Tokyo, Osiris, 2007

Kollar, Martin, *Nothing Special*, Arles, Actes Sud, 2008

Lasthein, Jens Olaf, *White Sea, Black Sea*, Stockport, Dewi Lewis, 2008

Lezmi, Frederic, *Beyond Borders*, Cologne, White Press, 2009

Marlow, Jesse, *Wounded*, Melbourne, Sling Shot Press, 2005

Mermelstein, Jeff, *Sidewalk*, Stockport, Dewi Lewis, 1999
— *Twirl and Run*, New York, PowerHouse, 2009

Meyerowitz, Joel, *Joel Meyerowitz*, Phaidon, 2001
— *Aftermath*, Phaidon, 2006
— *Legacy: The Preservation of Wilderness in New York City Parks*, New York, Aperture, 2010

Parke, Trent, *Dream/Life*, Kirribilli, NSW, Australia, Hot Chilli, 1999
— *Minutes to Midnight*, Brussels, Filigranes Éditions, 2005

Parr, Martin, *Bad Weather*, London, Arts Council of Great Britain, 1982
— *Martin Parr*, Phaidon, 2002
— *Luxury*, London, Chris Boot, 2009

Powell, Gus, *The Company Of Strangers*, Atlanta, J&L Books, 2003

Powell, Mark Alor, *Mexico XXI*, forthcoming 2011

Rai, Raghu, *Reflections in Colour*, London, Haus Publishing Ltd, 2008
— *Raghu Rai's Delhi*, London, Thames & Hudson, 2009

Savelev, Boris, *Secret City: Photographs from the USSR*, London, Thames & Hudson, 1988

Snoek, Otto, *Why Not?*, Rotterdam, the Netherlands, Episode Publishers, 2009

Titarenko, Alexey, *City of Shadows*, text by Irina Tchmyreva, St Petersburg, APT Tema, 2001

Tunbjörk, Lars, *Home*, Göttingen, Steidl 2003
— *I Love Borås*, Göttingen, Steidl, 2007
— *Vinter*, Göttingen, Steidl, 2007

Webb, Alex, *Crossings*, New York, Monacelli, 2003
— *Istanbul: City of A Hundred Names*, New York, Aperture, 2007

Wolf, Michael, *Hong Kong Front Door/Back Door*, London and New York, Thames & Hudson, 2005

Zurborn, Wolfgang, *Drift*, Heidelberg, Kehrer, 2007

SELECTED STREET PHOTOGRAPHERS' BOOKS AND EXHIBITION CATALOGUES

Abe, Jun, *Citizens*, Osaka, Vacuum Press, 2009

Anderson, Christopher, *Capitolio*, Mexico City, Editorial RM, 2009

Atget, Eugène, *Photographe de Paris*, New York, E. Weyhe, 1930, repr. New York, Errata Editions, 2009
— *Richard Wentworth/Eugène Atget: Faux Amis*, with introduction by Kate Bush and essays by Peter Ackroyd and Geoff Dyer, London, Photographers' Gallery, 2001

Barbey, Bruno, *The Italians*, New York, Harry N. Abrams, 2002
— *My Morocco*, London, Thames & Hudson, 2003

Bendiksen, Jonas, *Satellites: Photographs from the Fringes of the Former Soviet Union*, New York, Aperture, 2006

Boogie, *Boogie*, New York, PowerHouse, 2007

Bourcart, Jean-Christian, *Traffic*, Paris, Léo Scheer Editions, 2004

Brassaï, *Paris de Nuit (Paris By Night)*, Paris, Arts et Métiers Graphiques, 1932 (numerous reprints)

Cartier-Bresson, Henri, *The Decisive Moment*, New York, Simon & Schuster, 1952
— *The Man, the Image and the World*, London and New York, Thames & Hudson, 2003

Cohen, Mark, *Grim Street*, New York, PowerHouse, 2005

Davidson, Bruce, *Subway*, New York, Aperture, 1986; expanded edition Los Angeles, St. Ann's Press, 2004
— *East 100th Street*, Cambridge, Massachusetts, Harvard University Press, 1970; expanded edition, St. Ann's Press, Los Angeles, 2003

Deakin, John, *A Maverick Eye: The Street Photography of John Deakin*, London, Thames & Hudson, 2002

DeCarava, Roy, *The Sound I Saw*, London, Phaidon, 2000

diCorcia, Philip-Lorca, *Streetwork*, Salamamca, Ediciones Universidad de Salamanca, 1998
— *Heads*, Göttingen, Steidl, 2001
— *Philip-Lorca diCorcia* [exhibition catalogue], Peter Galassi (ed.), New York, Museum of Modern Art, 1995

Doisneau, Robert, *Paris*, Paris, Flammarion, 2009

Eggleston, William, *William Eggleston's Guide*, with essay by John Szarkowski, New York, Museum of Modern Art, 1976, facsimile edition 2003
— *William Eggleston*, London, Thames & Hudson, 2002

Elsken, Ed van der, *Love on the Left Bank*, Stockport, Dewi Lewis, 2002
— *My Amsterdam*, Amsterdam, De Verbeelding, 2005

Epstein, Mitch, *The City*, New York, PowerHouse, 2001
— *Recreation: American Photographs, 1973–1988*, Göttingen, Steidl, 2005

Erwitt, Elliott, *Snaps*, London and New York, Phaidon, 2003
— *Personal Best*, Kempen, Germany, teNeues, 2010

Evans, Walker, *American Photographs*, New York, Museum of Modern Art, 1938, repr. New York, Errata Editions, 2009
— *Many Are Called*, Cambridge, Massachusetts, USA, Riverside, 1966, repr. New Haven, Connecticut, USA, Yale University Press, 2004

Frank, Robert, *The Americans*, Paris, Delpire, 1958 (numerous reprints)

Freed, Leonard, *Black in White America*, New York, Grossman, 1967, repr. Los Angeles, Getty Publications, 2010
— *Worldview*, Göttingen, Steidl, 2007

Friedlander, Lee, *Self-Portrait*, New York, Haywire Press, 1970, repr. New York, Museum of Modern Art, 2005
— *Friedlander*, New York, Museum of Modern Art, 2008
— *Lee Friedlander* [exhibition catalogue], Peter Galassi (ed.), New York, Museum of Modern Art, 2005

Gill, Stephen, *Hackney Wick*, London, Nobody, 2005

Graham, Paul, *A Shimmer of Possibility*, Göttingen, Steidl, 2009

Gruyaert, Harry, *Made in Belgium*, Paris, Delpire, 2000

Kertész, André, *Day of Paris*, New York, J. J. Augustin, 1945
— *André Kertész: His Life and Work*, Pierre Borhan (ed.), Boston, Little, Brown, 1994, repr. Boston, Bulfinch Press, 2000

Killip, Chris, *In Flagrante*, London, Secker & Warburg, 1988, repr. New York, Errata Editions, 2009

Klein, William, *Life Is Good for You and Good in New York: Trance Witness Revels*, Paris, Éditions du Seuil, 1956, repr. Stockport, Dewi Lewis, 1995

Kolar, Viktor, *Viktor Kolar*, Prague, Torst, 2002

Kouldelka, Josef, *Invasion Prague 68*, London, Thames & Hudson, 2008; New York, Aperture, 2008
— *Koudelka*, with essays by Robert Delpire and Dominique Eddé, London, Thames & Hudson, 2006; New York, Aperture, 2006

Kurata, Seiji, *Flash Up, Street PhotoRandom Tokyo 1975–1979*, Tokyo, Shashin Workshop Group, 1980

Lartigue, Jacques Henri, *The Photographs of Jacques Henri Lartigue*, New York, Museum of Modern Art, 1963

Leiter, Saul, *Early Colour*, Göttingen, Steidl/Howard Greenberg Gallery, 2006

Levitt, Helen, *Crosstown*, New York, PowerHouse, 2001
— *Slide Show: The Color Photographs of Helen Levitt*, with foreword by John Szarkowski, New York, PowerHouse, 2005

Luskacova, Marketa, *Marketa Luskacova*, Prague, Torst, 2003

Manos, Constantine, *American Color 2*, second edition, London and New York, W. W. Norton, 2010

McCullin, Don, *In England*, London, Jonathan Cape, 2007

Mayne, Roger, *Street Photographs of Roger Mayne*, London, Zelda Cheatle Press, 1993; repr. London, Victoria & Albert Museum, 1996

Metzker, Ray, *City Stills*, New York, Prestel, 1999

Mikhailov, Boris, *A Retrospective*, Zurich, Scalo, 2003

Model, Lisette, *Lisette Model*, second edition, New York, Aperture, 2007

Moriyama, Daido, *Karyudo/Hunter*, Tokyo, Chuo Koronsha, 1972, repr. Tokyo, Taka Ishii Gallery, 1997
— *Farewell Photography*, second edition, Tokyo, PowerShovel, 2007

Papageorge, Tod, *Passing Through Eden: Photographs of Central Park*, Göttingen, Steidl, 2007

Ray-Jones, Tony, *A Day Off: An English Journal*, London, Thames & Hudson, 1974
— *Tony Ray-Jones*, with text by Russell Roberts, London, Chris Boot, 2005

Riboud, Marc, *Marc Riboud: 50 Years of Photography*, Paris, Flammarion, 2004

Roberts, Simon, *Motherland*, London, Chris Boot, 2007

Shore, Stephen, *Uncommon Places: The Complete Works*, London, Thames & Hudson, 2004; New York, Aperture, 2004
— *American Surfaces*, London, Phaidon, 2005

Singh, Raghubir, *A Way Into India*, London, Phaidon, 2002
— *India: River of Colour*, second edition, London, Phaidon, 2006

Solomons, David, *Happenstance: Black and White Photographs: 1990–2007*, Bump Books, 2009

Steele-Perkins, Chris, *The Teds*, 1979, repr. Stockport, Dewi Lewis Publishing, 2002
— *Tokyo Love Hello*, Paris, Editions Intervalles, 2007

Sternfeld, Joel, *American Prospects*, New York and Houston: Times Books/ Museum of Fine Arts, Houston, repr. Göttingen, Steidl, 2004

Stochl, Gary, *On City Streets: Chicago, 1964–2004*, second edition, Chicago, Chicago University Press, 2005

Strand, Paul, *Paul Strand: Sixty Years of Photographs*, New York, Aperture, 2009

Strauss, Zoe, *America*, Los Angeles, AMMO Books, 2008

Walker, Robert, *Colour is Power*, London and New York, Thames & Hudson, 2002

Weegee [Arthur Fellig], *Naked City*, New York, Essential Books 1945, repr. Cambridge, Massachusetts, USA, Da Capo Press, 2002
— *Weegee's New York: Photographs, 1935–1960*, Munich, Schirmer/ Mosel, 2006

Wessel, Henry, *Henry Wessel*, Göttingen, Steidl, 2007

Wiedenhofer, Kai, *Perfect Peace*, Göttingen, Steidl, 2002

Winogrand, Garry, *The Man in the Crowd: The Uneasy Streets of Garry Winogrand*, San Francisco, Fraenkel Gallery, 1999
— *Winogrand 1964*, with text by Trudy Wilner-Stack, Santa Fe, Arena Editions, 2002
— *Figments From The Real World*, with essay by John Szarkowski, New York, Museum of Modern Art, 2003
— *Public Relations*, New York, Museum of Modern Art, 2004
— *Animals*, second edition, New York, Museum of Modern Art, 2004

Wood, Tom, *All Zones Off Peak*, Stockport, Dewi Lewis, 1998
— *Tom Wood: Photie Man*, Göttingen, Steidl, 2005

Yoshiyuki, Kohei, *The Park*, Stuttgart, Hatje Cantz, 2007

GENERAL STREET PHOTOGRAPHY BOOKS AND EXHIBITION CATALOGUES

Baverey, Michel (ed.), *Images de la rue: Photographies américaines des années 1940-1960*, Nantes, Musée des Beaux-Arts, 2002

Crump, James, *Starburst: Color Photography in America 1970-1980*, Stuttgart, Hatje Cantz, 2010

Dyer, Geoff, *The Ongoing Moment*, second edition, London, Abacus, 2007

Holdt, Jacob, *United States, 1970-1975*, Göttingen, Steidl/Folkwang Museum, Essen, 2007

Hostetler, Lisa, *Street Seen: The Psychological Gesture in American Photography 1940-1959*, New York, Prestel/ Milwaukee Art Museum, 2010

Kozloff, Max, *New York: Capital of Photography*, New Haven, Connecticut, Yale University Press, 2002

Mellor, David Alan, *No Such Thing as Society: Photography in Britain 1967-1987*, London, Hayward Publishing, 2008

Meyerowitz, Joel and Colin Westerbeck, *Bystander: A History of Street Photography*, Boston, Bulfinch 1994, second edition 2001

Mora, Giles, *The Last Photographic Heroes: American Photographers of the Sixties and Seventies*, New York, Harry N. Abrams, 2007

Scott, Clive, *Street Photography: From Brassaï to Cartier-Bresson*, London and New York, I. B. Tauris & Co., 2007

20 x 10, London, In-Public, 2010

Westerbeck, Colin, *The Sidewalk Never Ends: Street Photography Since the 1970s*, Chicago, Art Institute of Chicago, 2001

INDEX OF PHOTOGRAPHERS

Page numbers in *italic* refer to illustrations. Page numbers in **bold** refer to photographers' illustrated biographies.